New Light on Old Masters

Studies in the Art of
the Renaissance
IV

E. H. Gombrich

New Light on Old Masters

Studies in the Art of
the Renaissance
IV

The University of Chicago Press

The University of Chicago Press, Chicago 60637
Phaidon Press Limited, Oxford, OX1 1SQ

This edition © 1986 by Phaidon Press Limited
All rights reserved. Published 1986
Printed in Great Britain at The Bath Press, Avon

95 94 93 92 91 90 89 88 87 86 5 4 3 2 1

Contents

Preface

The old masters in this volume, the fourth of my *Studies in the Art of the Renaissance* (the eighth of my collected essays published by the Phaidon Press), are Giotto, Leonardo da Vinci, Raphael, Giulio Romano and Michelangelo. None of them can be said ever to have lapsed into obscurity or to have lacked the attention of art lovers and art historians. But art-historical research would cease to make sense if it could not also throw new light on familiar subjects. That light, of course, must come from a fresh interpretation of the evidence, often from a new reading of texts and documents which had been previously neglected or misunderstood. I hope that the chapters in this volume will bear this out.

The first, entitled 'Giotto's Portrait of Dante?' suggests a way out of the impasse arising from contradictory evidence. Briefly, the figure in a fourteenth-century fresco in Florence, which tourists are still shown as Giotto's portrait of Dante, has long been known not to represent the poet nor to have been painted by Giotto. Yet there is a poem from the same century which speaks of such a portrait and it is here suggested that it refers to a lost mural which may indeed have been by Giotto.

The two chapters on Leonardo also deal primarily with texts, but this time with texts from the master's own hand. The first, 'Leonardo on the Science of Painting: Towards a Commentary on the Trattato della Pittura', challenges the current reading of that famous treatise as a record of Leonardo's powers of observation in the light of the theory put forward in *Art and Illusion*, and exemplifies the meaning and the limits of the master's claim to have based the art of painting on scientific reasoning.

The second, 'Leonardo and the Magicians: Polemics and Rivalry', examines the satirical texts in which Leonardo mocked the soothsayers and quacks of his time, and shows how profoundly his own conception of art was imbued with the desire to achieve the effects which eluded the magicians; it finally proposes an interpretation of one of Leonardo's most enigmatic writings in which he branched out into literary fiction.

The essay on 'Ideal and Type in Italian Renaissance Painting' also takes its starting-point from a text, a famous letter attributed to Raphael about the 'idea' he had in his mind, and proposes a reading suggested by *Art and Illusion* that leads to fresh analysis of the notions of type and ideal in the art of Raphael and his predecessors. The speech on Raphael on the occasion of the five-hundredth anniversary of his birth was delivered on the Capitol in Rome during the solemn inauguration of the Raphael celebrations throughout Italy. The occasion precluded the showing of slides, but it all the more encouraged a fresh look at the interpretations of the master's art which we encounter in the sources and documents. The study of Raphael's *Transfiguration* places one of his most famous masterpieces in a historical context suggested by the Bible and its Commentaries.

In the two studies devoted to Raphael's celebrated pupil Giulio Romano I return to the subject of my doctoral dissertation written more than fifty years ago. The first, ' "That rare Italian Master . . .": Giulio Romano, Court Architect, Painter and Impresario', describes the life and the duties of a devoted servant to an ambitious Italian lord on the basis of the documents, and suggests the channels through which the name of that master may have come into Shakespeare's *A Winter's Tale*. The second, 'Architecture and Rhetoric in Giulio Romano's Palazzo del Te', considers the peculiarities of that strange *plaisance*, not so much from the point of view of formal analysis but in the light of the aesthetic theories the Renaissance derived from ancient writings on Oratory.

In contrast to these more general observations, the essay on 'Michelangelo's Cartoon in the British Museum' suggests that the subject of this enigmatic work of the master's old age may be explained by the writings of a Greek Church Father, whose name Epiphanias occurs in the written records but has so far been misinterpreted.

London, March 1986 E. H. G.

New Light
on Old Masters

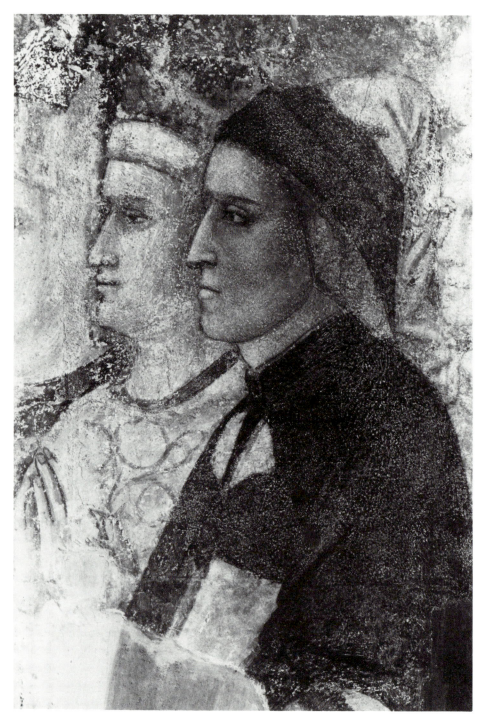

1. *The 'Dante portrait'*. Detail of Fig. 6

Giotto's Portrait of Dante?

To the memory of Keith Roberts (1937–79)

Some years ago Benedict Nicolson and Keith Roberts told me of their idea of this series of annual lectures each devoted to the discussion of a single portrait. After the bereavement which *The Burlington Magazine* suffered through the sudden death of Benedict Nicolson, it was Keith Roberts who invited me to give this lecture and even agreed to bend the rules to accommodate a portrait trailing a large question-mark behind it (Fig. 1). It is characteristic of the kind of friend he was that he immediately took a lively interest—only a few weeks before his sad and unexpected death he brought me the catalogue of an exhibition which, as he rightly thought, would come in useful for me, the exhibition at the Marlborough Gallery of works by Tom Phillips.[1]

These recent works (Fig. 2) can indeed serve as a reminder of the continued vitality of the Dante image as it lives in the Western tradition. The artist based his main version on Signorelli's portrait in Orvieto, but he also groped for a fresh vision of these familiar features, to see them in the round, as it were. For this, I think, is the decisive point. Dante is the first person for almost a thousand years whose name immediately evokes a vivid image of his physical presence. Not that he was the first person or even the first poet after the classical age whose portrait was handed down, but to appreciate the whole world which separates medieval portraits from our image of Dante, we need only look at the so-called Manesse Codex,[2] a delightful collection of the works of German Minnesänger which may well date back approximately to Dante's lifetime. Take the famous page showing Walter von der Vogelweide in the pose in which he described himself sitting cross-legged on a stone with his head supported by his hand (Fig. 3). There clearly is no attempt here

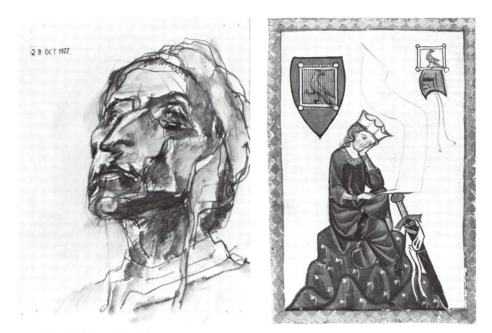

2. Tom Phillips: *Sketch for a series of Dante images*, 1977. London, Marlborough Fine Art Ltd

3. *Walter von der Vogelweide*. From the Manesse Codex, 1314–30. Heidelberg, University Library

to portray the actual features of Walter; they closely resemble the formula adopted for Heinrich von Veldecke. Certainly the miniaturist neither could nor did attempt to find out what these men had looked like. He marked them by their gestures or their costume; Tannhäuser is clad like a templar, and Ulrich von Lichtenstein is merely shown as a knight in armour, the heraldry taking the place of the physiognomy.

The portrait of Dante, to repeat, is no such mere sign or token. It has a life of its own. Not that it appears immediately fully fledged. The illuminated codices of the *Divine Comedy*, collected and discussed by Peter Brieger, Millard Meiss and Charles Singleton,[3] do not at first confront us with the Dante of our imagination, clad in red with his familiar head covering and his gaunt profile. But by the fifteenth century at the latest, illustrators tended to use this type, as Botticelli did in his memorable drawings.

It is the purpose of this lecture to attempt, by no means for the first time, to ask for the credentials of this image. I do not mean so much the question as to whether it would have enabled us to recognize Dante Alighieri as he walked the streets of Florence in his youth and manhood, and trod the path of exile for the last twenty years of his life; I do not think this question will ever be answered. What I want to know is rather whether there was

an archetype from which these Dante portraits are derived. I would not have proposed returning to a problem which has been the subject of so many books and articles,[4] if I had no suggestion to make, but I shall have no proof to offer for my hypothesis, which in any case will demand a good deal of recapitulation of what others have said.

Historical problems such as this one are very much like jigsaw puzzles. We have a number of pieces, of texts and monuments which we have to accommodate, but we cannot do so unless we can make them fit together.

The difficulty in bringing this to pass accounts for the question-mark behind the title of my lecture. The best known piece in the jigsaw puzzle is of course the figure on the wall of the Chapel in the Bargello which is still shown to tourists as Giotto's portrait of Dante (Fig. 1), though it is now more than a hundred years since the difficulty of making it fit with the other evidence was pointed out by Gaetano Milanesi, the editor of Vasari.[5]

Vasari was not the first but the most influential author to give currency to this identification in the second edition of his Life of Giotto;[6] the skill and persuasiveness with which he introduced it make it necessary to start with his account. The *Vita* of Giotto is for Vasari the story of the decisive step in the emancipation of art from the degrading bondage of the Byzantine manner towards a study of nature. Hence he opens the biography with the legend derived from Ghiberti of how Giotto the shepherd's boy was discovered by Cimabue drawing a sheep from the life with a pointed stone on a rock. Having become Cimabue's pupil he very soon surpassed his master, discarded that crude Greek manner and revived the good modern manner of painting, introducing the portrayal of the likenesses of living persons, something that had not been seen, as Vasari quaintly says, for two hundred years. At any rate, Vasari continues, even if others had tried it nobody succeeded like Giotto who, among others, portrayed, as is still to be seen in the Chapel of the Palazzo of the Podestà in Florence—that is the Bargello—Dante Alighieri, his contemporary and greatest friend, who was no less famous as a poet than Giotto was at that time as a painter. After a brief reference to Boccaccio's praise of Giotto's skill in the imitation of nature, Vasari adds that in the same chapel Giotto also painted his own portrait as well as that of Brunetto Latini, the teacher of Dante, and Messer Corso Donati, a great citizen of that time.

The purpose, then, for which Vasari places this work at the beginning of the *Vita* is quite apparent, and so is the element of historical truth it contains. Giotto's art did mark a turning towards nature[7] which could and did include a kind of portrayal unknown before. But what of the literal truth? Did Giotto draw a sheep on a stone, and did he make a portrait of Dante?

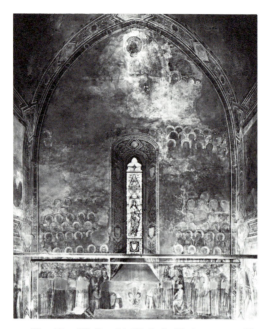

4. *The Altar Wall, with Christ in Majesty, c.*1336?
Florence, Chapel of the Palazzo del Podestà

Before we accept or reject even the possibility of such an event we must agree on what we mean when we talk of a portrait. Giotto's sheep would have been a study from nature, but we would not call it a portrait unless the sheep was a pet the boy wanted to remember. Ulrich von Lichtenstein encased in heraldic armour in the Manesse Codex is a portrait, but not a study from nature. There are any number of variants in between these two extremes.

Vasari certainly saw correctly that Giotto's figures are no longer types, they are, or often are, convincing individuals. We have no reason to doubt that in the fresco of the Last Judgement on the entrance wall of the Arena Chapel, Padua, the figure of the donor Enrico Scrovegni is a portrait intended to be recognized as such. It is hard to believe that the cleric who assists him is not also modelled on an individual, but we cannot tell whether it was the intention to promulgate and commemorate his likeness. When we come to the crowds of the blessed and the damned we can be even less sure of their status. The degree to which they are individualized may be due to the artistic desire of avoiding monotony and making them credible as human beings. Maybe it was known in Giotto's workshop that one of them resembled an apprentice or an awkward customer, as there are plenty of such stories told in Vasari of other works, but this resemblance may have been intentional or merely fortuitous. We cannot tell.

Earlier readers of Vasari were less plagued by such scruples and distractions. The story has often been told of how Vasari's description led a group of Italian art lovers in 1839 to petition the authorities to allow them to search under the whitewash for the portraits described.[8] What they found was a much-damaged fresco cycle with a vision of hell on the entrance wall and opposite on the altar wall a vision of Paradise, with Christ enthroned in Majesty over the window and the heavenly hosts arranged underneath (Fig. 4). In front, on the ground level, there is a throng of citizens in contemporary dress and near the painted steps, beside the altar, two kneeling figures in which we must see the donors (Figs. 5 and 6). The first discoverers had no doubt whatever that they had found the group Vasari had described and that one of the heavily damaged figures was the portrait of Dante by Giotto. Unhappily that profile had been disfigured by a nail driven through the eye which was subsequently restored in the most arbitrary way (Figs. 7 and 8). But several painters appear to have gained access to the chapel before the last traces of the original paint were obliterated by Marini. The English artist Kirkup is said to have made a tracing which is still preserved and which served as a basis of the famous print published by the Arundel Society.

Less known and indeed still unpublished are the copies made by the Swiss painter Franz Adolf von Stürler[9] (Fig. 9) to which the late Professor Kurz

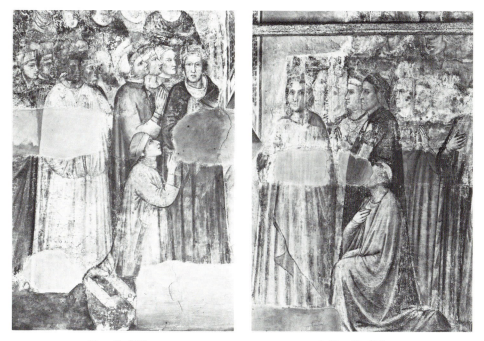

5. Detail of Fig. 4 6. Detail of Fig. 4

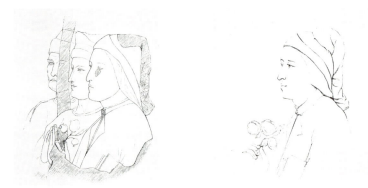

7.The 'Dante portrait' and other heads (Corso Donati and Brunetto Latini) before restoration.
After Crowe and Cavalcaselle, *A New History of Painting in Italy*, 1864
8. The 'Dante portrait' after restoration. After Crowe and Cavalcaselle, *A New History of Painting in Italy*, 1864.

drew my attention. They are now in the Museum in Berne and served Stürler as the basis for two rather indifferent paintings also kept there. Like the Italian restorer, Stürler later adjusted the mouth of the figure, pulling down its corners a little, presumably to conform with Dante's famous *sdegno*, his disdain of the world. Here, then, is the portrait we are asked to accept as the prototype of all others. Why has it made historians increasingly uncomfortable? The answer, as I said, is that for all Vasari's skill in welding his facts together the pieces resolutely refuse to fit.

There is first the attribution to Giotto. Admittedly this was not dreamt up by Vasari; the frescoes are mentioned among the master's works in Ghiberti's *Commentarii*, which are generally considered to be sober and reliable.[10] Whether they can be by Giotto depends of course on their date.[11] There is an inscription in the chapel proclaiming that *hoc opus* was made under the Podestà Fidemini of Verano, who held office between 1336 and 1338. Giotto died in 1336 and this leaves the theoretical possibility that he may still have had a hand in the planning. It is not a possibility which has appealed to critics of style, for some of the murals are certainly far removed from Giotto's manner, but the late Millard Meiss in the work I have mentioned[12] pointed out that the frescoes are not uniform and that the end walls of the chapel differ from the side walls. Investigations which Signor Tintori made at his request have shown that these end walls, including the altar wall with the alleged portrait, were done earlier, and so the possibility should not be denied that they could have been planned by Giotto's workshop, whatever this may mean in practical terms.

It is hard to argue these matters in front of bad photographs of faded murals, but I personally tend to accept the conclusion of Isermeyer,[13] who has argued

that the layout of these murals naturally betrays familiarity with Giotto's schemes, but represents a perfunctory simplification of his decorative ideas.

In any case the faint possibility that Giotto during his last years as Capomaestro in Florence had some control of the decoration would offer no help whatever to anyone who desired to cling to Vasari's account of the portraits in the chapel. After all, the whole point of Vasari's story was to show that Giotto was able to paint people from life, and to establish this fact he needed to place these frescoes very early in Giotto's career—not only to dramatize the innovation, but also because only in his early period could the master have had an opportunity of portraying from the life Brunetto Latini, who died in 1294, Corso Donati, who was killed in 1308, and most of all Dante himself, who was banished from Florence for ever in 1301. But if Dante was really portrayed on the altar wall of the Bargello Chapel at so early a date the question would arise whether he was sufficiently famous at that time to deserve this honour. It is true he had written the *Vita Nuova*, but the *Divine Comedy* may not even have been a plan at that time. To get out of this difficulty Cavalcaselle suggested[14] that Dante had found a place in the fresco not as a poet, but as a politician. He pointed to a brief truce in the terrible conflict between the Blacks and the Whites arranged by Cardinal Aquasparta in which Dante played a part as a delegate. It is an attractive theory, but historians

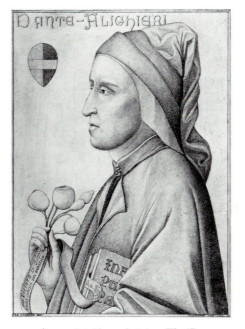

9. Franz Adolf von Stürler: *The 'Dante portrait'*, 1850. Bern, Kunstmuseum

tell us that the truce was much too short-lived to have deserved and received a monumental commemoration in a fresco of this kind.

To those who know Vasari's methods the ingenuities of these attempts to rescue his story seem rather misspent. Vasari was notoriously reckless in these as in other matters. As the court painter of the Medici who was asked to cover the walls of the Palazzo Vecchio with frescoes representing episodes of Florentine history, he needed portraits from the past and was inclined to assume that earlier artists felt the same need. Thus, rather than freely inventing the appearance of historical figures, he baptized some of the persons he found represented according to his convenience. He did the same for his *Vita*. One of the most glaring cases is his decision to call a figure in Andrea da Firenze's frescoes, in the Chapter House of S. Maria Novella, Cimabue and to use the figure for his portrait in his illustrated second edition.

Granted that defenders of Vasari's description of the Bargello frescoes could plead that whatever may be true of the unlikely identifications of Brunetto Latini and Dante's enemy Corso Donati in the group, the existence of the portraits of Dante and Giotto on the wall of the chapel was not Vasari's invention. Filippo Villani referred to such portraits in a revised edition of his brief life of Giotto dated around 1396.[15]

Now there probably were portraits on the altar wall, if, as one may assume, the kneeling figures represent donors. The men who converge on the centre, on the other hand, are certainly individualized, but it would be surprising at the time if the painter intended a monumental group portrait. But even if that were possible, could the group include a portrait of Dante, if, as the consensus now has it, it was painted somewhere around 1336? Dante had been banished in 1301 and condemned to the stake if he ever set foot in Florence without paying the penalties. The sentence had been renewed in 1315 and Dante had explicitly refused to accept any conditions for his return. To place the image of a condemned traitor so close to the altar of the Palazzo del Podestà would have been an astonishing act. Usually traitors in Florence were painted rather on the outside walls of the Palazzo, hanging by their feet.[16] And as if this argument were not enough to rule out the identification of the portrait, there is also the fact that its testimony clashes with the literary tradition of Dante's appearance, for Boccaccio,[17] in his life of Dante dating from about 1363–4, describes him as follows: 'Our poet was of middle height and in his later years he walked somewhat bent over, with a grave and gentle gait. He was clad always in the most seemly attire, such as befitted his ripe years. His face was long, his nose aquiline, and his eyes rather big than small. His jaws were large, and his lower lip protruded.' So far we have no difficulty in matching these words with our image—but then Boccaccio continues: 'His

complexion was dark, his hair and beard thick, black, and curly, and his expression ever melancholy and thoughtful.'

So Dante had a beard, a beard moreover which figures in Boccaccio's story of an ignorant woman who thought that the poet must really have visited hell because 'one can see how his beard is curled from the heat and smoke down there'. Fourteenth-century illuminations do sometimes show Dante with a beard, and maybe we would not, after all, recognize him. But defenders of the Bargello portrait have rightly argued that beards can be worn and shaved off several times in a man's lifetime. But what is less easy to evade is the question of the figure's age: it clearly represents a young man, and why should Giotto—if we concede the work to him—have painted Dante in 1336 as a young man? It is here that the defenders of the tradition use what they consider their trump card. Giotto evidently must have used a portrait he had made some forty years earlier of his dear friend and companion, *amico suo grandissimo*, as Vasari calls him, or simply, as another writer claimed,[18] reproduced the image he always carried in his heart.

The argument was evidently convincing to earlier generations, but alas, by now the story of this friendship between Giotto and Dante has also withered under the cold blast of criticism. Some fifty years ago Pier Liberale Rambaldi[19] demonstrated in a masterly article how this legend grew up and how it was to serve Vasari for the scaffolding of his *Vita* of Giotto. For the historian, the growth of this legend is an object lesson of the way a text can turn into its opposite through wishful thinking and misunderstanding.

In the eleventh canto of the *Purgatorio* Dante and Virgil have reached the ledge where the once vainglorious are purged of their sin of pride. Their proud necks are bent by heavy loads of stone to teach them humility. Dante himself has to bend low to see them and converse with them and in this posture he recognizes a miniature painter Oderisi da Gubbio. When he addresses him in flattering terms as the honour of Gubbio, the illuminator who has learned his lesson replies that really Franco Bolognese's pages are more radiant. He would not have conceded such excellence to his rival while he was still among the living, because of his ambition, for which he now pays the price, nor would he even be in Purgatory if he had not repented in time. Thereupon he launches on his famous art historical exemplum:

O vana gloria dell'umane posse,
com'poco verde in su la cima dura,
se non è giunta dall'etati grosse:
Credette Cimabue nella pittura
tener lo campo, ed ora ha Giotto il grido,

sì che la fama di colui è scura:
così ha tolto l'uno all'altro Guido
la gloria della lingua; e forse è nato
chi l'uno e l'altro caccerà del nido.
Non è il mondan romore altro ch'un fiato
di vento, ch'or vien quinci e or vien quindi,
e muta nome perchè muta lato.

'Oh empty glory of human powers. How brief a time its green endures upon the top, unless it is followed by a barren age. Cimabue believed he held the field in painting, and now the cry is Giotto's, so that the fame of the other is dim. Likewise one Guido has taken from the other the glory of the tongue, and maybe one is born by now who will chase both of them from their nest.'

'Earthly fame is no more than a whiff of wind which now comes from here and now from there, and changes name because it changes direction.' And so, Oderisi concludes his sermon to Dante, 'remember that in a thousand years it will make no difference whether you die famous or as an infant, and even this is but the twinkling of an eyelid compared with the revolution of the heavens.'

I think it helps in such cases to transpose Dante's story into modern terms and even into our own environment. Imagine the poet encountering an art historian who was known for his well-developed ego, if I may say so without offence, perhaps Joseph Strzygowski. Doing penance in purgatory as we shall all have to do, he is addressed by Dante as a famous scholar, but replies, 'My dear Sir, the theories of Alois Riegl were much more brilliant than mine, though I would never have admitted this in life and only shed my pride in my last hours. But what is reputation anyhow? It only lasts in a field which is subsequently neglected. Once Leo Planiscig thought he held the field as a connoisseur of Renaissance bronzes and now the recognized authority is Pope-Hennessy and Planiscig's reputation has faded.'

Of course the parallel does not fit, but it helps at least to make it clear what Dante did not say about Cimabue and Giotto. He did not say that Cimabue was a great painter, only that he considered himself great; he did not say, of course, that Giotto was his pupil, only that he was now more talked about than Cimabue and that anyhow it is utterly sinful to be proud of worldly success.

You might say that there is no more depressing example of the futility of moral sermons than the fate of Dante's words. He wanted to drive home the emptiness of fame and all he achieved was the spread of fame. The few

lines he wrote about the fickleness of reputations in art became the *fons et origo* of modern art history. It was my teacher Schlosser[20] who liked to meditate on this paradox which gave rise to what he considered the myth of Cimabue and the legends about Dante's friendship with Giotto. They were soon embroidered and elaborated in the early commentaries to the *Divine Comedy* and led to the earliest stirrings of the modern literature of art, the roots of the tree of which Vasari is the crown and *The Burlington Magazine* a late fruit. But it is precisely because we can trace the growth of this legend that we have difficulty in accepting its elements as historical fact. It was Filippo Villani[21] who shortly after 1380 included Giotto in his brief biographies of illustrious Florentines—not without an apology for talking of a mere crafts-man—and reported, one might say predictably, that Giotto had painted a portrait of Dante together with his own portrait, done with the help of a mirror, on the altar panel—*tabula altaris*—of the chapel in the Palazzo del Podestà. We know there was such an altar panel which soon disappeared, and so we cannot prove him wrong. Portraits on altar panels were certainly quite frequent in the trecento, if you think of the figures of donors, often represented very small on the lower margin, whose true identity may not always have been handed down. It is well to remember in this context that the trecento in Florence is bisected by the catastrophe of the Black Death, which separates the age of Dante and of Giotto from that of Filippo Villani, whose uncle Giovanni Villani, the famous chronicler, had died of the plague. Perhaps the inevitable loss of oral traditions favoured the growth of legends in these matters. At any rate, when Filippo Villani came to rewrite his account of Giotto around 1395–6 he said, as I mentioned, that Giotto's portrait of Dante together with his self-portrait were on the wall of the chapel in the Palazzo. He may have referred to the group we still know, though which of the figures near Dante might have been thought to represent Giotto remains an open question.

In all these matters the sceptics had and have an easy game, and on the evidence so far considered the story of Dante's portrait by Giotto in the Bargello would be most likely explained as a late and very dubious tradition. Indeed it would hardly be worth worrying about, if it were not for a fourteenth-century text which was published by Alessandro d'Ancona[22] to silence the doubters since it appears to describe this very portrait of Dante as a work by Giotto. He had found the manuscript of a sonnet by Antonio Pucci, a poet or rhyme-ster, who was born soon after 1300 and died at a ripe old age somewhere near 1388.[23] Mark that Pucci was therefore near thirty when Giotto died, and that he survived the Black Death. Moreover, he held official positions in the service of the Florentine Commune, first as a bell ringer summoning

assemblies, and when the bell got too heavy for him, as a trumpeter and town crier. His testimony cannot therefore be lightly dismissed, for he must have been familiar with the Palazzo del Podestà for most of his life. The text of this crucial and awkward document which must be compared with the fresco to which it has been related reads as follows:

> *Questi che veste di color sanguigno,*
> > *Posto seguente a le merite sante,*
> > *Dipinse Giotto in figura di Dante*
> > *Che di parole fe' sì bell'ordigno.*
> *E come par ne l'abito benigno,*
> > *Così nel mondo fu con tutte quante*
> > *Quelle virtù ch'onoran chi davante*
> > *Le porta con effetto nello scrigno.*
> *Diritto paragon fu di sentenze;*
> > *Col braccio manco avvinghia la Scrittura,*
> > *Perchè signoreggiò molte scïenze.*
> *E 'l suo parlar fu con tanta misura,*
> > *Che 'ncoronò la città di Firenze*
> > *Di pregio ond'ancor fama le dura.*
> *Perfetto di fattezze è qui dipinto,*
> > *Com'a sua vita fu di carne cinto.*

'This one, who is dressed in crimson colour placed behind the sacred merits, was painted by Giotto in the shape of Dante, who made such beautiful arrangements of words. And as he appears here as a benign presence, so he was in this world, with all those virtues that honour him who carries them with affection in his shrine. He was an upright paragon of sentences. With the left arm he clasps the writing, for he was master of many sciences. And his speech was so well measured that he crowned the city of Florence with praise of which the fame still endures. Here his face is perfectly painted as he was in the flesh during his life.'

Now it is true that the figure taken to be Dante wears a scarlet robe as did so many citizens of the time. It is also true that he holds a book under his left arm. Many other lines of the poem refer to Dante's achievements rather than to the portrait except that he is said to be placed behind the sacred merits (*le merite sante*), which has been taken to mean the meritorious and saintly women, which does not make much sense here. Still, while the text is linked with the fresco, deadlock is likely to continue in the question of Giotto's portrait of Dante in a fresco hardly by Giotto where Dante could hardly have figured.

In 1965 when I first turned to these problems having been asked to give the Barlow lecture on Dante at University College, London, it was again my friend Otto Kurz who gave me the advice to look at the text again. I did, and my doubts grew whether it must be taken to refer to the figure on the altar wall. I am glad to see that later Millard Meiss, in his publication, came to share these doubts and it was he, in fact, who encouraged me to elaborate the alternative hypothesis to which I have come at last. It takes its starting-point from the fact that there was another cycle of frescoes in the Palazzo del Podestà attributed to Giotto, though irretrievably lost, a moral allegory in the manner of other town-hall murals, and mentioned by Ghiberti among Giotto's works as *Il Comune rubato*, the Commonwealth Robbed.[24]

There is a relief on the tomb of Bishop Tarlati in Arezzo dating from around 1330, that is from Giotto's lifetime, labelled *Il Comune pelato*, the Commonwealth Stripped, which gives us an idea of the theme as it shows an old man enthroned being set upon by seven people who try to rob him and strip him of power and possessions (Fig. 10). This, it seems, was the central theme of Giotto's murals, but not the only one, for Vasari, who gives a description, places it in a wider setting.

In the great hall of the Podestà in Florence Giotto painted how the commune is being robbed by many. There he represented the Commune in the shape of a Judge sitting with a sceptre in his hand. Above his head he placed the balanced scales to show the justice of the rules he lays down, aided by the four Virtues—Fortitude with courage, Prudence with the laws, Justice with arms and Temperance with the words, a fine painting and a fitting and plausible invention.[25]

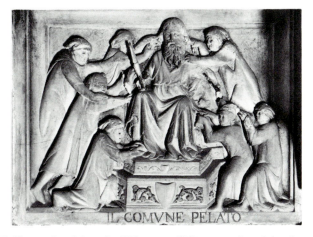

10. Agostino di Giovanni and Agnolo di Ventura: *Il Comune pelato*, from the tomb of Bishop Guido Tarlati, *c*.1330. Arezzo, Cathedral

It is unlikely that Vasari's description is based on first-hand knowledge of the painting, at least I think that the way he enumerates the four cardinal virtues points to a poem or inscription rather than a visual source.

Though different in scale, Giotto's cycle must have resembled the greatest of these civic allegories which has come down to us from the trecento, Lorenzetti's painting of *Good and Bad Government* in the Palazzo Pubblico in Siena, where we also see a figure enthroned flanked by the personifications of virtues and on another wall, much obliterated, the warning example of bad government, all explained in didactic inscriptions.[26]

In 1933 Salomone Mopurgo suggested that there is a parallel to Giotto's mural still visible in Florence, though not accessible to tourists, the end wall of the Audience Chamber of the Arte della Lana. Just as the Tarlati tomb reflects the central group of Giotto's composition so the mural of the Audience Chamber seems to echo the other elements described by Vasari, the Just Judge flanked by the four virtues and other figures (Fig. 11).

You will have guessed that it is in this lost fresco by Giotto in the Palazzo del Podestà that I want to look for the figure described by Antonio Pucci as a portrait of Dante and it is my task now to show you that such a conjecture is neither quite as wild nor as fruitless as it may sound.

It is not wild, because we know that two other sonnets by Antonio Pucci do describe Giotto's *Comune rubato*, if they do not reflect some of the inscriptions. The first is a lament addressed to the figures:

> Alas, Commune, how I see you beset both by foreigners and by neighbours, but most of all by your citizens who ought to exalt you in your high position. Those who should honour you most treat you the worst, there is no law they do not bend, with hooks, with saws and with fingernails they all try to tear a piece from you, there is no hair left on you; one pinches the sceptre and one takes off your shoes; another tears your garment and strips you . . .

To which the Commune replies that if everyone obeyed the laws as much as they enjoy robbery, Florence would be now more majestic than Rome ever was. However, revenge will come with the turning of the wheel of Fortune.[27]

Thumbing through Pucci's many sonnets, which have been collected from a variety of manuscripts, one finds others which would make sense in the context of Giotto's cycle, notably one addressed to a Just Judge[28] and perhaps others meditating on the Wheel of Fortune and the wickedness of the world.[29] I do not know if anyone has really asked what Pucci intended with these didactic rhymes. Some of them seem most suitable as inscriptions to be placed

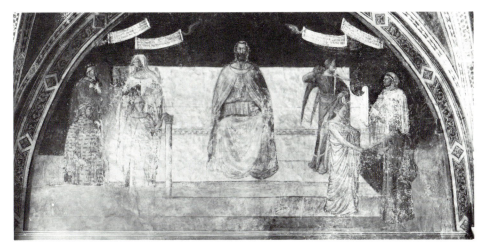

11. *The Just Judge with the Cardinal Virtues*, first half of the fourteenth century. Florence, Palazzo dell'Arte della Lana

on precisely such a fresco cycle. My hypothesis would be that the Dante sonnet by Antonio Pucci originally served the same purpose and referred to the same cycle and I should like to analyse its wording with this possibility in mind.

Take the opening: '*Questi che veste di color sanguigno . . .*' Who is being addressed? A visitor to the chapel? Is he expected to carry the manuscript of the description around him, or is the poem not more likely to be intended, at any rate, to be placed somewhere near the painting for all to read? '. . . *Posto seguente a le merite sante.*' A figure in scarlet was placed behind the '*merite sante*', literally the sacred merits. As I said, it was always strained to apply these words to the figure on the altar wall of the chapel; but if we could picture it side by side with the saintly or sacred virtues this would make sense. It is Dante himself in the first canto of the *Purgatorio* who speaks of the four cardinal virtues, the stars which illuminate Cato's face, as '*Li raggi delle quatro luci sante*',[30] and the inscription of the allegorical cycle in the Palazzo Pubblico in Siena describes Concordia as '*Questa santa virtù*'.[31]

It so happens that even the word '*merito*' is used in the inscriptions of the frescoes of the Arte della Lana, though this '*merito*' is a negative, not a sacred merit. It is the tempter, the corrupter, who says to Justice, '*Io posso meritar ben chi mi serve*', promising rewards for illicit services rendered. If you do not object to spinning out the maybes, you could imagine that in Giotto's cycle, similar to the one in Siena, these evil merits were explicitly contrasted with the '*merite sante*', the four virtues. And just as the tempter stands here in the Arte della Lana, so some admonishing figure might have stood close to the sacred virtues in a similar ceremonial garb of a councillor.

If we accept that possibility the second stanza of Pucci's sonnet also makes a little more sense.

> *E come par ne l'abito benigno,*
> *Così nel mondo fu con tutte quante*
> *Quelle virtù ch'onoran chi davante*
> *Le porta con effetto [affetto] nello scrigno.*

'And as he appears here as a benign presence, so he was in this world, with all those virtues that honour him who carries them with affection in his shrine.' Holbrook was perplexed by this reference to a shrine,[32] and I do not claim to have a perfect solution. I suppose Pucci may have meant the heart, and that he put it like that because he needed another rhyme on '*igno*'.

But in any case '*tutte quante quelle virtù*' seems to fit the context of an allegorical painting quite well and even the '*scrigno*' may have found an explanation in the painting.

Note that the next lines are implicit references to the various virtues, first Prudence:

> *Diritto paragon fu di sentenze;*
> *Col braccio manco avvinghia la Scrittura*
> *Perchè signoreggiò molte scïenze.*

'He was an upright paragon of sentences [wise sayings]. With the left arm he clasps the writing.' I don't believe this is likely to mean simply that he carries a book. I would imagine him holding a scroll or tablet with an inscription, and I can point to another line in Pucci's poems in which '*scrittura*' means unambiguously inscription.[33]

And so to Temperance:

> *E'l suo parlar fu con tanta misura,*
> *Che 'incoronò la città di Firenze*
> *Di pregio ond'ancor fama le dura.*

True, Dante exercised little temperance when speaking of Florence, but maybe it was all the more advisable for Pucci to stress the other side. For he wanted the figure to be the real Dante,

> *Perfetto di fattezze è qui dipinto,*
> *Com'a sua vita fu di carne cinto.*

Without wanting to place too much weight on the conjectural parallels between the mural of the Arte della Lana and Giotto's lost cycle in the Palazzo del Podestà, it seems to me that the cycle helps us to envisage also a prophetic

figure by the side of the Judge and the Virtues lifting a scroll and admonishing the citizens. One might imagine him as a gaunt imposing type dressed in Dante's red garb, with his stern profile and his commanding presence as we still recognize him from the frescoes of Castagno and from a panel by Giovanni dal Ponte at the Fogg Museum.[34]

I admit that I have no shadow of proof for this suggestion. All I can claim is that it would be convenient for the solution of the jigsaw puzzle to shift the traditional Giotto portrait, which has so stubbornly refused to fit, somewhere on to the margin and to start afresh with another piece which has to be constructed from our imagination as our archetype.

But, you may say, are we not back at square one, since I have argued at some length against the possibility of a portrait of Dante having been placed in the Palazzo chapel before his sentence had been revoked? Would the same not apply to any other room in the Palazzo? But let me recall what I said of the uncertain meaning of the term portrait. What we had been asked to believe if we took Pucci's sonnet to apply to the chapel wall, was that a commemorative image of a rebellious exile had been placed among the more or less anonymous city worthies representing the Commune, or at the very least that Pucci wrongly believed that this was the case. But before we conclude that Pucci cannot have been right, we must at least make the attempt to square his statements with any other evidence we have. I believe there is no more virtue in uncritical scepticism than there is in uncritical credulity. The historian's attitude towards his sources should rather resemble that of the ancient astronomer trying to 'save the phenomena'. Unless we can prove the contrary we must operate with the possibility that the documents have something to tell us. Pucci describes a painting by Giotto *'in figura di Dante'*. Can we rule out the possibility that he knew of such a painting, not, perhaps, as an official portrait but as a private allusion? Could it not have been widely assumed that the prophetic figure admonishing the citizens of Florence, which I imagine to have been included in the allegorical cycle, was a reminder of Dante? Indeed can we claim *a priori* that Giotto could never have intended it as such?

In asking this purely hypothetical question I am not committed to reviving the unlikely story of a friendship between Dante and Giotto. For while there is no evidence whatever that Giotto had ever met Dante it would be astonishing if the painter had had no reason to remember the poet with awe and gratitude. Although the mention of Giotto's fame in Dante's *Purgatorio* was not intended as an advertisement, the effect on Giotto's subsequent career could hardly have been more dramatic if that had been the purpose. The proverb says that nothing succeeds like success; and here was a poem which was soon

in everybody's mind which proclaimed that Giotto had *il grido*.[35] I do not want to be misunderstood. I would never claim that Giotto would not have acquired further reputation without this reference. But there is at least one document from his life which strongly indicates that the Dante passage had sunk in and had also impressed the Florentine city fathers. I am referring to the solemn instrument of April 1334 recording the appointment of Giotto as Capomaestro of the Commune of Florence.[36] Its tone is indeed extraordinary:

> Their Lordships the Priors of the Guilds, and the Gonfaloniere of Justice, together with the Committee of Twelve Good Men, desiring that the public works which are being carried out or should be carried out by the city of Florence for the Commune of Florence should proceed with honour and decorum, realize that these could not conveniently be accomplished unless an expert and famous man is placed in charge and authority, as head of these works, and that in the whole wide world nobody is said to be found who is more qualified in these and many other matters than master Giotto di Bondone, painter of Florence, and that he should be received in his native city as a great master and held dear in the aforementioned city and should have the wherewithal to settle in it for a continuous stay, from which stay as many as possible may profit from his skill and knowledge and no small degree of glory redound to the aforementioned city . . .

It is not often that a preamble to a civic appointment speaks in such terms. It looks as if some of the *boni viri* had begun to worry that that famous man who was reported in a well-known poem to have *il grido* was not in the service of the Commune but rather working for the King of Naples or elsewhere. I am sure Paatz was right when he felt that the phrase *accipiendus sit in patria sua velut magis magister* is an implicit, though possibly unconscious, allusion to the Biblical '*Nemo propheta in Patria*'. Let Giotto be an exception, *carus reputandus in civitate*, and let us do what we can, *materiam habeat in ea moram continuam contrahendi*. For it is Florence who would gain if he could be persuaded to settle; if as many citizens as possible profited from his *scientia et doctrina* the more *decus non modicum resultabit in civitate*. Maybe we hear the voice of hardheaded capitalists who realize that Florence owes her wealth and position to the *scientia et doctrina* of her craftsmen. But I believe these unprecedented words also betray something like anxiety. Let this prophet be honoured in his fatherland, let us profit from his stay in our midst—in other words, our reputation could not stand another prophet cast out as we cast out and banished Dante.

No doubt this is conjecture. Eight years were still to pass before Dante's son was given access to his father's confiscated property. But whatever the rights and wrongs of Dante's condemnation may have been in the eyes of the city fathers, some of them must have known that the poet's growing fame redounded not to their *decus* but to their shame. I believe it could be argued that Florence never lived down her treatment of her national poet and that the guilt feeling about Dante only enhanced the emphasis which Florentines increasingly placed on the many illustrious men of letters and artists who were the glory of the city.

I do not know if one can pinpoint the moment when this guilt feeling first expressed itself, but if I am right that it had its share in the destiny of Giotto it would not be absurd to expect that the master himself was aware of the circumstances. I do not pretend that this is more than historical fiction, but though we do not know whether Giotto would have been averse to commemorating Dante in the kind of figure I postulate, we can be quite sure that Pucci would have greeted it without reservation. His veneration for Dante comes out in many poems and to reconcile his bias with his patriotism he brazenly wrote that really Dante was a Guelph and not a Ghibelline.[37]

All this will not suffice to erase the question-mark from the title of my lecture, but maybe it can add a minute query to the question-mark itself. We need not deny all credit to Pucci's sonnet. After all, as a contemporary he must have known more than we know. But I do not want to overextend my credit. I am not prepared to back his concluding line that the figure painted by Giotto '*in figura di Dante*' resembled the poet exactly as he was in life '*Com' a sua vita*'. What I am prepared to do is to explain why, by the time he wrote, this had become important.

Here, at last, we are able to turn from mere conjectures and might-have-beens to more solidly documented facts, and the fact is that the desire to see an authentic likeness of a famous poet expressed itself strongly in the second half of the fourteenth century. The consequences of this demand are movingly and amusingly described by Petrarch in a letter dating from 1362, which I should like to render rather fully.[38] In a sense this text might be regarded as the Foundation Charter of our National Portrait Gallery.

Petrarch tells his correspondent, Francesco Bruni, of Pandolfo Malatesta's touching admiration. 'Since he only knew me by reputation,' the poet writes,

> he sent a painter from quite a distant place at great expense to where I was staying to make my portrait. I did not know he had kept it, but when he came to Milan many years later his first concern was to meet the person he had so far only known from his portrait ... and before

he returned home, being not quite satisfied with my first portrait, and finding also, as is natural, that my appearance had changed, he sent another painter. He would gladly have sent Zeuxis, Protogenes, Parrhasius or Apelles, if any such painters existed in our century, but since one has to be content with what the age produces, he chose the best among the very few there are; an artist of truly great merit, who came to see me, without my knowing the reason, and being my friend, he sat himself behind me as I was reading, and began to portray me without saying a word. I noticed, however, and though unwilling I let him go on and allowed him to portray me as he wished. But however much he applied himself with all his might and main, he did not succeed well, at least so it seemed to me and to others. If you ask me why, I cannot give you any other reason than that the things we desire most are the hardest to achieve... however, the great man still wanted my portrait as it was, and always treasured it because it bore my name.

Here we have the first document of a class of portraits I have not yet mentioned, although it may be the most widespread one—an intended likeness which fails to satisfy the sitter and his friends, but still must function as a portrait *faute de mieux*. Be that as it may, Petrarch's account of 1362 mentions that the first demand for his likeness was made several years earlier, that is in the 1350s, and it seems only reasonable to assume that if there was a wish for his image there must also have been a demand by then for a portrait of Dante. These are indeed the years when we encounter the first such image in a monumental setting which has a very good claim to have been intended as a likeness of the poet—one of the blessed in the Dantesque fresco cycle by Nardo di Cione.[39]

What is more relevant for us is the evidence that the growing demand for a likeness of Dante led to a tendency to recognize his features in many earlier murals which were vaguely thought to date from his time. The process could not have started without some prototype or standard by which other images were judged, but once it was under way there were plenty of dignified hooded figures with aquiline noses to choose from, the one on the wall of the Bargello Chapel being just one of them. Another is mentioned by Ghiberti, who says that Taddeo Gaddi painted in S. Croce a miracle of St Francis resurrecting a child. 'And in this story', says Ghiberti, 'there is also Giotto, Dante and a portrait of the master himself—that is Taddeo Gaddi—taken from the life.'[40] Maybe it was this alleged portrait to which Leonardo Bruni alluded in his life of Dante: 'His likeness,' he writes, 'can be seen in the Church of S. Croce on the left side in the middle, as you approach the main

altar; it is excellently painted from the life by a perfect painter of that time.'[41] Why Bruni did not mention the artist it is hard to say. He may have felt uncertain about his identity or have felt it below his dignity. But it is remarkable that he does not mention any portrait by Giotto.

By this time, there was a Chair in Florence for the reading and exposition of *The Divine Comedy* and the demand for a likeness of the great Florentine must have become official. It must have been needed, for instance, for the lost series of illustrious men painted in the Palazzo Vecchio towards the end of the century for which Colluccio Salutati wrote the inscriptions, including one on Dante.[42]

We also know that in 1396 an official project was launched to erect a kind of poets' corner in the Cathedral of Florence, a joint monument of marble to house the remains of Dante, Petrarch, Zanobi di Strada and Boccaccio,[43] and even if their bones could not be obtained the monument should be erected within six years.

It is well known that the efforts to obtain Dante's remains from Ravenna were never successful. The monument was not built, but a painted memorial was put up between 1413 and 1439 by the Franciscan, Antonio Neri, 'to remind the citizens that they should have Dante's bones brought to Florence and have honour done to him as he deserves.'[44] Apparently the painting was not very durable or satisfactory, and on the occasion of the second centenary of Dante's presumed birth, in 1465, Domenico Michelino[45] was commissioned to paint the panel which is still in the Cathedral, based on a model by Alessio Baldovinetti.

How should we regard it? Into what class of portraiture would we put it? Perhaps it is better not to ask this question but rather to remember a beautiful passage in Pliny's *Natural History* where the ancient encyclopedist speaks of the custom of placing authors' portraits in libraries.[46] He calls it a new invention to dedicate such images to those immortal minds who speak through their books, but he commends it in these memorable words: 'Our desires bring forth even the images which have not come down to us, as is the case with Homer. For I think there can be no greater happiness than the perpetual desire to know what someone was like. *Quo maius ut equidem arbitror nullum est felicitatis specimen, quam semper scire cupere qualis fuerit aliquis.*'

Leonardo on the Science of Painting:
Towards a Commentary
on the 'Trattato della Pittura'

Leonardo da Vinci's *Trattato della Pittura* was first published in 1651 from an incomplete collection of the master's notes and has enjoyed great fame ever since.[1] But its systematic study may be said to have started in earnest only when the facsimile of the best MS, the Codex Urbinas Latinus 1270, was published in 1956 together with an English translation by A. Philip McMahon.[2] In his detailed introduction to that standard edition Ludwig H. Heydenreich set out the reasons which make us think that in the Codex Urbinas we have a careful compilation made from Leonardo's manuscripts by his faithful friend and pupil Francesco Melzi. Only a fraction of these original manuscripts has come down to us, but in a further fundamental study Carlo Pedretti has shown that Melzi's indications allow us also to reconstruct at least one more of Leonardo's own notebooks (the Libro A)[3] which served as a source of this precious collection. With these instruments now in our hands the moment has come to re-assess Leonardo's thoughts as they are recorded and transmitted in this invaluable document. It may seem outrageous to claim that this has never been done, but it must be admitted that the *Trattato* makes no easy reading. However often individual sayings of the master have been quoted to support a particular interpretation of his art and his thought, the purpose of the whole is less easily summed up. One of the difficulties lies in the nature of the compilation with its repetitions and its rather haphazard composition which has prompted all editors to improve on Melzi's arrangement and attempt a more systematic sequence—attempts which occasionally obscure rather than illuminate Leonardo's thoughts.

Moreover, the fragmentary nature of some of these jottings which appear cheek by jowl with exercises in poetic rhetoric and with laborious geometrical demonstrations has encouraged a variety of contrasting interpretations. The nineteenth century saw in Leonardo the artist who was also the precursor of modern science, an original genius who had broken with the deadening

A contribution to *Leonardo e l'età della Ragione*, Milan, 1982

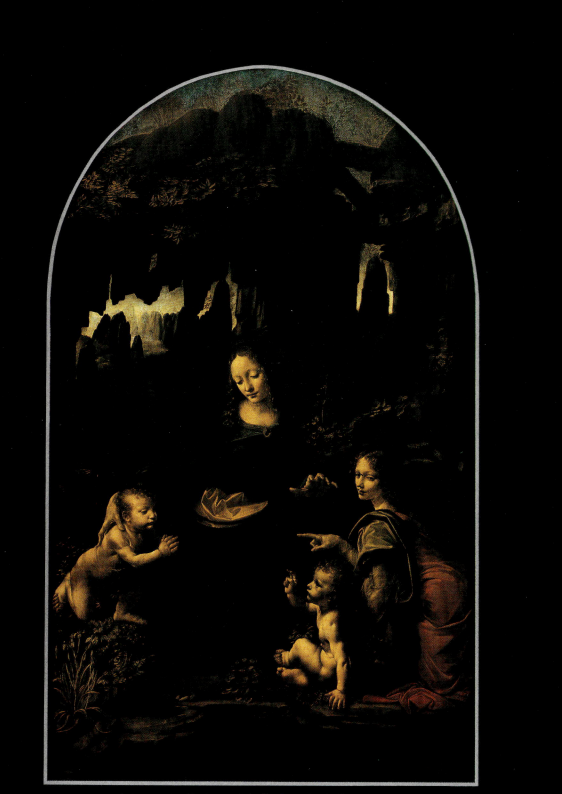

I. Leonardo: *Madonna of the Rocks*, 1483–6. Paris, Louvre

II. Gentile da Fabriano: Detail from the Berlin Altarpiece (Fig. 22)

III. Gentile da Fabriano: Detail from the *Adoration of the Magi* (Fig. 20)

authoritarianism of the medieval scholastics and ushered in a new era of unpre-judiced observation and experiment. We have realized for some time that this stereotype owes more to the ideology of Francis Bacon than to a close study of Leonardo's writings. Nobody who immerses himself in his notes on mechanics, on hydraulics or on anatomy will equate Leonardo's drawings and diagrams with the result of unprejudiced, that is to say untutored, observation. We know that this *'omo sanza lettere'*, the unlettered man, as he called himself, had a large library and had studied his predecessors to good purpose, not, of course, to repeat their findings, but to examine the validity of their results, which he often corrected without always being able to discard their influence altogether.[4] It is only in the study of the *Trattato* that the image of the artist who placed what he called the 'science of painting' on a new footing by using his eyes proved too appealing to be easily replaced by a more complex assessment. The earlier interpretation lingers on even in the introduction to the standard edition of the *Trattato* by Ludwig Heydenreich. Not only does the author exalt Leonardo's 'astounding powers of observation'—a verdict nobody would gainsay—he also claims to find in Leonardo's text an 'equation of seeing with comprehending' (p. xxxiii) and this is a reading to which I have never been able to reconcile myself.

In fact, I remember a conversation I had with the late Professor Heydenreich more than thirty years ago in a London restaurant when he stressed the role which the eye played in Leonardo's scientific and artistic achievement, and I was prompted to ask him whether he really found that the view through the window resembled in any way any of Leonardo's creations? I would not have asked the same kind of question if we had been talking about Camille Pissarro. Such a question and such a comparison only appears to be unorthodox and almost illicit because most art historians are brought up in a relativist creed. Even if they concede under pressure that the world outside the window looks to them more like a painting by Pissarro than like one by Leonardo, they may still consider it possible that each of these painters 'saw' the world exactly as he painted it. It is this refusal to accept objective standards in the study of representation which has, in my view, prevented art history from asking a number of crucial questions. At any rate, I could not have written my book on *Art and Illusion* if I had not adopted an objectivist point of view. In proposing that 'making comes before matching' and that this process pro-ceeds through 'schema and correction' I implied, of course, that we are entitled to speak of the imitation of nature as of an achievement which can be judged by objective criteria and of which we can give a historical account.[5] It is surely not by accident that I have found Leonardo's art and his views of central importance for the support they lend to this interpretation.

I have argued in particular that Leonardo's undoubted wish to reproduce natural appearances with scientific accuracy makes the dependence of his style on the tradition he had absorbed in the workshop of his teacher Verrocchio all the more striking. In another essay in this volume (see pp. 108–9) I have returned to the sway which his master's facial types exercised on his art and on the effort he made to break their spell in his so-called caricatures. I have also alluded in an earlier essay to the tenacity with which Leonardo stuck to the traditional formulas for mountains and rocks.[6]

Just as I would not claim that there are no people who resemble some of Leonardo's grotesque heads, I would not wish to doubt that there are mountains which exhibit the features Leonardo liked to draw and paint. But this fact does not contradict the observation that his vocabulary was strangely restricted. Indeed, I believe it is only against this background that we can understand the heroic effort he made in the *Trattato* to place the analysis of natural appearances on a new scientific footing. Far from advocating mere looking as a means to that end he never tired of stressing the importance of reasoning in this process.

We can infer from a passage in the *Trattato* that this programme met with considerable resistance on the part of the master's colleagues, the painters of his time. In the fifth section of the Codex Urbinas (221v–222r; McM 686) he presents a series of elaborate comments on the illumination of a sphere under an open sky illustrated by a number of complex geometrical diagrams (see Fig. 12). He may have felt that the complications got somewhat out of hand and were in need of justification, and so he inserted the remark: 'Here the opponent says that he does not want so much science, because for him the practice of drawing objects from nature is sufficient; the reply to this is, that there is nothing that deceives us more than confiding in our own judgement without any further reasoning'; as evidence, Leonardo here cites the illusionistic tricks by which alchemists and necromancers are able to deceive 'simple minds', a passage to which I also return in the next essay in this volume.

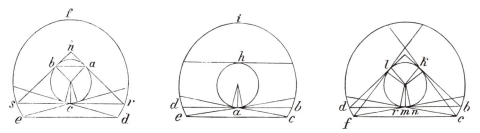

12. Diagrams of the fall of light
(woodcuts from Ludwig's edition of the Codex Urbinas of 1882)

There are other remarks by Leonardo in which he stresses the need for the artist to measure and to reason rather than to rely on observation alone.[7] To analyse his procedure in every case would require a full commentary of the *Trattato*. What is attempted here is only to exemplify the method Leonardo adopted in order to overcome the limitations of the eye and to achieve what he calls 'the certainty of mathematical demonstrations' (Cod. Urb. 240v; McM 872)—in other words the standards of Euclidean geometry.

It so happens that the paragraph of the *Trattato* in which this tell-tale phrase occurs provides the perfect introduction to the problems I want to single out for discussion. It is concerned with the modification of colour through light and shade and recommends a method by which the landscape painter can defeat this modification by resorting to matching.

> When you desire to imitate a colour, you must remember that when you stand in a shady place you should not seek to imitate a motif in sunlight because you would deceive yourself with such an imitation. What you have to do in such a case, if you want to adopt the certainty that belongs to mathematical demonstrations, is to take all the colours which you have to imitate, comparing the means of imitation with the object to be imitated in the same light so that your own colour should correspond to the colour in nature in your line of sight.

Leonardo here draws a schematic diagram which is reproduced in the Codex Urbinas (Fig. 13) and then he proceeds to explain his demand:

> Let us say that you want to imitate the mountain in the region which is exposed to the sun. Place your paints in the sunshine and there make your mixture of the colours you intend to use and compare them in the same sunlight, matching them with the colour to be imitated. Suppose the sun stands in the south and I draw a mountain in the west which is half in shadow and half in light, but suppose I here wish to imitate the illuminated side, I take a little piece of paper, covered with the paint of that colour which seems to me to resemble that of the motif, and I compare the two in a way that there is no gap between the true and the false and so I expose it to the rays of the sun, adding a variety of paints till the tone of each of them is alike and thus I will go on with every quality of shaded or illuminated colour. (Cod. Urb. 240v–241r; McM 872)

For all its rather complicated wording Leonardo's advice on how to achieve a perfect match of reality 'with the certainty that belongs to mathematical demonstrations' is basically simple, but strangely enough it is also wholly unrealistic. It is, of course, quite true that the paint which the artist has

*et che il tuo cs ove sia conterminale alla linea miraia
del color naturale.*

*Diciamo che tu nogsi imitare la montagna nella
parte che veduta dal sole, metti li tuoi colori al sole*

13. Codex Urbinas 240v

on his palette will change in appearance with the light that falls on it, but
this will also hold true when he has applied his colours to his panel or canvas.
Strictly speaking, every painting will radically change in appearance in different
light. If this fact prevented the matching of reality, the art of painting would
be impossible. It is possible only because what we perceive both in the painting
and in nature are colour relationships rather than absolutes. As Ruskin put
it in a passage I quoted in *Art and Illusion*: 'While form is absolute, so that
you can say at the moment that you draw any line that it is either right or
wrong, colour is wholly *relative*.'[8]

To return to Leonardo's example of a painter wanting to match the colours
of a mountain which is half in sunlight and half in shade—let us assume
for argument's sake that it is wholly under snow. What Leonardo demands
is that we should take our white paint into sunlight to match the sunlit slopes
of the snowy mountain. To be consistent, however, we would then have to
take the paint into the shadow to paint the shadowy side. It is clear that
this procedure would fail. Even on Leonardo's own precepts the painting
would then always have to be exhibited half in sunlight and half in shade,
but the mountain would still not look as it did in reality.

It is all the more puzzling to see that Leonardo fell into this error because
he more than anyone else had studied the modifications of colour in nature
through air and through light, and his capacity to render these modifications
even in the medium of drawing was unsurpassed. Even so, we find that in
his *Trattato* his very interest in the effects of what he was the first to call
'aerial perspective' sometimes tempted him to generalize too much on indi-
vidual observations.

There are a number of other diagrams and discussions in the *Trattato* con-
cerned with the painting of distant mountains which seem to me to be cases
in point. There are no fewer than thirteen sections in the manuscript which
turn on the question 'why the distant mountains appear darker on their peaks

than on their base'.[9] In one of the diagrams (Fig. 14) Leonardo attributes this phenomenon convincingly to what he calls the diminishing thickness of the air, that is, to the haze in the plain:

> The peaks of the mountains appear always to be darker than their bases and this occurs because the peaks of the mountains penetrate into an air which is thinner, according to the second proposition of the first book in which it is stated: that region of the air will be the more transparent and subtle the further it is away from the water and from the earth. It follows therefore that these peaks of the mountains which reach into that subtle air show themselves more in their natural darkness than those which lie further down which air, as has been proved, is much denser. (Cod. Urb. 232r; McM 825)

Here, as in so many other passages of the *Trattato*, Leonardo refers to a series of propositions or axioms (which are not included in the manuscript we have) and it is from these axioms that he derived the explanation of the phenomena he discusses. In other words, he proceeds *more geometrico*, modelling his demonstration on Euclid to give it that certainty of mathematical demonstrations at which he is aiming throughout.

The next paragraph of the manuscript with its three diagrams (Fig. 15) fully illustrates the abstract *a priori* character of some of these expositions. Continuing his discussion of the darkening of mountains with increasing height he first presents a diagram of three mountains of varying height at equal distance from each other, which would differ in brightness. If, as the second diagram shows, they were all of the same height, the proportions of distances and colours would be the same but, as Leonardo adds, 'such an arrangement

14. Codex Urbinas 232r

la me desima proportione nel
loro vischiaza re com'essi faveb
bono essendo d'una medesima
altezza perch' se fussi di mede
sima altezza essi sarebbono in
aria d'egual grossezza co'lo
loro srennitq' c'allora la pro·
portione delle distantie e de
colori sarebbe una medesima
ma tale dispo sitione non si puo
dimostvare al occhio perche sel

15. Codex Urbinas 232v

cannot be shown to the eye because if the eye is as high as the peak of the
mountains the first would obscure the other two', and thus, as he adds, 'this
demonstration is vain'—a conclusion which does not prevent him from spelling
it out by means of a lettered diagram to convince the reader 'that neither
the distance nor the colour is seen'.

It may well be that the compiler included in the manuscript a number
of paragraphs in which Leonardo repeated himself, but Leonardo's insistence
on this point is still remarkable: 'Why distant mountains appear to be darker
at their peak than lower down' (Cod. Urb. 234; McM 827), and again 'Why
the mountains appear to have darker peaks than bases when seen from a
long distance' (Fig. 16). A further diagram is headed 'Of the mountains and
how they should be varied in painting' (Fig. 17): 'I say that the air lying
between the eye and the mountain looks brighter in p than in a, and this
can arise from various causes, the first being that the air between the eye
and p is greater in quantity than that between the eye and a and therefore
brighter, the second that the air is denser in the valley in p than in a, a
mountain top' (Cod. Urb. 235v; McM 830).

It appears that Leonardo here again is thinking of haze, which alone could
account for his observation that there is more of it in p than in a, thus counter-
acting his idea that a greater quantity of air results in increasing darkness.

In the next note Leonardo even attempts to quantify his observation of
aerial perspective (Fig. 18):

Of mountains: much more is seen of the peaks of mountains at various
distances than anything on them and this occurs because at every degree

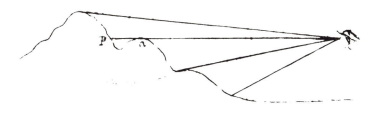

la sua bassezza e della sua distantia e causa chile
cime de monti che più s'inalzano più mostrano la
sua natu- rale oscu-
rità per che m'aco
sono impe- dite dalla
grossezza de l'aria
nella cima che nella
loro basa o'nella uicinita' che nella remottione, Pro-
uasi, o, p, d, s, c, v, a, R, sono gradi dell'aria che sem-

16. Codex Urbinas 234r

terposta infra l'occhio e l p; e maggior soma che

quella che s'interpone infra l'occhio e l, a, e per con

17. Codex Urbinas 235v

of their distance from the eye towards the east they acquire an increasing
loss of distinctness and brightness of the air or of whiteness. It is twice
as bright from f to b as it is from f to a. (Cod. Urb. 237v; McM 829)

Again Leonardo must be commenting on the whiteness of the haze, which
he thinks will double with the distance from the eye which looks towards
the east (presumably in the morning).

However, we must beware of seeking the explanation of Leonardo's exposi-
tions solely in terms of our own view of the phenomena of nature. It was
not only what he observed that mattered in these notes, but also what he
had derived from the science of optics he had studied in ancient and medieval
treatises. This link with the Epicurean doctrine of vision becomes particularly
clear in another note, where Leonardo refers to the visual images which fill

*accade perche in ogni grado di distantia dall'ochio
in ucvso l'ovriente s'acquista gradi di perditione e chia-*

18. Codex Urbinas 237v

the air—the doctrine according to which the sense of sight should be under-
stood in analogy to the sense of smell. Just as particles of objects fill the
air and are sampled by the nose in smelling, so in seeing, infinitely thin parts
of visible objects fill the air and penetrate the eye.[10]

It is to this doctrine that Leonardo refers in the following note (Fig. 19),
which introduces a further complication by distinguishing the view of moun-
tain tops when seen from above or below:

> The peaks of mountains seen one behind the other from above downwards
> do not grow brighter in proportion to the distance of those mountain
> peaks from one another, but they do so much less, according to the
> seventh proposition of the fourth book, which says that the further reaches
> of the lands seen from above as far as the horizon grow darker, and
> those which are seen from below (which are seen at the same distance
> as the first) always grow brighter. (Cod. Urb. 231v–232r; McM 824)

The observation is somewhat surprising in view of Leonardo's insistence else-
where that mountain peaks look dark, but in what follows he is ready with
an explanation based, as indicated, on traditional optics:

> This occurs according to the third proposition of the ninth book, which
> says that: the denseness of the air seen from below is much brighter
> and more resplendent than that seen from above which is to be explained
> by the fact that the air seen from above is somewhat penetrated by the
> dark visual images from the earth below and that is why it appears to
> the eye darker than the one seen from below upwards which is penetrated
> by the rays of the sun, which reach the eye with much brightness. Hence
> the same occurs with mountains and the land in front of them, the visual
> images of which pass through the air in question and show themselves

aeuu aifrauuc c uemo injia coro cjje come de moua
ma molto meno per la settima del 4° che dice le
distantie dr paesi uedun
dalto inbasso in sino allori
zonte ueño oscurando er
quelle che son' uedute di basso
in alto nella medosima dis=
tannia del 6°. ...

19. Codex Urbinas 231v

either dark or bright according to the darkness or brightness of the air. (Cod. Urb. 232r; McM 825)

One cannot help asking whether the phenomena which Leonardo here attempts to explain so elaborately really occur with such regularity. Whatever Leonardo may have seen when he once climbed Monte Rosa, most of us have had many opportunities of looking down on landscapes from above when we looked out of the window of a plane, and even photographed the beautiful spectacle. Neither our memory nor our photograph confirms that the landscape grows darker towards the horizon. It looks as if Leonardo's *a priori* reasoning was not based on observation, but this time on the powerful tradition of his craft, to which he, like any other painter, was so much indebted.

We find, in fact, that Cennino Cennini in his famous handbook for painters, *Il libro dell'arte*, propounds the following rule: 'When you have to make mountains which appear to be further in the distance make your colours darker, and when you intend to show them nearer make the colours lighter.'[11] The practice of certain early quattrocento painters who must have trained at the time of Cennino Cennini illustrates his surprising precept, which derived no doubt from the tradition I discussed elsewhere[12] according to which dark colours recede and white comes forward as in the painting of folds. A master such as Gentile da Fabriano did not apply Cennini's rule mechanically, but one of the scenes in the background of his Uffizi *Adoration* (Fig. 20, Col. Plate III) shows the mountain in the foreground brightly illuminated, while the distant ranges recede into the dark.

I know of no detailed study investigating the replacement of this convention by a more realistic rendering of landscape distances in Italian painting, methods which prepared the ground for Leonardo's studies of aerial perspective. He himself certainly did not apply the rules of his *Trattato* in his landscape backgrounds, such as those of the *Mona Lisa* and the *St Anne* (Fig. 21, Col.

Plate V), where he conjures up the play of light and the effects of mists on his rocky peaks. Even so, the *Trattato* suggests that he continued to feel obliged to justify and explain his rule that mountain tops should appear dark. Discarding optics he presents an alternative explanation in another diagram (Fig. 23), which is not concerned with rocky peaks, but with wooded hills: 'The peaks of mountains and hills appear to be darker, because a great number of trees grow one next to the other and the ground between them cannot be seen, which ground is brighter, as can be observed on beaches and for the same reason the area in the middle of their slopes looks darker' (Cod. Urb. 237v; McM 835).

The passage forms the transition to that wonderful description of the change in the vegetation of mountains as one climbs towards their top.

20. Gentile da Fabriano: *The Adoration of the Magi*. Detail. 1423. Florence, Uffizi

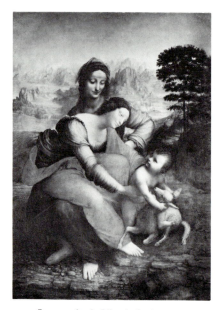

21. Leonardo da Vinci: *St Anne*, 1510. Paris, Louvre

22. Gentile da Fabriano: *Madonna and Child*, *c.*1400. Berlin-Dahlem, Staatliche Museen

*Le sõmita delle montagne e'de colli parãno piu scure
perche maggiore somma d'alberi si scontrano l'u-
no ne l'altro e'nõ si uede il piano loro mtrvuallo*

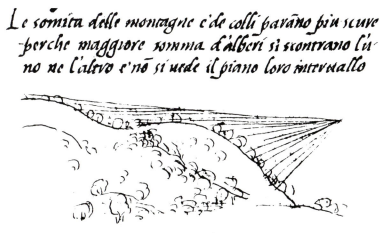

23. Codex Urbinas 237v

The grass and trees will be paler in colour to the extent that the soil
that nourishes them is more meagre and lacking in moistness ... the
trees will be smaller and thinner the nearer they are to the summit ...
therefore, painter, you will show the summits of mountains composed
of rocks in large parts not covered by soil and the grass that grows there
sparse and stunted and largely pale and dry ... and show small bushes,
dwarfed and aged, and diminutive in size, with short thick branches
and few leaves revealing in large part their decayed dry roots interwoven
with the cracks and fissures of the withered rocks ... and as you descend
further towards the bases of the mountains the trees are more vigorous
and thick with branches and leaves and their verdure is as manifold as
are the species of plant that grow in the forest ... (Cod. Urb. 236v,
237r; McM 839)

Here, of course, we encounter Leonardo the naturalist, the observer of
nature in all its variety. We cannot doubt that he took note of the changing
vegetation during his exploratory climbs. But it is precisely on reading these
detailed descriptions that one is confronted with the strange contrast between
Leonardo's observations on the one hand and his methods of representation
and of demonstration on the other. We could not imagine a landscape painting
by Leonardo showing the crippled vegetation of high altitudes in such detail
as he describes.

Here again the contrast between his practice as a painter and his observations
in the *Trattato* can only be described as astonishing. The sixth section of
the Codex entitled *Di li Alberi et verdure* offers on some fifty pages the most
detailed analysis of the appearance of trees and leaves ever to be written,

at least before the relevant chapters in Ruskin's *Modern Painters*.[13] The notes
incorporated in the manuscript generally date from Leonardo's second stay
in Milan after 1505 and are unrivalled in their subtlety and sophistication.
All that can be attempted here is to analyse the principles by which he pro-
ceeded in order to lay the foundation of a science of painting. There is no
doubt that in making this attempt Leonardo was out first of all to modify
and replace the workshop practice that had dominated the tradition particularly
in the South. Indeed, it may be useful at this point to start with the precepts
found in Cennini, to have a background, as it were, against which Leonardo's
discussions can be seen:

> If you want to adorn the aforementioned mountains with woods of trees
> and plants, first put the body of your tree in pure black ... then make
> a layer of leaves of dark green, that is of blue green, ... and see to
> it that it is thickly painted. Then mix your green with yellow so that
> it is brighter and make fewer leaves and begin to reduce them towards
> the crown of the trees. Then touch up the brightnesses of crowns with
> more yellow and you will see that the trees and plants appear in relief.
> But first when you lay in the trees make the roots and a few branches
> of the trees and place there the leaves and then the fruit and then put
> on the greenery a few blossoms and little birds (LXXXVI).

The procedure which Cennini outlines is again founded on the conviction
that bright colours stand out in relief when seen against darker tones, so
that he makes the treetops and a few isolated leaves catch the light, while
the mass of the foliage is painted dark. Once more, Gentile da Fabriano offers
a splendid example, with the trees flanking his Madonna (Fig. 22), though
here angels take the place of Cennini's birds and fruits (Col. Plate II).

In *Art and Illusion* (Chapter 5, III) I used Leonardo's analysis of the structure
of trees as an example of the method by which he replaced traditional proce-
dures through an *a priori* consideration of the growth of trees and its effect
on their final shape (Fig. 24b). He conceived the division of the branches more
or less in analogy to the delta of a river. The more tributaries develop, the
less water there is in each of them. This makes him conclude that after adding
up the thickness of the branches or twigs after each division the sum must
be the same as the width of the trunk or branch below. 'Every division of
the branches, when joined together, adds up to the thickness of the branch
at their meeting point' (Cod. Urb. 234v; McM 874)—a principle lucidly
explained in a diagram from Leonardo's notes which was also copied into
the *Trattato*.

As a result of this principle, as we read on fol. 246r (McM 900), the annual

24a. Codex Urbinas 246r

24b. MS M 78v; before
1500. Paris, Bibliothèque de
l'Institut de France

growth of a tree is reflected in these ramifications, which in their turn always add up to the width of the trunk (Fig. 24a). It is a hypothesis of great simplicity and elegance, although it is again an *a priori* construction arrived at by abstract reasoning rather than by measurement. I have on my file a letter from the East Malling Research Station of the Horticultural Society, which was consulted on my behalf. The writer was impressed by Leonardo's exercise in 'biometrics', as he called it, but he could not confirm his ideas. Of eight apple trees he measured not one conformed to Leonardo's prediction, in fact the sum total of the diameters of the branches vastly exceeded the diameter of the trunk, though lower down, nearer the first division, the discrepancy was less glaring. This is the kind of observation I should like to envisage for a commentary on the *Trattato*, which would have to be written by a whole committee of experts. Not that these scientific findings wholly invalidate Leonardo's construct. For though the schema suffers many variations and modifi-

cations in nature, some of which Leonardo himself acknowledged, it draws attention to the principle of growth which underlies the shape of any tree and thus commits the painter to create a tree in his mind and with his hands much more convincingly than Cennini's advice would allow him.

However schematic Cennini may have been, his method attempted to solve one of the most recalcitrant and complex problems in painting—the rendering of trees in foliage. There are few tasks of the painter which force him so relentlessly to confront and overcome the basic distinction between reality and appearance, between things as they are in themselves and things as they look in certain conditions, as the rendering of trees in a landscape. It is notoriously impossible to paint every leaf on a tree, not only because our patience and our media would not allow this, but also because most leaves are not visible to the naked eye. Hence, what a tree invites the artist to represent is the general appearance: he must resort to what we call a summary treatment without failing to convey that this general appearance, this sum, is the result of almost infinite elusive details. Given the typical character of this task and the frequency with which painters of all periods had to wrestle with it, it is again surprising that there is no systematic treatment of this problem in the art-historical literature. Looking back at the reductive methods of the Byzantine tradition showing every leaf of a tree (Fig. 25) and at Giotto's global formulas for trees (Fig. 26) we would not only be led to admire the methods of the Van Eycks in rendering the light and lustre of foliage (Fig. 27) but would also gain a measure of Leonardo's achievement in the extraordinary pages of the *Trattato*, which aim at a scientific tabulation of all possibilities.

Even in this context the idea of precise matching is introduced by Leonardo, though the compilers have placed this extraordinary passage at the end of the section rather than at the beginning, where it possibly belongs:

> Those who do not want entirely to trust their judgement in imitating the true colours of leaves must pick a leaf from the tree they want to imitate and mix their colours on top of it and when this mixture is not seen to be different from the colour of the leaf you will be certain that it wholly imitates it, and you can do the same with other things you want to imitate. (Cod. Urb. 268r; McM 981)

It is strange that Leonardo should have given this advice; he must have known that exact matching is, at best, a limiting case. He, if anyone, was interested in the infinite modifications which the apparent colour of the leaf would undergo in natural conditions, and most of the section deals precisely with this problem. Systematic as ever, he lists four factors which affect the appearance of the foliage of trees, he calls them lustre, light, transparency

25. *John the Baptist*, *c.*1330. Mosaic. Florence, Baptistery

26. Giotto: *Joachim and the Shepherds*, *c.*1304–6. Padua, Scrovegni Chapel

27. Hubert (?) and Jan van Eyck: *Altarpiece of the
Mystic Lamb*. Detail. 1426–32. Ghent, St Bavo

and shadow. The crucial discussion of these factors in the paragraph in question
offers some difficulty to the interpreter and has in fact misled translators,
but taken in context the meaning becomes clear:

> If the eye looks down on this foliage more of the illuminated part will
> be seen than of the areas in shadow and that occurs because the illuminated
> part is greater than the shadowed area and in that part is contained light,
> lustre and transparency. I shall at first leave transparency on one side
> and shall describe the rendering of the illuminated part which is expressed
> in the fourth degree of the tonal scale which can be observed on the
> surface of bodies, that is, the middle quality. By this I mean that it
> is not the principal light but the middle one, after which follows the
> other fourth of the middle, that is to say not the principal shadow but
> the middle one, so that the middle illuminated part stands between the
> lustre and the middle shadowy one. (Cod. Urb. 251v–252r; McM 910)

What Leonardo here wants to say in unusually difficult terms is that every
colour can, for the purpose of the painter, be presented on a four-point scale

V. Leonardo: *Study of a copse*, c.1498. Windsor Royal Library (see also Fig. 37)

VI. *The Interior of a Wood*. Photograph by A.F. Kersting

28. Schematic diagram showing gradations of shade

(Fig. 28). The extremes are the darkness of the shadow and the brightness of lustre. In between these two there is the middle quality, a term also used by Cennini. Leonardo, however, is anxious to divide this middle quality in two, one darker adjoining the shadow, the other brighter adjoining the lustre, and it is this brighter one he wants applied to illuminated leaves which lack sheen or lustre. In other words, he insists here that the traditional three grades from darkness to light are insufficient for the task in hand. But after this minor modification of workshop practice he turns once more to the quality of transparency in a passage to which sufficient attention seems never to have been paid. Transparency, he remarks rather obviously, never occurs in opaque bodies. 'But since', he adds, 'at present I am speaking of the leaves of trees I must describe this other accidental quality which is important in the rendering

c'interposta infra il lustro et la qualita mezana ombrosa . 252.
la qual qualita' mezana ombrosa c'interposta infra la
mezana aluminata et l'ombre principali la ãza parte
che' la trasparentia questa sola accade nelle cose traspa-
renti e'non nelli corpi opachi ma parlando ai presente alle
foglie delli alberi e'nesassario descriuere questo secondo
accidente il quale e'd'inportantia alla figuratione delle piãte
benche dinanti a'me nene stata usata che ce me sia notitia
questa e'situata come fia detto di sotto.

　　　　　Delle trasparentie delle foglie
Quando illume e'allouiente et l'occhio uede la pianta disotto
in uerse tramontana esso uedra la parte orientale dell'al
bere in gran parte trasparente eccetto quelle che sono occu-
pate dall'ombra delle altre foglie e la parte occidentale
dell'albero sara oscura perche riceue sopra di se l'ombra
della meta della ramificatione cioe quella parte che uolta
all'oriente

29. Codex Urbinas 252r

30. Piero della Francesca: *The Baptism of Christ*. Detail. *c*.1450–5. London, National Gallery

of plants although before me it has not been used.' There is no other passage in the *Trattato* in which Leonardo refers to his own artistic practice and claims an innovation of signal importance to the rendering of appearances. However much has been written about the meeting of art and science in the person of Leonardo, this contribution he claims to have made to the science of painting has not been discussed. Since this oversight must be due to a misreading of the text,[14] the original page from the Codex Urbinas is here reproduced (Fig. 29).

Lacking the kind of history of artistic method in the rendering of trees which I have described as desirable, it is hard to tell whether Leonardo's claim to priority can be substantiated. Maybe he himself would have conceded that Piero della Francesca in his *Baptism of Christ* (Fig. 30) in the National Gallery, London, had come near to rendering transparency, but this remains a mere hint compared to his own efforts. I believe that the leaves seen against the sky above the grotto in the Louvre *Madonna of the Rocks* (Fig. 31, Col. Plate I) perfectly confirm the master's claim to have here rendered an optical effect that had so far eluded painters both north and south of the Alps.

Turning to the many relevant chapters of the *Trattato*, we find how Leonardo systematically observes these four qualities of shadow, light, lustre and transparency in various clearly stated conditions, though there is one puzzling note in which he warns the painter against portraying foliage transparent to the sun because this quality leads to confusion (Cod. Urb. 26or; McM 977).

Maybe he was anxious at first to demonstrate a system of three variables and their interaction which a painter must learn to recognize. These variables are: 1, the position of the source of light, mainly that of the sun; 2, the position of the beholder, that is his eye; and 3, the distance of the motif from the point of observation.

31. Leonardo: *The Madonna of the Rocks*. Detail of Col. Plate I

To start with a simple example illustrated on fol. 262v (McM 968) (Fig. 32). If there is a row of three trees with the sun on the left and the eye opposite the central one, it stands to reason that we will see the middle one half lit and half in shade, the one on our right will turn its illuminated side towards us, the one on our left will seem to be plunged in shadow. In the MS E, from which most of these notes and diagrams are taken, Leonardo rapidly sketched the trees themselves, but he was obviously dissatisfied and effaced one of them (Fig. 33a).

Another diagram of circles (Fig. 34) illustrates a different but equally simple point (Cod. Urb. 266r; McM 964): the effect of the viewing-point on the appearance of intervals between trees standing in a row. The interval will be clearly seen between *a* and *b*, but will increasingly be seen to diminish and close up altogether, not in itself a surprising observation but one typical of Leonardo's thoroughness.

In what follows I shall largely limit myself to some of the examples which are illustrated in the *Trattato* to show a few more of the complex permutations and variations Leonardo thought out. The diagram on fol. 255v (McM 914) (Fig. 35) shows the tree under the vault of heaven, which is the source of diffused light or what Leonardo calls *lume universale*. In such a case, we learn, the part of the tree that is turned skywards will be brighter than the one that is turned earthwards, all of which is demonstrated with lettering. The letter *o* (next to the trunk) marks the part which looks towards the earth (*p-c*) but receives a little light from the part of the sky marked *c-d*, while the highest part of the crown (*a*) receives light from the highest point of heaven, that is *b-c*, but if the tree has dense foliage the darkness will reverberate, and such trees, especially laurels, firs and box trees, will look darker near the centre.

uengono l'ombre, et mostrano il lume c'l'ombre ingnelli

occhio

che l'occhio uede doue uede ellume c'l'ombre prouasi

32. Codex Urbinas 262v

33a. Detail of MS E 18v, *c.*1513–14. Paris, Bibliothèque de l'Institut de France
33b. Detail of MS E 19r

uc'sel la metta trasforato cioe', c, c, occupato dall'albero
d;

occupata dall'albero, e, e pocco piu oltre tutta la trasfora

34. Codex Urbinas 266r

Quella parte della Pianta si dimostrava vestita d'ombre
di minore oscurita' laquale
fia piu remo- ta dalla terra
Prouasi, a, b, sia la Pianta, n,
, b, c, sia l'emis- perio aluminato
la parte disotto dell'albero uede
la terra, p, c, cioe, d la parte, o, et
uede un poco del emisperio in
, c, d, ma la parte piu alta nella concauita, a, e ueduta

35. Codex Urbinas 255v

parte oscura dell'albero secondo, e cosi faranno tutti suc-
cessiuamente che saranno situati cole predette conditioni

S, sia il lume, r, sia l'occhio, c, d, n, sia l'albero, 2°, a, b, c,
sia il secondo, dico che, r, occhio uedera la parte, c, f,

36. Codex Urbinas 264r

Another diagram (McM 932) (Fig. 36) concerns trees when seen from below, as indeed we frequently see trees. In the first, on the left, S is the source of light (probably the sun) and R near the ground opposite marks the position of the eye. The tree on the left bounded by the letters N, D and C, will be seen against the light and will appear largely transparent except at the one lower corner, where it is seen against the shadowed part of the second tree; but as soon as you move to the point F marked on the next diagram your eye will see the part of the tree on the left (O-P) dark against the bright background of the illuminated tree marked n-g.

We are lucky to have this kind of demonstration also from Leonardo's own hand in one of the most famous sheets of the Windsor collection which shows his study of trees in red chalk (Fig. 37, Col. Plate IV). A drawing on the reverse (Fig. 38) is accompanied by a text which eluded the compiler of the treatise though there are germane considerations in the Codex Urbinas.

That part of the tree that is seen against shade is all of one colour and
where the trees, or rather the branches, are denser it looks darker because
the air is absent. But where the branches are seen above other branches
the luminous parts show themselves brighter and the leaves more shiny
because of the sun which illuminates them. (Richter I, p. 456)

One can only marvel at the subtlety with which Leonardo brought out
this differentiation and even more in the drawing of the copse (Fig. 37), which
he left without the text he almost certainly intended to add. If he had done
so, fewer art historians rightly admiring this miracle of sensitivity might have
been tempted to compare the drawing with Impressionist sketches. Whether
or not the master made the drawing in front of the motif, he did not aim
at an innocent eye but at a systematic analysis of appearances.

If he really aimed at illustrating all the paragraphs of the *Trattato* with
drawings of such perfection his work would have been an even more astounding
feat than it is. The few purely didactic sketches which are preserved in his
notes and were copied into the Codex give us an idea of what we have lost

37. Leonardo: *Study of a copse. c.*1498. Windsor, Royal Library 12431r

because a limit was set even to Leonardo's capacity of carrying out his innumerable projects.

Consider the note on fol. 253v (McM 911) (Fig. 39) which deals again with the effect of the background, this time the effect on the appearance of individual leaves which, of course, cast shadows on each other:

> The first shadows cast by the first leaves on the second of the leafy branches are less dark than the ones cast by those shadowed leaves on the third leaves and the same goes for those cast by the third shadowed leaves on the fourth, and so it appears that the illuminated leaves which are seen against the third and the fourth shadowed leaves stand out more clearly than do those which are seen against the first shadowed leaves.

Maybe Leonardo's emphasis on the leaves which are seen to 'stand out' still recalls the traditional methods exemplified by Cennini.

A few pages later in the Codex the concern for the rendering of every individual leaf comes to its climax with Leonardo showing two lettered diagrams (Figs. 40 and 41a), the first explaining once more the three qualities,

38. Leonardo: *Study of a tree*. *c*.1498. Windsor, Royal Library 12431v

shadow, lustre and transparency; if the light comes from N and falls on the leaf S while the eye is in M the eye will see B in the shadow and C transparent. However, if the leaf is concave and seen from below it will sometimes appear half in shadow and half transparent. 'Let po be the leaf, N the source of light and M the eye, this eye will see the part marked o (obscured in the Codex by hatching) shaded because the light does not strike it at equal angles on the right side nor on the reverse, and let p be the right side illuminated by the light which shines through to the reverse side' (McM 939).

Though this laborious demonstration of a fairly simple situation may strain the patience of the reader, he is likely to be reconciled by the next paragraph, which shows the master at his best. The cluster of leaves rapidly sketched in three degrees of illumination (Fig. 42b) is intended to illustrate the observation that 'when the leaves are seen in between the source of light and the eye, the one closest to the eye will be darker and the one furthest away will be brightest provided that it does not have the air as its background. This happens in the case of leaves which are beyond the centre of the tree, that is to say, situated towards the light' (McM 927).

While these and many other passages in the *Trattato* concentrate on the first two variables I mentioned, the position of the sun, and that of the observer, in other words study the appearance of foliage at close quarters, Leonardo also concerns himself, of course, with the third variable, the effect of distance.

39. Codex Urbinas 253v

40. Codex Urbinas 260r

c'meza trasparente com'e' p,o, sia la foglia et il lume,
et l'occhio, n, il quale uedra, o, a
brato perche il lume non la perc
infra mgoli c: quali ne da driti
ne dn riverso, ci,p, fia aluminan da dritto il gua
lume traspare nel suo riuerscio,

Delle foglie oscure dinanzi alle trasparenn
Quando le foglie saranno incerposte infra'l lume e'l'occ
allora la piu micina all'o
chio sara piu scura et la p
vemem sara' piu chiara n
campeggiando ne l'aria et g
to accade nelle foglie che son
dal centro del albero in la c
in uerso il lume,

Della Piante Giouannii, et loro foglie

41a, 42a *left*. Codex Urbinas 260v
41b, 42b *right*. MS G 10v, *c*.1510–16. Paris, Bibliothèque de l'Institut de France

The beautiful diagram on fol. 258v (McM 956) (Fig. 43a) simply and clearly illustrates what he elsewhere calls the perspective of losses, *prospettiva de perdimenti*; this implies that the further a tree is from the observer the less is seen of the individual branches and the more the general outline of the crown approximates a spherical shape. This happens, as Leonardo demonstrates in another simple diagram (Fig. 43d), because in a rectangular body the smaller area covered by the angles will be the first to be lost from sight. Leonardo attributed this effect of distance to the intervening air, which is of course the reason for the term 'aerial perspective', which we also use. He was right in connecting the blue tones of the distance with this fact even though he attributed the blue of the air to it being composed of light and of darkness (fol. 263v; McM 961). It seems that he was less aware of the other variable accounting for the loss of detail at distance, the limited power of resolution of the eye, which we can remedy so easily by looking through field-glasses.

One more example must suffice to show how Leonardo saw the interaction of these variables, which led him to ever-increasing complications. His diagram on fol. 257v (Fig. 44) is intended to demonstrate the effect of the eye looking

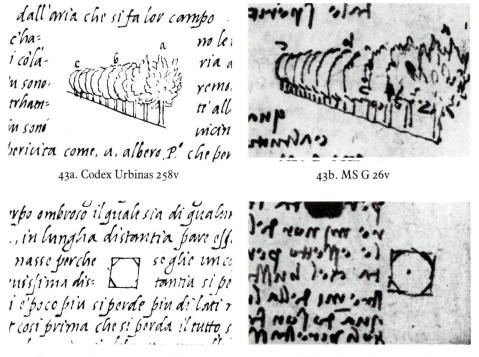

43a. Codex Urbinas 258v 43b. MS G 26v

43c. Codex Urbinas 259r 43d. MS G 26v, c.1510–16. Paris, Bibliothèque de l'Institut de France

down on a row of trees lit from above. The geometry of the situation would lead one to expect to see more of the shadowed parts of the more distant trees and Leonardo reminds us first that these would therefore have to look increasingly dark. But here he checks himself, for he wants us to remember that the more distant trees would also be seen through a thicker layer of air and that this will tone down their darkness: 'If it were not for the fact that a larger amount of air interposes itself between the eye and the second tree, than between the eye and the first (which results in a brightening of the darkness), the perspective of colour would diminish the opposite way.' The passage (McM 918) is somewhat puzzling because elsewhere Leonardo tends to equate the perspective of colour with the effect of the air.

We must never forget that some of the passages which have here been culled from the rich variety of descriptions in this section of the *Trattato* may represent tentative jottings, which the master himself might have discarded or revised if he had ever succeeded in giving his treatise a final and systematic form. Not that it is easy to imagine how his endeavours could ever have reached completion. The programme of analysing every conceivable aspect of trees and verdure in terms of such a limited number of variables could hardly have been carried out. But this Utopian ambition of Leonardo's

life work can be found in many of his projects, in his study of the movement of water and air no less than in his anatomical researches. But in none of these fields should his heroic efforts be considered as vain. Anyone who immerses himself in Section 6 of the *Trattato* will find it an eye-opener. One begins to notice the manifold effects of light and lustre on leaves and the appearance of trees at varying distance and in various types of illumination with a new clarity and intensity. Even photographs of trees acquire a fresh interest as soon as our attention is thus alerted. The reader is invited to study the effects of light, shade, lustre and transparency in their infinite interactions in Mr Kersting's photograph of a forest scene (Col. Plate VI). How Leonardo would have welcomed this technical means of recording the varied phenomena of nature with more 'mathematical precision' than he was able to do. Indeed, the perfect commentary on the *Trattato* must be envisaged with many more photographic illustrations in colour to support or even to modify his analysis. Leonardo himself would never have understood the neglect, let alone the contempt, into which the study of appearances has fallen in this century.

As things are, we have to go back to John Ruskin, whose *Modern Painters* I have mentioned before, to find a true follower of Leonardo's programme. What has stood in the way of a just appreciation of Ruskin's achievement is that his book aimed to prove that every effect of nature was rendered more correctly by Turner than by any other artist. Even where Ruskin may have been right, we do not like the painters of the past being criticized and given bad marks in the intemperate terms he liked to use. But if we forget his strictures on Gaspard Poussin's stereotypical trees we can still admire the passion and poetry of the description with which he wishes to counter such culpable simplifications. Its very length brings it home to us how infinite

44. Codex Urbinas 257v

is the task which Leonardo set himself. Having advised the reader to break off a bough of an elm in full leaf and to study the infinite variations in the shapes, Ruskin continues:

> ... if nature is so various when you have a bough on the table before you, what must she be when she retires from you, and gives you her whole mass and multitude? The leaves then at the extremities become as fine as dust, a mere confusion of points and lines between you and the sky, a confusion which, you might as well hope to draw sea-sand particle by particle, as to imitate leaf for leaf. This as it comes down into the body of the tree, gets closer, but never opaque; it is always transparent, with crumbling lights in it letting you through to the sky; then, out of this, come, heavier and heavier, the masses of illumined foliage, all dazzling and inextricable, save here and there a single leaf on the extremities; then, under these, you get deep passages of broken, irregular gloom, passing into transparent, green-lighted, misty hollows; the twisted stems glancing through them in their pale and entangled infinity, and the shafted sunbeams, rained from above, running along the lustrous leaves for an instant; then lost, then caught again on some emerald bank or knotted root, to be sent up again with a faint reflex on the white under sides of dim groups of drooping foliage, the shadows of the upper boughs running in grey network down the glossy stems, and resting in quiet chequers upon the glittering earth; but all penetrable and transparent, and, in proportion, inextricable and incomprehensible, except where across the labyrinth and the mystery of the dazzling light and dream-like shadow, falls, close to us, some solitary spray, some wreath of two or three motionless large leaves, the type and embodying of all that in the rest we feel and imagine, but can never see.[15]

How would Leonardo have reacted to this poetic *tour de force*? He was himself a master of descriptive prose and some of his evocations of natural phenomena will be quoted in the next chapter. But he also knew that description will always be a poor second to visual representation. As he says in the *Paragone*: '... your pen will be worn out before you can fully describe what the painter can demonstrate immediately by means of his science. And your tongue will be paralysed by thirst and your body by [lack of] sleep and hunger before you can describe with words what the painter can show you in an instant' (Cod. Urb. 6r; McM 36).

In any case the *Trattato* proves that what was needed for laying the foundation of the science of painting was not an observant eye, such as Ruskin had, but a rational mind capable of analysing appearances *more geometrico*.

Leonardo and the Magicians:
Polemics and Rivalry

Leonardo da Vinci's so-called 'Prophecies' belong to the most bizarre products of his ever-active mind. These are humorous inventions in the same vein as his riddles and fables and some of them may strike one at first as little better than schoolboy jokes. For instance, 'in a large part of the country man will be seen walking on the skins of large beasts', which Leonardo explains as referring to the soles of shoes made from oxhides (C.A. 1033r; R. II, p. 295).[1]

Leonardo never did things by halves and so we find that on two pages now inserted in the Codice Atlantico in the Ambrosiana of Milan (1033r and v) (Figs. 45 and 46) he collected no fewer than 74 of these prophecies;[2] almost a hundred more can be found on other pages of his notebooks. Their humour frequently has a satirical edge. He was poking fun at the prophets and sooth-sayers of his time.[3] This purpose becomes quite explicit in a kind of stage direction he added to one of these passages: 'Speak it in a frenzy, or like a fanatic with a diseased brain'; the prophecy he wanted to be read out in this way is another of the familiar teasers entitled: 'Of the Ditch: many will be busied in the taking away from a thing that will grow in proportion as it is diminished' (C.A. 1033r; R. II, p. 294).

It looks as if he had collected these riddles for his own use and gave performances to entertain his contemporaries. He may well have excelled in mimicking certain well-known prophets of his time who made people's flesh creep by predicting the end of the world or the coming of the Antichrist, and the portents which would accompany these cataclysms. It was this aspect that must have given him special pleasure, because he liked to show that something quite ordinary and indeed trivial can be made to look mysterious and menacing: 'Of the Reflection of Walls of Cities in the Water of their Ditches—the high walls of great cities will be seen upside down in their ditches' (C.A. 1033;

A lecture given in Vinci in April 1983 on the occasion of Leonardo's birthday

45. *Profesie*. Codex Atlantico 1033r. Milan, Biblioteca Ambrosiana

46. *Profesie*. Codex Atlantico 1033v. Milan, Biblioteca Ambrosiana

R. II, p. 298). Once more it is the tone which effects the transformation of the utterance from the natural to the apparently supernatural. Leonardo sometimes went very far in this parodistic transformation, stating something which anybody would consider totally obvious: 'The generation of man shall come to such a pass as not to understand each other's speech; that is, a German with a Turk' (Inst. de France, Cod. I; R. II, p. 305). Here the prophecy comes first and then the trivial explanation, and indeed in what follows I shall adopt this alternative sequence which Leonardo used in several manuscripts. In this sequence the 'prophecy' reveals its similarity, if not identity, with the riddle,[4] that ever popular pastime which Leonardo also cultivated in the form of the *rebus*: 'The wind passing through the skins of animals will make men leap—That is the bagpipe which makes people dance' (Inst. de France, Cod. I; R. II, p. 306). Indeed some of Leonardo's notes repeat time-honoured riddles such as the following: 'And many will be hunters of animals which, the fewer there are the more will be taken; and conversely, the more there are the fewer will be taken' (C.A. 1033; R. II, p. 294), the solution is 'of catching lice' and Leonardo's note is a version—not an improvement—on that silly riddle which is said in ancient literature to have driven old Homer to distraction and to his death when he asked a group of fishermen about their catch and they answered: 'Those we caught we left behind and those we did not catch we carry with us.'

Aristotle in his *Poetics*[5] defined the riddle or enigma as 'the description of a fact by an impossible combination of words'. In his view this effect depends on the device of metaphor such as 'I saw a man weld bronze upon a man with fire'. The answer to this riddle is supposed to be the application of the cupping bowl which was heated and applied to the body to draw blood. As a matter of fact, Leonardo used metaphor sparingly but sometimes to good effect as when he uses the term 'the mouth of the oven' for the baking of bread: 'In every city, land, castle, villa, and house, men shall be seen who for want of food will take it out of the mouth of others, who will not be able to resist in any way' (C.A. 1033; R. II, p. 296). This riddle or prophecy exhibits one of the most frequent tendencies of Leonardo's jokes, the desire to disgust or shock by describing an entirely harmless thing in an apparently horrible way: 'Oh! how foul a thing, that we should see the tongue of one animal in the guts of another—Of the Tongues of Pigs and Calves in Sausage-skins' (C.A. 1033; R. II, p. 294). In describing the ordinary as the horrendous Leonardo moves from humorous satire almost imperceptibly to denunciation, leaving us to guess whether he wants us to laugh or cry at the fate of the slaughtered kids: 'The time of Herod will come again, for the little innocent children will be taken from their nurseries, and will die of terrible wounds

inflicted by cruel men' (Cod. Forster II, 9v; R. II, p. 308). From here there is only one step to the most famous and most terrible of prophecies, Leonardo's denunciation of the cruelty of man, which was certainly heartfelt:

> Animals will be seen on the earth who will always be fighting against each other with the greatest loss and frequent deaths on each side. And there will be no end to their malice; by their strong limbs we shall see a great portion of the trees of the vast forests laid low throughout the universe; and when they are filled with food, the satisfaction of their desires will be to deal death and grief and labour and fears and flight to every living thing; and from their immoderate pride they will desire to rise towards heaven, but the excessive weight of their limbs will keep them down. Nothing will remain on earth, or under the earth, or in the waters, which will not be persecuted, disturbed, and spoiled, and those of one country removed into another. And their bodies will become the tomb and passage of all the living bodies they have killed. O Earth, why dost thou not open and engulf them in the depths of your vast caves and abysses, and no longer show heaven so cruel and horrible a monster? (C.A. 1033; R. II, p. 302)

Because of its very passion the passage also shows us perhaps what attracted Leonardo to this kind of literary game; it demonstrates the power of words and the need for rational man to rid himself of the mental habits due to ordinary language. Only in this way could he achieve that detachment which allowed him to see things as they are. There are several prophecies which play on the purely conventional character of language of which every scientific mind must or should be aware: 'All men will suddenly be transferred into opposite hemispheres—The world may be divided into two hemispheres at any point' (C.A. 1033; R. II, p. 299).

What goes for the geometrician's and the geographer's lines, which he can draw at will, clearly applies to language as such. Much of the humbug we encounter in life simply derives from the character of language, which can make ordinary matter sound mysterious and complicated: 'Very often a thing that is severed is the occasion of much union; that is, the comb made of split cane which unites the threads of cloth' (Inst. de France, Cod. I, 65r; R. II, p. 305). In a more scientific vein: 'A great part of the sea will fly towards heaven and for a long time will not return; that is in clouds' (Cod. Arundel, 42v; R. II, p. 303). Or drawing on his artistic interests in shadows he writes: 'Huge figures will appear in human shape, and the nearer you get to them, the more will their immense size diminish—Of the shadows cast by a man at night with a light' (Inst. de France, Cod. I, 50v; R. II,

p. 307), and finally an example of the many enigmatic descriptions of ordinary religious customs: 'Unhappy women will, of their own free will, reveal to a man all their sins and shameful and most secret deeds—Of Friars who are Confessors' (C.A. 1033; R. II, p. 301). Without being necessarily hostile, these formulations reveal the same kind of detachment that speaks from Leonardo's wholly unconventional designs for church interiors with the notorious inscriptions: '*logo dove si predicha*' (place for preaching) (Fig. 47) and '*teatri per uldire messa*' (theatres for hearing mass) (Inst. de France, Cod. B, 55r and 52r; R. II, p. 44).

But however much Leonardo enjoyed these mental gymnastics he would hardly have collected so many of these dark sayings if he had not intended to make fun of the mysterious predictions and warnings which echoed through the centuries from the time of the Hebrew prophets and the Sibylline oracles. I shall have to come back towards the end of this essay to the question of whether Leonardo had anything more specific in mind, but these prophecies certainly served him also in his campaign against the claims and absurd pretensions of charlatans. Well known as is Leonardo's opinion of all kinds of magical practices, I still want to refer to some of his utterances, all the more as one of them resembles in its form some of the prophecies we have just sampled. It is a remark in MS F: 'And many have made a trade of delusions and false miracles, deceiving the stupid multitude' (Inst. de France, Cod. F, 5v; R. II, p. 250).

Leonardo rarely resisted the temptation of accusing these occult practitioners of a desire for gain, as in the opening paragraph of his projected anatomical treatise:

47. *Place for preaching.* MS B 55r, *c.*1488–9. Paris, Bibliothèque de l'Institut de France

It seems that nature revenges itself on those who wish to work miracles, so that they possess less than other more quiet men. And those who want to grow rich in a day live for a long time in great poverty, as always happens, and to all eternity will happen, to alchemists who try to make gold and silver, and to engineers who would have dead water give motive power to itself and produce perpetual motion, and to those supreme fools, the necromancer and the enchanter. (Windsor 19070v; R. II, p. 85)

One class among these practitioners not mentioned here Leonardo must have encountered so frequently in the society in which he moved that he felt the need to apologize for his views. In a passage of the *Paragone* where he stakes his familiar claims for painting to be a science, since the knowledge of perspective is essential to the artist as it is to the astronomer, he adds: 'I am speaking of mathematical astrology and not of the fallacious divination by the stars; let those who make a living thereby from fools forgive me for saying so' (Cod. Urb. 13v; R. I, p. 63).

In Leonardo's view there were degrees of the nonsense propagated by pseudo-science. Thus he says in the *Trattato* in a paragraph headed 'Of physiognomy and chiromancy': 'False physiognomy and chiromancy I shall not discuss at length, because there is no truth in them and this is clear because such chimeras have no scientific foundation. It is true that the face shows some indication of the nature of men, their vices and complexions'; after which he goes on to outline the idea later described as Pathognomics, the idea that habitual facial expressions will leave their marks on the physiognomy so that 'those who have very clearly marked lines between the eyebrows are irascible'— the trace of frequent frowns. 'But what of the hands?' Leonardo continues, 'you will find many men in great armies killed at the same hour with the knife, and many dying at the same hour in shipwreck and none of these has a sign in the palm similar to that of any other' (Cod. Urb. 109r and v; McM 425). The same argument had been used in antiquity by the sceptics to counter the claims of astrology and similar prophecies.

The distinction in the degree of condemnation accorded to pseudo-scientists also marks another of Leonardo's attacks where he wishes to save alchemy from his worst strictures since the alchemist, after all, aims at dealing with the simple products of nature by using his hands, as men do who by such means have produced glass, etc.:[6] but there are no such extenuating circumstances for those who believe in what he called necromancy,

that flag and standard which, fluttering in the breeze, rallies the stupid crowd, always demonstrating by their behaviour the infinite effects of this art; and there are books full, declaring that enchantments and spirits

can work and speak without tongue and without organic instruments—
without which it is impossible to speak—and can carry the heaviest
weights and raise storms and rain; and that men can be turned into cats
and wolves and other beasts, although indeed it is those who affirm these
things who first become beasts. (Windsor 19048v; R. II, pp. 252–3)

How is it, we may ask, that the stupid crowd can be deceived by these
fraudulent effects? Leonardo replies in another passage of the *Trattato* which
I have cited as an important part of his scientific creed. Having discussed
at great length the fall of light and the distribution of shadows on an opaque
sphere by means of geometrical demonstrations (see page 34 and Fig. 12),
he interrupts the discourse with these words:

> Here the opposition says that it does not want so much science, that
> it is enough to practise drawing from nature. The reply is that there
> is nothing more deceptive than to rely on our own opinion, without any
> other reason, as experience always proves the enemy of alchemists, necro-
> mancers and other ingenious simpletons.[7] (Cod. Urb. 222r; McM 686)

The point is surely that our senses can be deceived and often are deceived,
but our reason remains a sure guide. It is reason, as we have seen, which
Leonardo calls in as his principal ally against the claims of the necromancers,
who imply that ghosts and spirits can speak. How could they, he reiterates
in many drafts, since we know how the sound of the voice is produced by
the human organs and a spirit without a body cannot possibly have a voice.

The most famous and most eloquent of these diatribes, from which I have
already taken an extract, is too long to quote *in extenso*, but I must here
give the decisive passages to convey the flavour of this passionate outburst:[8]

> Surely, if this necromancy did exist, as is believed by small wits, there
> is nothing on the earth that would be of so much importance alike for
> the detriment and the service of man. If it were true that there were
> in such an art a power to disturb the calm serenity of the air, converting
> it into darkness, and to make turbulence or winds, with terrific thunder
> and lightnings rushing through the darkness, and with violent storms
> to overthrow high buildings and to root up forests; and thus to oppose
> armies, smashing and annihilating them; and, besides these, frightful
> storms which will deprive the peasants of the reward of their labours.
> Now what kind of warfare is there to hurt the enemy so much as to
> deprive him of the harvest? What naval warfare could be compared with
> that of the man who has power to command the winds and to make
> ruinous gales by which any fleet may be submerged? Surely a man who
> could command such violent forces would be lord of the nations, and

no human ingenuity could resist his crushing force. The hidden treasures and gems reposing in the body of the earth would all be made manifest to him. No lock or fortress, though impregnable, would be able to save anyone against the will of the necromancer. He would have himself carried through the air from east to west and through all the opposite sides of the universe. But why should I enlarge further on this? What is there that could not be accomplished by such artifice? Almost nothing, except to escape death. (Windsor 19048v; R. II, p. 253)

There may be many who are reminded by this splendid poetic description of Shakespeare's Prospero in *The Tempest*. Prospero too commands the winds and can cause shipwreck, and he too can cast spells and bind Ariel, the sprite, to his service and purpose. I believe that this echo is no mere accident. After all, Prospero is a typical product of the Renaissance imagination. We have recently become increasingly aware of this aspect of Renaissance thought and its roots in Medicean Florence through the researches of Frances Yates and D. P. Walker.[9]

It was the revival of Neo-Platonism which carried with it a conception of the universe as a harmonious interaction of forces descending from the planets and pervading the whole of nature, which favoured a belief in the possibility of magical practices. In such a universe action at a distance was not, by itself, a miraculous event, no more so than the resonance of the string of a lute when the right notes were struck on another instrument. Thus, while in the traditional belief of magic and witchcraft the assistance of demons, if not the devil, was presupposed, Neo-Platonism blurred the difference between magic and science by propagating faith in the philosopher whose superior insights have turned him into a miracle worker. His power does not depend on a pact with the devil—he is the Magus of which Prospero is such a memorable embodiment.

Perkin Walker has shown to what an extent Marsilio Ficino was intent on practising this Neo-Platonic magic for the sake of psychological, not to say medical, effects in his prescriptions for herbs, precious stones, talismanic images and astrological music. Frances Yates in her turn has brought into relief the influence exercised by the newly discovered hermetic writings attributed to the ancient Egyptian Magus, 'thrice great' Hermes. There is a laconic reference in Leonardo's manuscript M (Inst. de France; R. II, p. 356) to 'Ermete filosofo', probably dating from the Milanese period, but we cannot tell why Leonardo jotted it down. Conceivably he may even have wanted to remember the name for use in a polemic.

It is never safe to speculate about the psychology of so exceptional a being

as was Leonardo, but would he have written with such passion and such
poetic force if he had not felt the attractions of this dream of Prospero in
his youth?

In that famous draft of a letter to Lodovico il Moro in which Leonardo
offers his services as a military engineer, realistic claims are strangely mixed
with the promise of near miracles:

> If by reason of the height of the banks, or the strength of the site and
> its position, it is impossible, when besieging a place, to use bombardment,
> I have methods of destroying every rock or other fortress, even if it were
> founded on a rock, etc. (see Fig. 48).
>
> Again, I have kinds of mortars; most convenient and easy to carry;
> and with these I can fling small stones resembling a storm; and with
> the smoke of these cause great terror to the enemy, to his great harm
> and confusion. (C.A. 1082; R. II, p. 326)

Looking back on these dreams in his years of wandering Leonardo could
not but have reflected on the vanity of his claims. Had he been able to achieve
these military miracles, the Sforzas would have remained the Lords of Milan
throughout his lifetime, or Cesare Borgia master of all Italy.

But meanwhile it was reason, rationality, which showed the way he could
take to a realm where the fictitious miracles of the magician were capable
of being realized—the realm of the imagination where the effects of painting
are at home. It is sufficient here to quote that marvellous paragraph in the
Trattato headed characteristically 'The pleasure of the painter' to realize its
kinship with the diatribe against the necromancers quoted above.

48. *Bombarde*, *c*.1487. Windsor, Royal Library 12652v

49. *Deluge*, *c*.1514. Windsor, Royal Library 12379

The divinity which belongs to the science of painting transmutes the painter's mind into a likeness of the divine mind. With untrammelled power he can reason about the generation of the various natures of the diverse animals, plants, fruits, landscapes, fields, landslides in the mountains, places fearful and frightful, which bring terror to those who view them; and also pleasant places, soft and delightful with flowery meadows in various colours, swayed by the soft waves of breezes, looking beyond the wind that escapes from them, rivers that descend from the high mountains with the impetus of great deluges, dragging along uprooted plants mixed with stones, roots, earth and foam, carrying away everything that opposes its own ruin. And also the sea with its storms, which battle and contend with the winds that fight with the sea; having reared itself up in proud waves, it falls, crushing the wind that beats against the base of the waves, enclosing and imprisoning it beneath itself it splits and tears it, mixing it with muddy foam (see Fig. 49). Sometimes the angry sea vents its rage, and having been vanquished by the winds, it escapes from the ocean bed, and plunges over the high banks of neighbouring promontories, where, coming over the summits of mountains, it descends into the valleys beyond. Part dissolves into spray, snatched by the fury of the storm; part escapes from the winds, falling back into the sea in rain; and part descends, spreading ruin from the high promontories, bearing away all that opposes itself to ruin, and often it meets another wave coming toward it, and in the clash, raises itself to heaven, filling the air with confused and foamy mist, which, battered by the

winds on the sides of the promontories, creates dark clouds that are the
prey of the conquering wind. (Cod. Urb. 36r and v; McM 280)

Here as so often Leonardo is tempted to dwell on his favourite theme,
the power of tempests and floods, those frightful storms which the necro-
mancers claimed to be able to unleash. To be sure, the painter's power cannot
make him sink hostile fleets, but he can make our flesh creep by reminding
us of their effects. More than merely reminding, in fact. For though the storm
in the painting may only be imaginary, the psychological effect is real enough.
That compelling power over the mind which Ficino had surrounded with
such mystery, Leonardo hoped to obtain by rational means. What else is
the *Paragone*, the comparison of the various arts which forms the first section
of his *Trattato*, than an attempt to prove that such effects can indeed be achieved
by the science of painting? To repeat that passage I have so often quoted
in my writings[10] 'That the painter is lord of all manner of people and of
all things':

> if the painter wishes to see beauties that charm him it lies in his power
> to create them, and if he wishes to see monstrosities that are frightful,
> buffoonish or ridiculous or pitiable (see Fig. 50), he can be lord and
> god thereof; and if he wishes to produce inhabited regions or deserts,
> or dark and shady retreats from the heat, or warm places for cold weather
> he can do so. (Cod. Urb. 5r; R. I, p. 54)

The painter's claim to be a creator is rhetoric, magnificent but rhetoric
all the same. What is not rhetoric is the conviction that he can achieve the
very effects of nature through his art, when he conjures up heat or coolness
as required. To achieve his effects of artifice and wonder,

50. *Dragon, c.*1503–6. Windsor, Royal Library 12369

the painter's mind must of necessity transform itself into the very mind of nature in order to act as an interpreter between nature and art, it must be able to expound the causes of the manifestations of her laws and the way in which the likenesses of the objects that surround the eye meet with their images in the pupil of the eye. (Cod. Urb. 24v; R. I, p. 97)

In a note of the Codice Atlantico Leonardo enlarges on this point:

Here the forms, here the colours, here the character of every part of the universe are concentrated to a point; and that point is so marvellous a thing. O marvellous, O stupendous necessity, by thy laws thou dost compel every effect to be the direct result of its cause by the shortest path. These are the miracles. (C.A. 949v; R. I, p. 120)

It is by means of these true miracles and not the fraudulent ones of the necromancers that painting achieves the effects which Leonardo celebrates in the *Paragone*. This idea of psychological power was traditionally associated with the power of music, which was both exalted and feared by Plato and repeatedly referred to in ancient literature and by Ficino. Leonardo, as we know, was also a musician and he speaks with due respect of music which by its harmonic rhythms 'delights the soul of man within him' (Cod. Urb. 16v; R. I, p. 77), but it would not have suited his purpose if he had enlarged too much on this traditional praise. His purpose was to prove that painting should also be called a liberal art because it is not only equal but superior to music, and here he went beyond the tradition of ancient writers. In antiquity painting was habitually held up to admiration for its power to create illusions not only in man but also in animals—as exemplified by the story of the birds which came to peck at the fruit painted by Zeuxis, and similar anecdotes.

Leonardo did not neglect this argument,[11] writing for instance: 'I once saw a dog, deceived by a portrait of his master, giving him a joyful welcome; and I have seen swallows fly to perch on iron bars painted in imitation of lattices that protrude from the windows of buildings' (Cod. Urb. 5v; R. I, p. 56).

There is kinship here between 'natural magic' and the 'magic' of painting, for in these cases the artist can contrive to produce the very same effects which are produced by the natural objects themselves. But what matters most for Leonardo is the fact that the painter can go beyond copying nature and yet achieve what he calls 'the effect of nature' by his skill and insight. In an important section of the *Paragone* he discusses mechanical methods of imitating nature by tracing the appearance of objects through glass or trans-

parent paper and filling in the chiaroscuro. But in his view such short cuts should not become an excuse for laziness. They are only justified occasionally in the case of artists who can also produce the effects of nature by means of the imagination (*che sanno fare di fantasia li effetti di natura*—Cod. Urb. 24r and v). In any case they would be of no help when it comes to composing an invented story which is after all the purpose of the science of painting.

No painter of the period who reflected on his art could ever believe that the imitation of nature was the beginning and end of his art. Most commissions he received were after all for religious paintings and these demanded other skills. Leonardo boldly refers to the role of images in religion, and describes with relish the veneration with which sacred images are treated:

> Do we not see that pictures representing holy deities are kept constantly concealed under extremely precious covers and that before they are un-covered great ecclesiastical rites are performed with singing to the strains of instruments; and at the moment of unveiling, the great multitude of peoples who have flocked there throw themselves to the ground, worshipping and praying to Him whose image is represented for the recovery of their health and for their eternal salvation, as if the Deity were present in person. (Cod. Urb. 3r and v; R. I, p. 36)

He goes on to speak of pilgrimages, which prove the attractions of the unique image and its superiority over mere words, and he ends with the asser-tion that it seems 'that the Divine Being loves such a painting and loves those who adore and revere it . . . and bestows grace and deliverance through it according to the belief of those who assemble in such a spot'. This formulation is sufficiently ambiguous to leave it open what Leonardo thought himself, except if we remember one of the prophecies entitled: 'Of worshipping the pictures of saints: men will speak to men who hear not; having their eyes open they will not see; they will speak to these, and they will not be answered. They will implore favour of those who have ears and hear not; they will make light for the blind . . .' (C.A. 1033; R. II, p. 295). Here the effect of religious images is not in doubt but the efficaciousness of prayer is.

What is not in doubt either is the power of the painter to arouse love and even lust. The painter

> can place a true image of the beloved before the lover, who often kisses it and speaks to it, a thing he would not do to a description . . . the painter's power over men's minds is even greater, for he can induce them to love and fall in love with a picture which does not portray any living

woman. It once happened to me that I made a picture representing a sacred subject which was bought by one who loved it and who then wished to remove the symbols of divinity in order that he might kiss her without misgivings. Finally his conscience prevailed over his sighs and lusts and he felt constrained to remove the picture from his house. (Cod. Urb. 13v; R. I, p. 64)

Maybe the fact that the *Paragone* is so obviously a literary exercise has tempted students of Leonardo's ideas to take it less seriously than it deserves to be taken. For whether or not we need to take all the anecdotes he tells in support of his thesis *au pied de la lettre*, we cannot and must not ignore his emphasis on what he sees as the true purpose of his art. He describes it in less rhetorical terms elsewhere in the *Trattato*:

The elements of narrative paintings ought to move those who look at or contemplate them in the same way as do the figures in the story. That is, if the painting represents terror, fear, flight, sorrow, weeping and lamentation; or pleasure, joy, laughter and similar conditions, the minds of those who view it ought to make their limbs move so that they seem to find themselves in the same situation which the figures in the painting represent. If they do not do so, the skill of the painter is in vain. (Cod. Urb. 61v; McM 267)

What is remarkable in this extraordinary demand is that it goes in fact beyond what is claimed for painting in the *Paragone*. There he also speaks of the power of the contagion paintings can cause. 'An artist painted a picture that whoever saw it at once yawned, and went on doing so as long as he kept his eyes on the picture, which represented a person who also was yawning' (Cod. Urb. 14r; R. I, p. 64). But in the same paragraph he concedes to the poet that he can move his audience to tears and laughter, 'But the painter will move you to laughter and not to tears, because crying is a more intense effect than laughter.'

Given Leonardo's conviction just quoted from the *Trattato*, this admission must have come harder to him than he might have cared to own. Among the many reasons which gradually made him, in the words of a contemporary, 'most impatient of the brush', this might have been one.[12]

Those who remember Vasari's *Vita* of Leonardo will find that the anecdotes he tells about the master chime in surprisingly well with what we have learnt about Leonardo's search for the strongest psychological effects. They will recall the first of these stories, of Leonardo being asked by his father to make a painting on a round piece of wood and deciding to do a head of the Medusa,

for which he collected all sorts of nasty creatures composing the image of a terrible monster.[13] Predictably the father took flight when shown the painting and the artist remarked that it had served its purpose, since it had produced the intended effect. We also read that Leonardo abandoned the brush for even stronger methods during his stay in Rome. 'On a very strange lizard found by the Vine-dresser of the Belvedere he fastened scales taken from other lizards, dipped in quicksilver, which trembled as it moved, and after giving it eyes, a horn and a beard, he tamed it and kept it in a box. All the friends to whom he showed it ran away terrified.'[14] To further illustrate Leonardo's pleasure in frightening people by seemingly miraculous effects, Vasari adds that he would often

> dry and purge the guts of wether and make them so small that they might be held in the palm of the hand. In another room he kept a pair of smith's bellows, and with these he would blow up one of the guts until it filled the room, which was a large one, forcing anyone there to take refuge in a corner, demonstrating how these transparent and inflated skins which originally took up so little space now fill so much of it, which he compared to *virtù*.[15]

Having sampled something of Leonardo's type of humour in his prophecies we may well give credit to these stories. It is indeed not too hard to imagine that speech about *virtù* (strength or force) which Leonardo may have delivered during that bizarre demonstration.

No doubt the portrait of Leonardo which Vasari gives us in the tantalizingly few pages of his *Vita* is superficial, but I do not think it is wholly distorted. I believe, for instance, that he tells us the truth when he writes: 'At that time the King of France came to Milan and since Leonardo was asked to produce something bizarre he made a lion which advanced a few steps and then its chest opened and was seen to be full of lilies.'[16] What Leonardo was expected to do was indeed frequently '*una cosa bizarra*', in other words to produce effects which were normally attributed to the arts of magicians.

This is an aspect of his artistic personality which we are less able to appreciate than were his contemporaries. The princes and lords who took him into service certainly valued his skill and inventiveness in the arrangement of pageants and theatrical shows. The tantalizing glimpses of these performances which is all that is left to us surely suggest that Leonardo must have known how to create psychological effects. Remember that enigmatic note on a theatrical performance which has caused so much comment among Leonardo scholars:[17] 'When the paradise of Pluto is opened there may be devils placed in twelve pots like openings into hell. Here will be Death, the Furies, Cerberus, many

naked children weeping, here are fires made of various colours' (Cod. Arundel 231v; R. I, p. 386).[18]

Once more one is reminded of the *Paragone*: 'If you say: I shall describe hell for you, and paradise or any other delights or terrors, there too the painter is your superior because he will place things before you which, though silent, will express such delights or terrors that they will compel your spirit to flight' (Cod. Urb. 13v; R. I, p. 64).

If that could be claimed for the painted representation of hell, how much more would it apply to the image on the stage, complete with the sound effects of weeping children? Indeed if Leonardo really meant—at least at times—what he had written in the *Trattato*, that without the ability to elicit tears 'the skill of the artist is in vain', we may be allowed to speculate on the reasons for his occasional excursion into the realm of literary fiction. In thus testing the power of words he showed himself a master of strong effects and he never hesitated to go to the extreme in appealing to our imagination. Even the famous description of the deluge 'and how to represent it in a picture' goes much further in its word painting than the painter's brush could ever go (Fig. 51):

> Ah! what dreadful noises were heard in the dark air rent by the fury of thunder and lightnings ... Ah! how many laments! and how many in their terror flung themselves from the rocks! ... Ah! how many mothers wept over their drowned sons, holding them upon their knees, with arms raised spread out towards heaven and with cries and howlings railed against the wrath of the gods ... (Windsor 12665v; R. I, pp. 353–4)

It is always hard to decide whether Leonardo is really thinking of a painting when he analyses the natural effects of these colossal catastrophes with cool scientific rationality: 'A mountain falling on a town will fling up dust in the form of clouds, but the colour of this dust will differ from that of the clouds. Where the rain is thickest let the colour of the dust be less conspicuous and where the dust is thickest let the rain be less conspicuous' (see Figs. 52 and 53) (C.A. 79a; R. I, p. 357).

However much has been written about Leonardo's apocalyptic visions (Figs. 54 and 55) which so much appeal to our anxious age, the respective share in these fantasies of visual representation and verbal description remains hard to determine. How were the drawings and the descriptions to be communicated and used—if they were so intended? Did Leonardo ever envisage an illustrated work of the imagination?

There is at least one document which poses this question with particular emphasis—I mean the sheets in the Codice Atlantico with rapid sketches of

mountain peaks and swirling waters which also contain Leonardo's notoriously enigmatic notes on a disaster in the Levant (Figs. 56 and 57).[19] So vivid are these descriptions and so rich in geographical detail that Richter believed them to bear testimony to Leonardo's journey to these regions. The idea

51. *Notes on the appearance of the deluge, c.1512–16.* Windsor, Royal Library 12665v

52. *Deluge*, c.1512–16. Windsor, Royal Library 12376

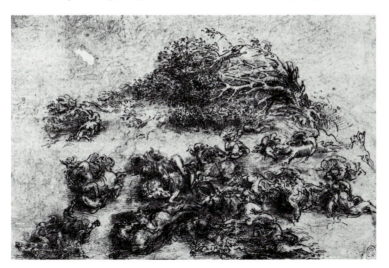

53. Detail of Fig. 52

had to be abandoned; it is quite clear that here, too, Leonardo was giving free rein to his imagination. Indeed he appears to have started on the page with a plan of what can only be interpreted as a fantastic tale.[20]

Division of the Book: Sermon and conversion to the faith.—The sudden inundation, to its end.—The destruction of the city.—The death of the people and their despair.—The chase for the preacher, his release and benevolence.—Description of the cause of this fall of the mountain.—The mischief it did.—Destruction by snow.—The finding of the prophet.— His prophecy.—The inundation of the lower portion of Eastern Armenia,

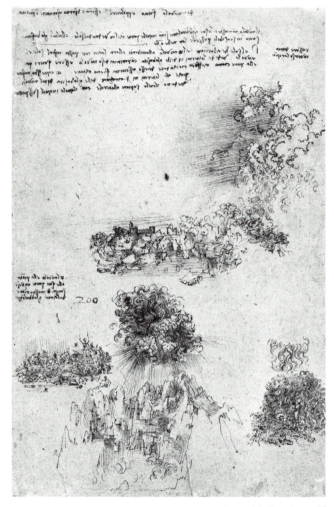

54. *Apocalyptic Vision*, c.1512–16. Windsor, Royal Library 12388

55. Detail of Fig. 54

the draining of which was effected by the cutting through the Taurus Mountains. How the new prophet shows that this disaster had happened as he said. Description of the Taurus Mountain and the river Euphrates. (C.A. 393v; R. II, 319–20)

The writing which adjoins this table of contents indicates that in all probability Leonardo envisaged his tale in the form of a fictitious report to an oriental official: 'to the deftedar of Syria, Lieutenant of the Sacred Sultan of Babylon.'

In the very first draft he cannot resist the temptation to start with the account of the disaster which was obviously to be the core of the story: 'The recent disaster in our northern parts, which I am certain will terrify not you alone but the whole world, will be related to you in due order, showing first the effect and then the cause...'—'first the effect and then the cause'—let us keep this promise in mind, though Leonardo must have felt that for a letter to a superior the text started too abruptly, and so he begins again, this time with the description of Mount Taurus which, in the draft, was to form the end of the story; but it does deal with the description of an effect and an explanation of its cause, the effect being the alleged appearance of a comet that seemed to change its form, the cause the sunlight touching the unbelievably high mountain peak while the valley below was still plunged into night:

Finding myself in this part of Armenia, to carry into effect with due love and care the task for which you sent me, and to make a beginning in a place which seemed to me to be most suitable to our purpose, I entered into the city of Calindra, near to our frontiers. This city is situated on the shore of that part of the Taurus range which is divided from the Euphrates and looks towards the peaks of the great Mount Taurus to the west. These peaks are of such a height that they seem to touch the sky, and in all the world there is no part of the earth higher than its summit, and the rays of the sun always fall upon it on its east side, four hours before daytime; and being of the whitest stone it shines resplendently and fulfils the function to these Armenians which a bright moonlight would in the midst of the darkness; and by its great height it outreaches the utmost level of the clouds by a space of four miles in a straight line. This peak is seen in many places towards the west, illuminated by the sun after its setting, until the third part of the night. This it is which while we were with you in happier time we had supposed to be a comet, and which appears in the darkness of night to change its form, being sometimes divided in two or three parts, and sometimes

57. *Mount Taurus and the report to 'the deftedar of Syria'.* Codex Atlantico 393v. Milan, Biblioteca Ambrosiana

long and sometimes short. And this is caused by the clouds on the horizon of the sky which interpose between part of this mountain and the sun, and by cutting off the solar rays, the light on the mountain is blocked by various banks of clouds, and therefore varies in the form of its brightness. (C.A. 393v; R. II, pp. 317–19)

The analysis or explanation is also anticipated in the plan:

Why the mountain shines at the top from half to a third of the night, and looks like a comet to the inhabitants of the West after the sunset, and before day to those of the East.

Why this comet appears of variable forms, so that it is now round and now long, and now again divided into two or three parts, and now in one piece, and when it is lost and when to be seen again. (C.A. 393v; R. II, p. 320)

Starting again on the other page, which is equally divided between texts and sketches, Leonardo resumes his draft, heading the fictitious letter 'Of the shape of the Taurus Mountain', reverting, after more apologies for failing to write earlier, to the first purpose of the report: 'diligently and painstakingly to investigate the cause of so great and stupendous effect', a task which necessitates, as he says in two drafts, a description of the nature of the place.

And with that tireless persistence which only Leonardo was able to summon and sustain he starts yet again with a new text: *Qualità e Quantità del Monte Tauro* (C.A. 393v), which I must omit.

Richter assumes and Pedretti in his commentary concurs that another text, Codice Atlantico 573r (R. II, p. 323), must belong to the same project. This, too, is couched in the form of a letter. After two false starts Leonardo plunges into the report, reverting to his obsession with natural disasters. It corresponds to the headings in the plan 'The sudden inundation, to its end, the destruction of the city, and the death of the people and their despair'.

... In the first place we were assailed and attacked by the violence and fury of the winds; to this was added the falling of great mountains of snow which filled up all this valley, thus destroying a great part of our city. And not content with this the tempest sent a sudden flood of water to submerge all the low part of this city; added to which there came a sudden rain, or rather a ruinous torrent and flood of water, sand, mud and stones, entangled with roots and stems and fragments of various trees; and every kind of thing flying through the air fell upon us. Finally a great fire broke out, not brought by the wind, but carried, as it would seem, by thirty thousand devils, which completely burnt up all this neigh-

bourhood, and it has not yet ceased. And those few who remain unhurt are in such dejection and such terror that we hardly have courage to speak to each other, as if we were stunned. Having abandoned all our business, we stay here together in the ruins of some churches, men and women mingled together, small and great, just like herds of goats. The neighbours out of pity succoured us with victuals, and they had previously been our enemies. And if it had not been for certain people who succoured us with victuals, all would have died of hunger. Now you see the state we are in. And all these evils are as nothing compared with those which are promised to us shortly.

What are these dire promises or prophecies to which Leonardo here alludes? Let us not forget that in the plan, after the line 'Destruction by snow' we find the words 'The finding of the prophet, His prophecy'. Leonardo did not believe in prophecies, but he liked to make fun of them. Could we here find an allusion to the '*profetie*' with which I began? The temptation to see such a connection becomes hard to resist when one realizes that right under the plan Leonardo wrote one of his mock prophecies: 'Of Funeral Rites, and Processions, and Lights, and Bells, and Followers: The greatest honours and ceremonies will be paid to men, without their knowledge' (C.A. 393v; R. II, p. 294). The connection becomes even more suggestive if we consider that a number of prophecies appear on the reverse of the sheet with the description of Mount Taurus, which also contains a sketch map of Armenia and a mountain peak labelled with three names Leonardo apparently took from an account of the Levant, and that the third column—presumably Leonardo's last—ends with a paragraph headed 'Division of the Prophecy', suggesting a system proceeding from rational to irrational animals, to plants and ceremonies, and so on.

The preceding notes do not conform to the arrangement, which was clearly an afterthought, but it is still significant that he here speaks of *the* Prophecy and not of prophecies. I quote the first six of them in the sequence in which Leonardo jotted them down:

Of ants: These will form many communities, which will hide themselves and their young ones and victuals in dark caverns, and they will feed themselves and their families in dark places for many months without any light, either artificial or natural.

Of bees: And many others will be deprived of their store and their food, and will be cruelly submerged and drowned by folks devoid of reason. O justice of God! Why dost thou not wake and behold thy creatures thus ill-used?

Of sheep, cows, goats and the like: Endless multitudes of these will have their little children taken from them, ripped open and slain, and most barbarously slaughtered.

Of nuts, olives, and acorns, and chestnuts, and such like: Many offspring shall be snatched by cruel thrashing from the very arms of their mothers, and flung on the ground and crushed.

Of children wrapped in swaddling bands: O cities of the sea, in you I see your citizens—both females and males—tightly bound, arms and legs, with strong withers, by folks who will not understand your language and you will only be able to assuage your sorrows and lost liberty by means of tearful complaints and sighing and lamentation among yourselves; for those who bind you will not understand you, nor will you understand them.

Of cats that eat rats: In you, O cities of Africa, your children will be seen quartered in their own houses by most cruel and rapacious beasts of your country. (C.A. 393; R. II, pp. 292–3)

Why these geographical references, the cities by the sea and the cities of Africa? Are they just meant in a general way to create an atmosphere, or did Leonardo envisage them in a more definite exotic setting? It might have suited his general satirical purpose to take a distant land of foreign customs and foreign creeds as a setting for his prophecies, since this made it easier for him to satirize his countrymen and even their religion without causing too obvious offence. Let us not forget that the opening line of the draft is 'The sermon and conversion to the Faith'.

True, it is hard to envisage how Leonardo might have integrated his satirical jest with his tale of ruin and destruction, a tale, let us remember, which was to contain an enigmatic episode—'The chase for the preacher, his release and benevolence'—alluding, maybe, to the kindness which the victims of the disaster had experienced from their hostile neighbours. In any case Leonardo distinguishes here between the 'preacher' and the 'finding of the prophet', who is, or may be, the same person mentioned towards the end: 'How the new prophet shows that this disaster had happened as he said'. Had he foreseen the disaster? Was it he who saw that the inundated lower portions of Armenia could be drained by cutting through Mount Taurus? Would this have been another stupendous effect of which we would have learned the cause?

I do not know the answers to any of these questions, and it may well be that we shall never know them unless a lucky find provides us with another clue. We know from Castelfranco that there are echoes in Leonardo's description of Mount Taurus of Sir John Mandeville and Isidore of Seville.[21] They

describe the enormous height of the peak and the immense length of the shadow it casts. Could it be that Leonardo was stimulated by these accounts to speculate on the appearance of such a mountain at night and on the possibility that its summit might be taken for a comet of changing shape; and could this in its turn have given him the idea first of writing about such a portent in a distant land which could be given a perfectly rational explanation, and then of linking it with apparent portents described in the prophecies? Maybe once he conceived of such a plan he could not resist bringing in his favourite topic, the description of a natural disaster, proposing to explain its real causes and the way it could be remedied by the true power of man, the power of reason. Admittedly this hypothesis still hangs in the air, all that may be claimed for it is that it nowhere contradicts the evidence and would make this enigmatic fragment fit in with his general philosophy. Maybe he hoped to contrast the prophets and their tales of woe with the beneficent *predicatore* in a fantasy which was also a moral fable.

Leonardo who despised any kind of claim to supernatural power knew that it was only in fiction that he could command the elements, but he also aspired to a knowledge of the laws of nature which would enable man to harness the elements and to divert them from their destructive fury. How often in his career as an engineer had he not been called upon to do precisely this.[22] 'Every day', says Vasari with pardonable exaggeration, 'he made models

58. *Prophecy of flight.* Detail (reversed) of Codice sul volo degli uccelli 18v. 1505. Turin, Biblioteca Reale

and designs for the removal of mountains with ease and for piercing them in order to pass from one place to another.'[23] Indeed we now know through the Codex Madrid that his plan for diverting the course of the Arno was further advanced than we had realized.

The charlatans claimed that they could produce effects, but being ignorant of their causes they could only resort to fraud. Leonardo realized that only knowledge, *scientia*, was capable of producing those miracles of which the ignorant dreamt in vain. It is significant, I believe, that when his mind turned to the millennial dream of human flight he twice resorted to the language of prophecies. Once pessimistically, in the denunciation of man I have already quoted, 'from their immoderate pride they will desire to rise towards heaven, but the excessive weight of their limbs will keep them down', but then in an optimistic vein in that famous utterance in which the miracle of flight is foretold in a prophecy which, if not literally true, was vindicated by history (Figs. 58 and 59):

> From the mountain which is named after the great bird, the famous bird which will fill the world with its great fame will start on its flight.
> (Turin, Bibl. Reale 18v; R. II, p. 357)

If you want to solve this riddle, go to the airport in Rome which rightly bears the name of Leonardo da Vinci.

59. *Machine for flying*, c.1488–9. From MS B 79r.
Paris, Bibliothèque de l'Institut de France

Ideal and Type in
Italian Renaissance Painting

The term 'ideal' which occurs in the title of this lecture has come to us from the philosophy of Plato. The impact of this philosophy on the theory of art is the subject of a masterly book by Erwin Panofsky called *Idea*,[1] tracing the various interpretations of the concept which, in the end, was swept aside by the Romantic revolution, that radical re-orientation which still influences much of the critical vocabulary today. It is not my purpose in this essay to advocate a return to that academic theory; what has interested me during recent decades are not so much the problems of aesthetics as those of the history and psychology of image-making, and I should like to look at the concept of the Ideal from this point of view. For this purpose I have chosen as my starting-point a famous letter by Raphael of 1514[2] which has been quoted again and again by academic critics, but I have tried to go outside the well-trodden ground of metaphysical debates in order to ask what this text may teach an art historian interested in psychology.

Raphael's letter, which is addressed to the famous diplomat and man of letters Baldassare Castiglione (Fig. 61), was hardly written without the assistance of another learned man of the circle, though we need not doubt that whoever helped the artist to pen it was faithful to Raphael's intention. Apparently Castiglione had complimented Raphael on a fresco he had just carried out for the Papal banker Agostino Chigi in what is now the Villa Farnesina (Fig. 60a), and the letter refers to this compliment and tries to return it with an elegant twist:

> As for the Galatea, I should consider myself a great master if only half of the many compliments your Lordship wrote to me were deserved. However, I recognize in your words the love you bear me, and would say that in order to paint one beautiful woman I'd have to see several

The Gerda Henkel Lecture given in Düsseldorf in March 1982

beautiful women, always on the condition that I had your Lordship at my side in making the choice. But since there is a shortage both of good judges and of beautiful women, I make use of a certain idea which comes

60a. Raphael: *Galatea*, 1511–12. Rome, Villa Farnesina

60b. Detail of Fig. 60a

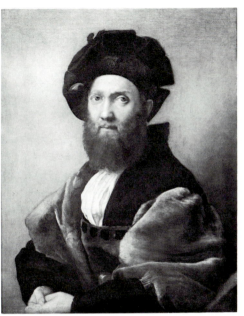

61. Raphael: *Baldassare Castiglione*, 1514–15. Paris, Louvre

into my mind. Whether it carries any excellence of art I do not know, but I work hard to achieve it.

There are various implications in this elegant statement which must be briefly spelt out. The normal task of the painter is the imitation of nature, what the Greeks called mimesis. In other words, in ordinary circumstances Raphael would have chosen a model and represented her features as faithfully as he could, but this procedure would not do for the task in hand of representing a nymph of legendary beauty, because there are no models around who are of such outstanding beauty. Hence Raphael alludes to an alternative method, which is mentioned several times in classical antiquity—allegedly the painter Zeuxis, confronted with the task of representing the fair Helen of Troy, had asked for the five most beautiful girls in the city of Croton, where he was working, and had chosen the most beautiful feature of each to arrive at a composite image by selective imitation.[3] Raphael says in his letter that he could only adopt this procedure if such a famous judge of beautiful women as Count Castiglione advised him on selection. But, and here comes the point, he really doubts whether it could be adopted since both good judges and beautiful women are rare; and in the absence of both he has discarded the imitation of nature and imitates instead a certain idea he has in his mind, working hard to achieve this type of excellence.

It is easy to see that there are Platonic elements in this formulation. It would be sufficient here to refer to a passage in a famous dialogue by Marsilio Ficino, the philosopher who was so prominent in the revival of Platonism in the Renaissance:

> Granted that Alcibiades is handsome, but in what parts is he handsome? In all except in his pug-nose, and his eyebrows, which are higher than they ought to be. These, on the other hand, are beautiful in Phaedrus, but in him the thickness of the legs is not pleasing ... So, if you observe men individually you will praise none of them in every detail; whatever is right anywhere you will gather together and will make up a single figure in your mind, based on the observation of all, so that the absolute beauty of the human species ... will be gathered in your soul in one image. You value little the beauty of each man, dear Socrates, if you compare it with your idea. You possess that idea not thanks to the bodies, but thanks to your own soul.[4]

Plato had taught that the soul owes this Idea to its former existence; before it entered the body and was wedded to matter, the soul was granted the sight of the Idea of Beauty undimmed by matter, and thus our knowledge of the ideal is really based on memory.

There is no reference to this sublime conception in Raphael's letter, and maybe this is not an accident. It seems possible to me that his words contain an allusion to a topical issue which was hotly debated in the very years the *Galatea* was painted. I am referring to the text of a letter not mentioned by Panofsky, published in September 1512, that is perhaps about a year before Raphael wrote to Castiglione. This earlier letter was written by Gianfrancesco Pico, the nephew of the famous philosopher Pico della Mirandola. True, the point at issue was not directly connected with painting. Most critical thought in the period centred on language, on rhetoric and the style of speech. But here, too, the question of imitation loomed large. Pietro Bembo, another member of Raphael's circle, had made a name for himself by an uncompromising orthodoxy in this matter. A good Latin style could never be achieved without a faithful imitation of a standard author, that is to say of Cicero. Any deviation from the great classical model in the choice of words or in the construction of sentences would lead the modern author straight to perdition.

It was against this narrow doctrine that Gianfrancesco Pico protested in a pamphlet addressed to Bembo entitled *De Imitatione*[5] (On Imitation), where he proposes a different theory. Briefly, he wants to replace slavish imitation by genuine education. We must develop our inborn capacities of judgement

before we can decide what models we want to follow and how far. Some passages of this important text are relevant to my story because they propound a somewhat different version of the doctrine of the Idea, which even in the wording comes rather close to Raphael's formulation:

> Among the renowned ancients you will never find the effort to imitate anyone in such a way that they swore by their words, their phrases and their paragraphs as if they were perpetual infants and less independent than the birds who learn to fly by themselves when they are taken out of their nests by their parents, having merely watched them fly three or four times.

Whatever we may think of this argument based on somewhat dubious natural history, it serves the author to lean on Aristotle's pronouncement that of all creatures man has the greatest capacity for imitation and for learning. Man was endowed with this instinct and disposition from birth and it would mean doing violence to Nature if one wanted to break or divert this natural tendency. 'Hence', he goes on, 'there exists in our mind a certain idea (*idea quaedam*), or something like a seed by the force of which we are animated to tackle any task and which it behoves us to cultivate rather than to kill.'[6]

> Now Nature implants in us, together with other faculties, the idea of correct speech, and shapes in our mind the image of its beauty, to which we look as the standard when judging our own speech or that of others. Nobody attains to complete perfection. ... Nature having distributed her gifts never to one alone but to all and sundry, so that it is this very variety which together constitutes the Beauty of the Universe. Or do you think that the prudent painter acted in vain when he decided he could not find in one female body all the beauty he needed? ...

You need be neither a Platonist nor an Aristotelian to admit that Pico saw a genuine problem here. It is the problem that has recently become topical again, when the linguist Noam Chomsky found that he had to postulate an inborn disposition in man for the learning of speech, without which we could never learn the use of language, which is exactly what Pico said. Only Pico went further and extended this view to all human skills. No painter could paint a beautiful figure if he were not born with a standard of beauty.

I happen to believe that the history of ideas only becomes really interesting if we do not simply record changing opinions, but also ask how we might assess them. This, I know, is a somewhat unfashionable approach, but I should like to ask, nevertheless, how far Raphael was right, if we interpret his state-

ment about the idea in his mind in our own terms. To do so, we have to step back a good deal and to reformulate the question. We have to, because we no longer believe in the radical distinction between the imitation of nature in art and the use of mental images. I say we do not believe, perhaps I should have said that I do not, because my book on *Art and Illusion* is devoted to this thesis.[7] I there put forward two formulations to sum up my tenets. The first is 'making comes before matching'. In making an image the artist must first establish a structure, a shape which he can subsequently approximate to reality. I called this process of gradual approximation, in conformity with an old psychological formula, one of 'schema and correction', or 'schema and modification'. There are periods in history where we can watch this process, notably the development of ancient Greek sculpture, which started from the schematic type of the body ultimately derived from Egyptian art and led by a series of approximations to a naturalistic image; in the fifth century Polycleitos created what was called the perfect canon or schema of the fine body in his Doryphoros; in the fourth century, so we read in the ancient authors, Praxiteles added grace, and finally, at the time of Alexander the Great, Lysippus claimed that he followed Nature alone, in other words that a statue such as his Apoxyomenos is like a cast from nature.[8] Naturally it is not. It does mark an important step further towards mimesis, but it is not the facsimile of a human body. I do not claim that there can be no such facsimiles. In eighteenth-century medical schools, wax models of individual organs and dissected bodies were prepared for teaching purposes, and there is no reason to assert that these could never have been faithful copies of a real organ. But if they were, they still achieved this fidelity to nature, this realism, through that concentrated effort of schema and correction which approximates reality asymptotically, as it were. The idea that imitation comes first and that those who dislike the result as being too gruesome or too trivial will subsequently touch it up, like a photograph, or 'idealize' it, seems to me a dangerous oversimplification. And it is with this oversimplification that we have to come to grips when we try to assess Raphael's letter and the striving for the ideal in Renaissance art.

When Giorgio Vasari came to write the history of that art in his Lives of the Painters, first published in Florence in 1550, he explained how struck he was by the exact parallel between the rise of art in antiquity and in the new cycle.[9] To him this rise started from rock bottom as it were, because all medieval works of art seemed to him quite devoid of merit. Devoid, because they operated merely with schematic formulas or types. But from such crude icons painted in what he called 'the ugly Greek manner', art was awakened, and proceeded by slow modification first to the style of Giotto, who achieved

an impression of solidity, and then, in the fifteenth century, to that of Masaccio, who mastered perspective, light and shade, till in Vasari's own century masters such as Raphael achieved perfection. If you read Vasari you see that in his view painting came to satisfy two standards, one which we may call realism, the imitation of nature, the other which we may call the ideal, the creation of beauty. Of the two, realism appears to have precedence, it is the necessary condition of a good painting that it contains no mistakes, no distortion of natural appearances. In a seminal article Svetlana Alpers has shown that we can never get the measure of Vasari if we think of this demand for realism as a mere philistine enjoyment of pictures which look like reality.[10] To him, and to the whole age, the overriding aim of painting was religious, and this aim had come to imply a demand for verisimilitude. The painting should help the faithful to visualize the event from legend or from the Bible as if it happened in front of his eyes. This had not always been the aim of Christian art, on the contrary (to put it schematically), the earlier employment of images by the Church was principally didactic and pictographic. It should replace for those who could not read what writing offered to the literate. Hence when the thirteenth-century Tuscan painter Margaritone d'Arezzo had to represent the Nativity next to other themes from the legends of the saints on an altar panel, he certainly did not aim at a vivid evocation of Holy Night (Fig. 62). It was sufficient for him to remind the members of the congregation of the event in the Story of Salvation by repeating the time-honoured formula.

62. Margaritone d'Arezzo: *The Nativity* and *St John boiled in oil* from the altarpiece of the Virgin and Child Enthroned, *c.*1262? London, National Gallery

I believe that those are right who attribute the shift in the function and purpose of religious art to the mendicant preaching orders of the thirteenth century,[11] notably to St Francis himself, who re-enacted the event, bringing an ox and an ass and possibly also a baby into the church to enable the congregation to re-live the scene. The memory of this moving celebration lives on in one of the frescoes in Assisi. In the art of Giotto the pictographic conception has been totally discarded. Even though in his fresco in Padua (Fig. 63) the old formula may still be noticeable the conception is wholly new: we look into the stable where Mary lovingly receives the child and we also witness the message of the angels to the shepherds, one of whom turns his back to us. As soon as art strove for this imaginative participation, the development of new means and methods followed almost as a matter of course. The convincing rendering of the spatial setting and of the magic of light in innumerable evocations of the Nativity in Christian art from Fra Angelico to Rembrandt serves to prove that the increasing mastery of the means of rendering nature need not impair the sense of awe and devotion.

But if we look at the conquest of appearances in art in the light of this central function, it cannot escape us that it includes more than the imitation of everyday reality. For the tasks of religious painting obviously demand the representation not only of natural but also of supernatural beings, angels no less than the Holy Virgin. A realistic image of the Virgin must be an image of a woman of surpassing beauty. The words of the Song of Songs were applied to her, 'Thou art fair my beloved, there is no spot in thee', and liturgy dwelt on this theme. So does the image of the Holy Virgin on the Ghent Altar (Fig. 64) with the inscription 'Hec est speciosior sole'—she is fairer than the sun. Surely any art that strove for visualization had to strive to do justice to that exalted theme. In this respect, the search for the ideal was not peculiar to the Renaissance. It was postulated in that shift towards the evocation of the sacred story of which I have spoken, a shift which affected the art of the North no less than that of the South. We have all seen lovely images of the Holy Virgin in the Gothic style, like that of the Krumau Madonna at the Vienna Kunsthistorisches Museum which dates from around 1400 (Fig. 65). It belongs to a type which rightly is known to art historians as *Schoene Madonnen*, beautiful madonnas; I say rightly, though I realize that earlier, more archaic images may appeal more immediately to modern taste, for instance, the Essen Madonna of the early eleventh century (Fig. 66), which may strike us as more numinous and more awe-inspiring than the later work in all its refinement.

Needless to say, Vasari would not have understood this modern preference. We have seen that for him the art of the Middle Ages represented a deplorable

63. Giotto: *The Nativity and The Annunciation to the Shepherds*, *c*.1306.
Padua, Scrovegni Chapel
64. Jan van Eyck: *The Virgin* from the wing of the Ghent Altarpiece, *c*.1432.
Ghent, St Bavo

65. *The Krumau Madonna*. Detail. *c*.1400. Vienna, Kunsthistorisches Museum
66. *Golden Madonna*, 11th century. Essen, Cathedral

decline, from which only the Renaissance rescued the arts. What he noted in particular in the early images of his native country were the wide-open staring eyes which looked to him 'as if possessed',[12] as for instance a Roman-esque picture of the Virgin by the Master of Vico l'Abate (Fig. 67). But even within the style which Vasari called the 'clumsy' Greek manner we find this convention giving way to another, almost opposite, treatment of the eyes. I refer to the Byzantine type of the Virgin with the slanting, half-closed eyes, a type that became widespread in Italy. One may well ask why this equally unnatural convention was so widely imitated? Maybe we can here speak of a reaction which slightly overshot the mark. The new convention arose from the wish to avoid that rigid stare, most of all, of course, in the image of the Holy Virgin, to whom these wide-open eyes seem much less suited than the modestly lowered half-closed lids as on the panel of the Madonna from San Remigio (Fig. 68).

What matters most in this context is the tenacity of the type even when the Italian masters had abandoned the Byzantine formula. It lingers on not only in the wonderful image of the Holy Virgin in the centre of the Maestà by Duccio in Siena (Fig. 69), but also in the revolutionary art of Giotto (Fig. 70). Even among the successors of the two masters the formula remains the

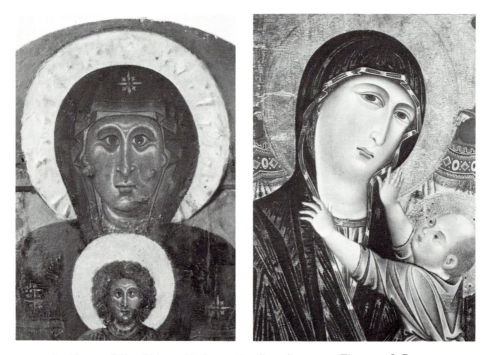

67. Master of Vico l'Abate: *Madonna*. Detail. 13th century. Florence, S. Rosano
68. *Madonna of San Remigio*. Detail. *c.* 1290. Florence, San Remigio

hallmark, as it were, of trecento painting in Florence and Siena, witness the Madonna by Taddeo Gaddi (Fig. 71) or that other one by Pietro Lorenzetti (Fig. 72) in the Pinacoteca in Siena, where the treatment of the eyes strikes us as even stranger because these artists appear to have mastered the rendering of three-dimensional reality with ease. Here, as so often, one feels tempted to ask why these artists kept so closely to the traditional type? Surely painters in the fourteenth century must have enjoyed looking into the eyes of a pretty girl, but there seems to have been no bridge between their everyday perception and their workshop practice. The practice, as we know, took the inherited type as a starting-point, which they were permitted to modify but not to discard.

Even those Gothic images I mentioned before, which celebrate the beauty of the Holy Virgin, were derived, after all, from traditional types which were spread from workshop to workshop in model books.[13] Indeed such examples allow us to trace in detail how types of beauty were passed on from artist to artist in the age of International Gothic. They were in tune with the general tendency of the style to which the Beautiful Madonna belonged, and which is sometimes characterized as the 'soft' style. Here, too, we may speak of a systematic modification of the traditional conventions. The general tendency

69. Duccio: *Madonna*. Detail from the Maestà, *c*.1310. Siena, Museo dell'Opera del Duomo
70. Giotto: *Madonna of Ognissanti*. Detail. *c*.1320. Florence, Uffizi

71. Taddeo Gaddi: *Madonna del Parto.*
Detail. 14th century. Florence, San
Francesco di Paola

72. Pietro Lorenzetti: *Madonna* from the Pala
del Carmine. Detail. *c.*1329. Siena,
Pinacoteca Nazionale

must have been to avoid the impression of rigidity, stiffness or angularity, and thus to achieve the extreme of pleasing gracefulness, as for instance in a drawing of St Margaret which borders on the pretty pretty (Fig. 73).

But this extreme Gothic idealism (if we so want to call it) around 1400 provoked a memorable reaction, a new wave of realistic portrayal which is felt both North and South of the Alps. Compare the Gothic feeling of that lovely and precious painting from Cologne, Stephan Lochner's *Virgin of the Rosebower* (Fig. 74), with the painting by Robert Campin, now in London (Fig. 75), where even the traditional halo is turned into a realistic representation of a firescreen. It seems that for a time, at least, this increase in realism, in the imitation of every detail of appearances, trumped the striving for the ideal. The Madonna is a naturalistic type of a homely woman rather than the Queen of Heaven.

In the South, in Florence, the same radical realism is manifested in the art of Masaccio, who was seen by Vasari as the pioneer of what he calls the Second Manner, the style of the quattrocento, which resolutely approached the imitation of nature in the mastery of perspective and of realistic lighting. Like Robert Campin in the North, Masaccio visualized the Holy Virgin as a real credible woman, perhaps even a woman of the people (Fig. 76).

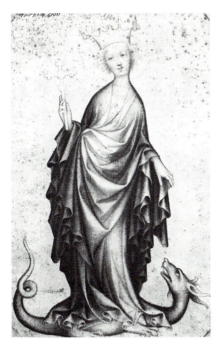

73. *St Margaret*, c.1400. Budapest,
Printroom

74. Stephan Lochner: *Virgin of the Rosebower*,
c.1440. Cologne, Wallraf-Richartz-Museum

75. Robert Campin: *Madonna of the Firescreen*.
Detail. c.1430. London, National Gallery

76. Masaccio: *Virgin and Child*. Detail. 1426.
London, National Gallery

Masaccio died young, but his new conception of art triumphed in the masters of the early quattrocento, notably Filippo Lippi. If we compare his representation of the *Coronation of the Virgin* of 1441 (Fig. 78) with that of the leading Gothic master of the previous generation, Lorenzo Monaco (Fig. 77), we

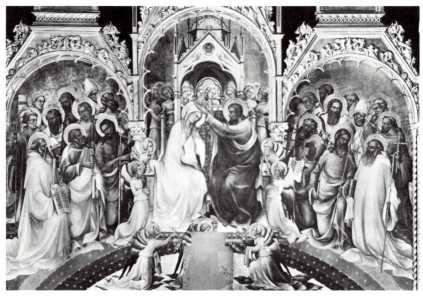

77. Lorenzo Monaco: *The Coronation of the Virgin*, 1414. Florence, Uffizi

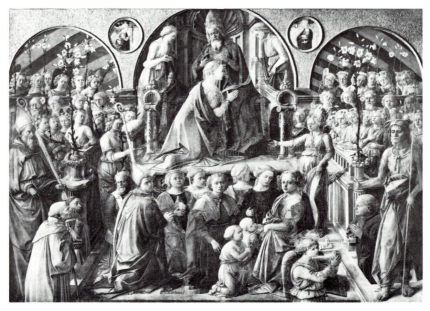

78. Fra Filippo Lippi: *The Coronation of the Virgin*, 1441. Florence, Uffizi

cannot but see this change of direction. The one is a heavenly apparition; the divine ceremonial takes place above the spheres in a golden heaven assisted by beautiful angels. In Filippo Lippi's version we seem to have moved from heaven to earth. He has composed the scene within a kind of stage set, a realistic portrayal of a scene crowded with real solid bodies. Remember the poem by Robert Browning, 'Fra Filippo Lippi', which attempts to make us imagine the shock such a style may have caused within the Church. Browning's Prior asks the painter to rub out what he has painted because his figures remind him too much of the flesh, they are too sensuous for comfort. I do not think there ever was such a Prior. The sentiment expressed by Browning belongs to the Victorian era with its Pre-Raphaelite ideals. But artistically Browning has seen a real problem, the problem of what was to be done about heavenly beauty when the schema was so closely approached to tangible reality.

In what follows I should like to focus on this question in the light of individual examples. I want to illustrate a series of close-ups, taken by a zoom lens, as it were, to show this development as concretely as possible. The ideal medium here would be a trick film using continuous modifications and transformations. In following three examples of the distillation of ideal types out of more down-to-earth traditions I hope to show that there is no difference in principle between the approach to representation to be found in the art of the realists and in that of their more famous idealistic pupils, Botticelli, Leonardo and Raphael. All operate with types, it is the character and function of the types which change.

Filippo Lippi is a good starting-point, for the facial type he favoured is so easily recognizable, though perhaps less easily described in words. Fig. 79 shows a detail of the *Coronation* and Fig. 80 one from the *Feast of Herod* in Prato. Notice the articulated and divided chin in this broad face with a hint of snub nose, full cheeks and a smooth curved forehead. We hear that Filippo Lippi fell in love with the model he employed for a painting, a nun by name of Lucrezia Buti, and eloped with her, before he got dispensation to marry her.[14] To what extent it is Lucrezia's type we see in his paintings, or whether Lucrezia happened to have been his type and therefore attracted his attention and passion we shall never know. But it is not hard to demonstrate with a few more examples the persistence of that schema within slight though lovely variations. Suffice it to look at two Madonnas, one in Florence (Fig. 81), one in Rome (Fig. 82).

It is this female type which is taken up by Filippo Lippi's gifted pupil Sandro Botticelli, as one can see by comparing Filippo's painting in Washington (Fig. 83) with an early Botticelli in Boston (Fig. 84). We notice the same dependence if we set two of Filippo's heads from Prato (Fig. 85) side

by side with Botticelli's relatively early group of Judith (Fig. 86), focusing on the type of these two women with their articulated chins, their high cheeks and domed foreheads. The degree to which Botticelli used and re-used this schema is really astounding, but so is the subtle transformation with which he turned it into a type of ideal beauty: Fig. 87 is the head of his allegory

79. *Head.* Detail of Fig. 78

80. Fra Filippo Lippi: Detail from *The Feast of Herod*, 1452–64. Prato, Cathedral

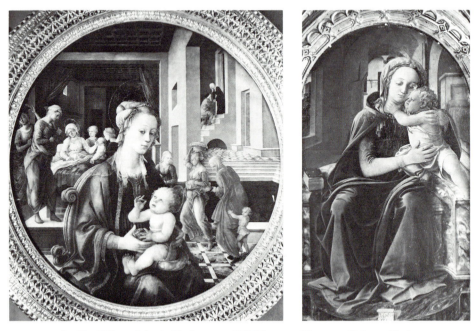

81. Fra Filippo Lippi: *Madonna and Child*, 1452. Florence, Palazzo Pitti
82. Fra Filippo Lippi: *The Tarquinia Madonna*, 1437. Tarquinia, Museo Nazionale (on loan to Palazzo Barberini, Rome)

of Courage, and Fig. 88 the head of the Venus of the *Primavera*; it is the
same head, but somehow the Venus is illuminated from within through the
smile and most of all through the look of the eyes. Or observe the near-identity
between the head of a saint from Botticelli's St Barnabas Altar (Fig. 89) and
the head of Venus (Fig. 90) in his painting of *Mars and Venus*, and remember

83. Fra Filippo Lippi: *Madonna and Child*,
c.1440. Washington, National Gallery of
Art, Samuel H. Kress Collection

84. Botticelli: *Madonna and Child*, *c*.1470.
Boston, Isabella Stewart Gardner Museum

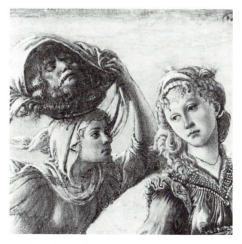

85. Fra Filippo Lippi: *Two Heads*. Detail
from *The Feast of Herod*, 1452–64. Prato,
Cathedral

86. Botticelli: *Judith with her maidservant and
the head of Holofernes*. Detail. *c*.1470.
Florence, Uffizi

once more the Filippo Lippi type. Take a group of angels (Fig. 91) from the *Coronation* of Filippo Lippi and compare them with those typical heads of Botticelli's angels (Fig. 92) which so captivated the Victorian re-discoverers of the artist. Or remember the head of the *Madonna of the Pomegranate* (Fig. 93) and its kinship with the head of Venus from the *Birth of Venus* (Fig.

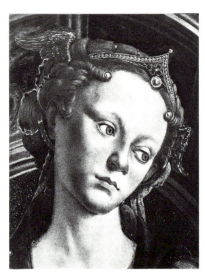

87. Botticelli: *Head of Courage*. Detail. 1470. Florence, Uffizi

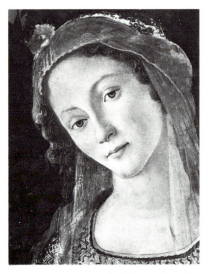

88. Botticelli: *Head of Venus*. Detail from *Primavera*, *c*.1478. Florence, Uffizi

89. Botticelli: *Head of St Catherine*. Detail from the St Barnabas Altar, *c*.1483. Florence, Uffizi

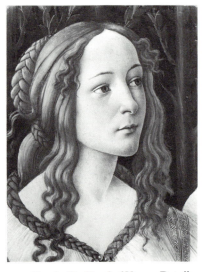

90. Botticelli: *Head of Venus*. Detail from *Mars and Venus*, *c*.1485. London, National Gallery

94), his most famous creation of beauty. It has sometimes been suggested that the degree to which the sacred and the profane can be interchanged in these images may be due to the meaning they had for the master or his patrons. This may be so, but the more important point is surely that once Botticelli had discovered how to transform and transfigure the type he had

91. Fra Filippo Lippi: *Group of Angels.*
Detail of Fig. 78

92. Botticelli: *Group of Angels.* Detail
from the *Madonna of the Pomegranate*,
1487. Florence, Uffizi

93. Botticelli: *Head of the Madonna.*
Detail from the
Madonna of the Pomegranate, 1487.
Florence, Uffizi

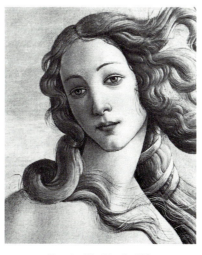

94. Botticelli: *Head of Venus.*
Detail from the *Birth of Venus*,
c.1485.
Florence, Uffizi

learned from his master into a vision of haunting beauty he did not, and perhaps could not, deviate from it.

But for all his charm and magic Botticelli is perhaps only a minor master compared to Leonardo da Vinci. The name of Leonardo stands for one of the greatest explorers of nature who ever lived, and so his dependence on acquired types must really pose a problem. His notebooks are filled with minute observations of natural phenomena, which he never ceased to urge on the attention of the developing painter; and yet, when we turn from his notes to his art we find him almost as wedded to types he had learned in his youth as the previous two artists I have discussed. It is well known to what extent the facial type of a warrior, embodied in Verrocchio's equestrian monument to Colleoni (Fig. 95), haunts the imagination of his pupil Leonardo. It may be less surprising to find a repeat of the warrior type in an early drawing in London (Fig. 96) than to find it in the countless profiles of men Leonardo drew in the course of his life.[15]

These types recur in his many scientific studies, as when he explores the fall of light on a diagrammatic profile (Fig. 97), or is concerned with the proportions of the human head (Fig. 98). They also recur in his countless

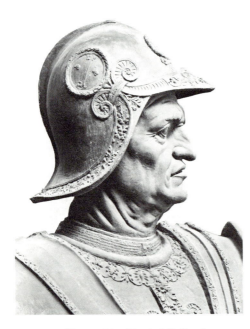

95. Verrocchio: *Head of Colleoni.*
Detail from the equestrian monument,
begun 1479. Venice, Piazza SS.
Giovanni e Paolo

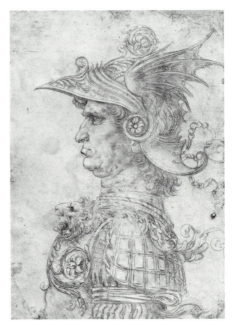

96. Leonardo: *Profile of a soldier,* c.1480.
London, British Museum

so-called caricatures, where he frequently varies the characteristic features of the schema by either exaggerating them or turning them into the opposite, as in Fig. 99, where the type with the prominent chin and the toothless mouth is confronted by a chinless old man with exaggerated lips. More than that, we know that the master even used this schema for the heads of the apostles of the *Last Supper* (Fig. 100), harking back to the formula which Kenneth

97. Leonardo: *Study of a profile*, *c*.1488. Windsor, Royal Library 12604v

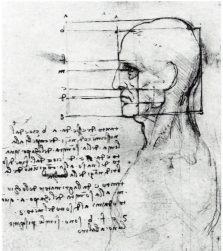

98. Leonardo: *Study of a profile*, *c*.1488. Windsor, Royal Library 12601

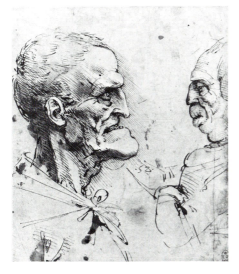

99. Leonardo: *Two caricature heads*, *c*.1490. Windsor, Royal Library 12490

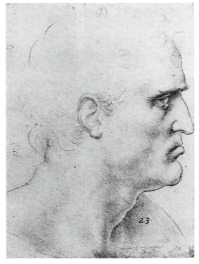

100. Leonardo: *Study for an Apostle*, *c*.1490–7. Windsor, Royal Library 12548

Clark aptly compared with the armature a sculptor uses when modelling a head.[16]

These observations will prepare us for the fact that Leonardo also developed his ideal of feminine beauty from the repertory of types used by his teacher Verrocchio. Of course this fact is not my discovery. On the contrary, it was known to Vasari. Vasari, who was probably the first systematic collector of drawings, mentions that he owned a few drawings of female heads by Verrocchio, adding that Leonardo repeatedly imitated them for the sake of their beauty.[17] It has been suggested that a drawing in the British Museum belongs to this class Vasari mentions (Fig. 101); a glance at the lovely head of Leonardo's *Madonna of the Rocks* in the Louvre (Fig. 102) convinces us that Vasari was right. We see the same heavy eyelids, the same delicately modelled face, and yet Leonardo was able to transfigure the type of Verrocchio's drawing, much as Botticelli did with the types of his master, Filippo Lippi. There is a story, also told by Vasari, which must have arisen out of this visible difference. He writes that when Leonardo was an apprentice to Verrocchio he painted an angel in the master's painting of the *Baptism of Christ* (Fig. 103), and that this angel so surpassed the handiwork of the older painter that he decided to give up painting altogether. The story is a typical anecdote which cannot be quite true in that form, but the two angels have often been compared

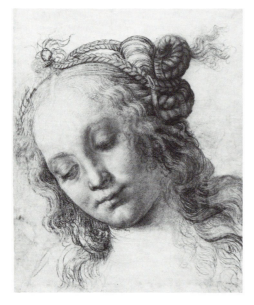

101. Verrocchio: *Head of a girl*, c.1475–80. London, British Museum

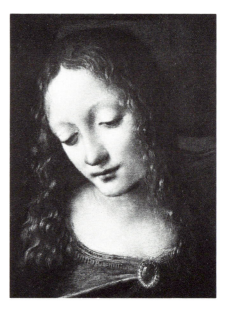

102. Leonardo: *Head of Madonna*. Detail from the *Madonna of the Rocks*, 1483–6. Paris, Louvre

to the disadvantage of Verrocchio's more earthy figure. Yet precisely because this contrast exists, it is all the more striking how much of the armature of Verrocchio remains visible in the types we associate with Leonardo's art. Indeed, without Verrocchio's matter-of-fact realism (Fig. 104) Leonardo's art could not have taken flight towards the ideal.

I do not want to overstate my case, as if Leonardo himself had never looked at nature. Of course he sometimes drew from a model, as he seems to have done for the ravishing drawing for the angel of the Louvre *Madonna of the Rocks* (Fig. 105), but then the same is true of Verrocchio as we may guess when we look at the reverse of the British Museum drawing (Fig. 108), which

103. Verrocchio and Leonardo: *Heads of two Angels.*
Detail from the *Baptism of Christ, c.*1472–5. Florence, Uffizi

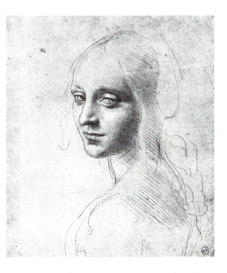

104. Verrocchio: *Head of an angel,*
*c.*1475. Florence, Uffizi

105. Leonardo: *Study for an angel in the*
*Madonna of the Rocks, c.*1483. Turin,
Biblioteca Reale

may well have been drawn from the life. I need hardly repeat that we must not make too sharp a distinction between a drawing made from memory and one from life, least of all in the art of Leonardo, whose visual memory was as miraculous as was his skill of hand.

In two sheets at Windsor we can watch the master proceeding from making to matching. His many studies of a bust of a young woman (Fig. 106) start from a schematic oval, that egg shape artists used to be taught as a starting-point for portrayals, and proceed towards greater articulation, particularly in the region of the neck and breast, which is exemplified in another masterly drawing (Fig. 107). In any case, when Leonardo meditated on the representation of a beautiful figure, the schema that first flowed into his pen was Verrocchio's. Compare his study for the lost composition of *Leda and the Swan* (Fig. 109) with our London head (Fig. 101). Or compare Leonardo's ethereal vision of St Anne (Fig. 110) once more with a head drawn by his teacher (Fig. 111). There is no need, I hope, to labour this point, for it has often been observed that even when he painted a portrait, such as the *Mona Lisa* (Fig. 112), he approximated the features of his sitter to his ideal type which is also embodied in the Louvre group of St Anne (Fig. 113). What alchemy he used in this transformation remains his secret. His pupils never could do it. But without a starting-point in the solid craft of Verrocchio he could not have done it either.

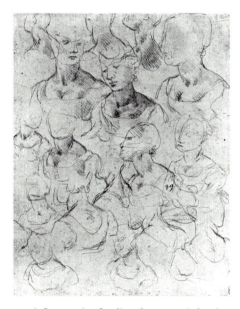

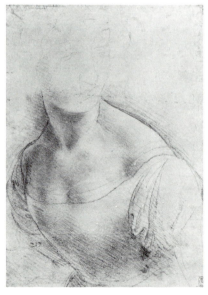

106. Leonardo: *Studies of a woman's head*, c.1480. Windsor, Royal Library 12513

107. Leonardo: *Bust of a woman*, c.1501. Windsor, Royal Library 12514

And so we come back on a circuitous route to the art of Raphael. It was again Raphael's first biographer and critic Vasari who remarked how closely the master's early work such as the enthroned Virgin in New York (Fig.

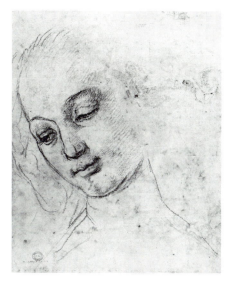

108. Verrocchio: *Head of a girl*, *c*.1475–80, London, British Museum

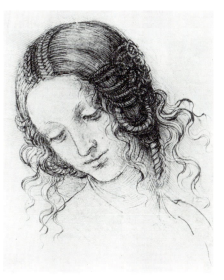

109. Leonardo: *Study for the head of Leda*, *c*.1509. Windsor, Royal Library 12518

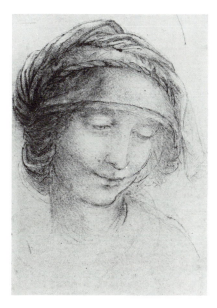

110. Leonardo: *Study for the head of St Anne*, *c*.1509. Windsor, Royal Library 12533

111. Verrocchio: *Head of a young woman*, *c*. 1475. Oxford, Christ Church Picture Gallery

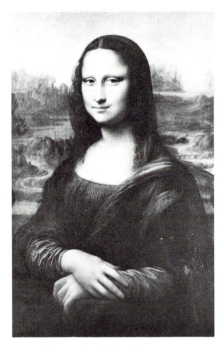

112. Leonardo: *Mona Lisa*, *c*.1503–6.
Paris, Louvre

113. Leonardo: *Heads of the Virgin and St Anne*.
Detail from *St Anne*, 1510. Paris, Louvre

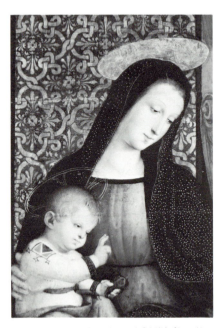

114. Raphael: *Virgin and Child*. Detail.
c.1504. New York, Metropolitan
Museum of Art

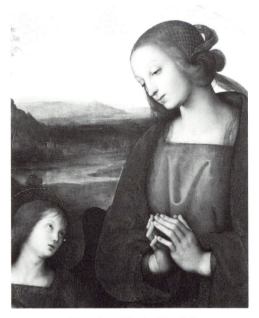

115. Perugino: *Virgin*. Detail from
an Altarpiece, *c*.1500. London,
National Gallery

114) resembles that of his teacher Perugino (Fig. 115).[18] Now Perugino even more than any of the other artists I discussed certainly operated with types, not to say stereotypes. In his case we know, yet again from Vasari, that the monotony of his ever-repeated types attracted criticism in his own time, though Perugino rejected it as unjust.[19] In a way we can sympathise with him, for surely he did not paint his Madonnas all to hang in a row, let alone to be tabulated, as the author of a recent art-historical book has done, in a series of types and variations. At his best he can be truly lovely as his drawing of 1483 at Windsor (Fig. 116) for the head of the Virgin in the Uffizi (Fig. 117) will surely convince anyone. But though Vasari asserted that it is impossible to distinguish Raphael's early work from that of his teacher, and though there is indeed a great similarity between Raphael's *Solly Madonna* (Fig. 118) and the *Virgin and Child with St John* from Perugino's workshop in Frankfurt (Fig. 119), we soon find that all-important slight modification which turns a rather bland and over-regular head into something more animated and spiritual. Compare the head of Perugino's Madonna with that of Raphael's famous *Madonna del Granduca* in the Palazzo Pitti (Fig. 120). It would be a hopeless enterprise to dissect and explain Raphael's achievements in the realm of Beauty, and I am not going to try to analyse his means any more than I did in the case of Botticelli or of Leonardo.

116. Perugino: *Head of the Virgin*, 1493.
(Study for Fig. 117) Windsor, Royal Library
12744

117. Perugino: *Virgin*.
Detail from an Altarpiece, 1493.
Florence, Uffizi

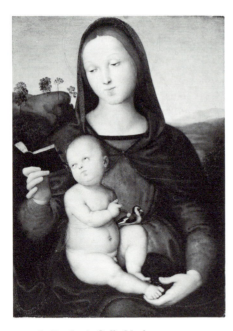

118. Raphael: *Solly Madonna*, *c*.1500.
Berlin-Dahlem, Staatliche Museen

119. Workshop of Perugino: *Virgin and Child with St John*, *c*.1500. Frankfurt, Städelsches Kunstinstitut

120. Raphael: *Madonna del Granduca*. Detail. *c*.1505. Florence, Palazzo Pitti

The paintings must speak for themselves, at least to those to whom they still speak, as they did to generations of art lovers in the past. We are suspicious of beauty, indeed ever since the Pre-Raphaelites and their descendants turned to the so-called Primitives these types of perfection at which Raphael aimed have become somewhat suspected of being hackneyed or cheap. I happen to believe that this is a very superficial judgement, born from the fear of liking something obviously beautiful rather than merely interesting. However, it is not with my feelings in this matter that I am concerned, but once more with the magic of transformation which rests on mere nuance, but a nuance which is telling. We can observe in Raphael's drawings that he too starts from Perugino's oval (Fig. 121), but his heads acquire flesh and solidity in the paintings, such as the *Madonna of the Meadow* in Vienna (Fig. 122), without losing that inner light. Whether you look at the *Small Cowper Madonna* (Fig. 123) or the *Madonna di Foligno* of a few years later, you can still see the Perugino form and complexion showing through the type, as it were, but it never looks a mere type. Like Leonardo, only with different means, Raphael knew how to animate these heads in expressions of ecstasis and devotion. The formula has become particularly difficult to take for those who remember its exploitation in subsequent devotional art, but it was once novel and significant in the evocation of religious rapture, whether we think of the *St Cecilia*

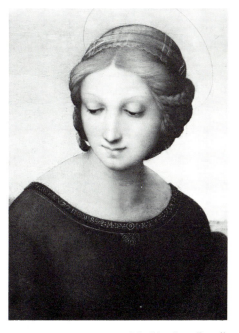

121. Raphael: *Head of the Virgin*, c.1502–3. London, British Museum

122. Raphael: *Madonna of the Meadow*. Detail. 1506. Vienna, Kunsthistorisches Museum

in Bologna (Fig. 124), or that most famous evocation of a heavenly vision, the *Sistine Madonna* (Fig. 125). The large eyes of the Madonna no less than the lowered eyelids of St Barbara are far removed from the Perugino type, but some family relationship still remains.

It cannot be hard to guess what I have been driving at, for if we place the *Galatea* (Fig. 126) side by side with one of these ecstatic saints, this time *St Catherine of Alexandria* in London (Fig. 127), we see once more that the type of beauty is a transformation or modification of the master's schema or vocabulary. The similarity is all the more surprising as the physical ideal of classical sculpture had cast its spell over the minds of Roman art-lovers. No doubt Raphael's image of the triumphant pagan nymph and her train of seagods owes much to that inspiration, but where it was a matter of beautiful features he obviously made no more distinction between sacred and secular themes than Botticelli had done.

It would be easy to jump to the conclusion, therefore, that when in the letter which was my starting-point, Raphael claimed that he had modelled the beautiful nymph on a certain idea he had in his mind, he was simply referring to his training and practice. Whatever metaphysics his friends may have foisted on him, you might say, he derived his image not from a Platonic idea of Beauty, but from a type which he owed to tradition.

123. Raphael: *Small Cowper Madonna*, *c*.1505. Washington, National Gallery of Art

124. Raphael: *St Cecilia*. Detail. *c*.1514. Bologna, Pinacoteca

I think we may here have indeed something like a schema for an answer, but one we should not accept without considerable modifications. It would certainly not be correct, in my view, to say that Raphael simply deluded himself or others when he spoke of beauty, and that his approach was entirely conditioned by his upbringing and his culture—in other words, that it was to that extent entirely subjective. I have indicated before that I do not share the tendency towards relativism which is so much the fashion today. Just as I believe that Vasari was right in describing the development of representation in terms of increasing fidelity to nature, so I also accept his claim that in what he called the Third or Perfect Manner of art in the Renaissance the problem of Beauty was mastered as it had not been mastered before, at least since the days of classical antiquity.

It is only our century, in fact, which has questioned this assertion. It was a commonplace in the past that the Renaissance perfected the representation of the beautiful body; not only Raphael, of course, but also Giorgione in Venice (Fig. 128) and Michelangelo in Rome (Fig. 129), to recall some of the most famous images. Nor was this conviction a purely theoretical one. During the same centuries, from the sixteenth to the nineteenth, artists from the North undertook their pilgrimage to Italy to study the ideal at the source

and to bring back to their homelands what their patrons desired most, the ability to create beauty.

One of the first of the artists to be captivated by the new magic was the German Albrecht Dürer, who wrestled all his life with the problem of beauty, both in his studies of proportion (Fig. 130) and in his writings, which often return to a confession of perplexity if not despair, '*Die Schoenheit, was das sei, das weiss ich nicht*' (Beauty, what that may be I do not know).[20] Was

125. Raphael: *Sistine Madonna*. Detail. *c.*1514. Dresden, Gemäldegalerie

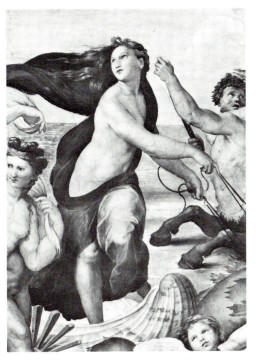

126. Raphael: *Galatea*. Detail of Fig. 60a

127. Raphael: *St Catherine of Alexandria*, c.1509. London, National Gallery

all his striving based on a pathetic illusion? Did not that echo of Platonic philosophy that reached him from Italy tempt him to a hopeless quest? Is not the search for the ideal the pursuit of a will-o'-the-wisp? For is it not obvious that there is not one ideal, one type of perfection? Have I not shown in this lecture that there are many, the Gothic ideal and the Renaissance, the beauty of Botticelli, so unlike that of Leonardo, that of Raphael so unlike that of Michelangelo?

This is an argument which has acquired increasing popularity since the time of the Romantics, who stressed the varieties of human conditions and human cultures. But though the argument has won the day, I do not think it quite holds water. The fact that there are many different shades of red does not prove that there is no part of the spectrum which is rightly described as red. The fact that happily there are many types of beauty here on earth does not prove that beauty is the same as ugliness.

In contrast to such relativism I hold that there is an identifiable human response which is the response to beauty, or if you like, the delight in beauty. In this respect I think Gianfrancesco Pico della Mirandola, whose views I quoted at the outset of this essay, was right. We do not have to learn this response, it is inborn, inborn as a capacity to categorize and to discriminate between various kinds of visual or physiognomic impressions. But a capacity to respond is not the same as a capacity to create. The ability to delight in a picture does not enable us to paint one. Nothing is more important in the theory of art than this obvious distinction between response and creation. We are able to recognize a good imitation of nature when we see it, whether

128. Giorgione: *Reclining Venus*, c.1510. Dresden, Gemäldegalerie

it is an artificial flower or the portrait of a friend, but we may never acquire the skill to produce one.[21] That skill, to return for a last time to the central tenet of my book on *Art and Illusion*, is only acquired step by step through 'schema and correction' or, as I should like to say now, through trial and error. We are groping our way towards a rendering of the motif by systematically eliminating mistakes. It was this critical attitude that enabled the artists of antiquity and of the Renaissance to overcome the technical and perceptual obstacles that stand in the way of a realistic imitation of the three-dimensional world. The closer they came to this achievement, the less they were satisfied with the solutions offered by their predecessors. 'Since nothing'—to quote Dürer once more—'is less pleasing to a man of good sense than mistakes in painting, however much diligence may have been employed in the work.'[22] In fact not even much good sense is needed. As soon as the aim is realized, even the layman notices what Dürer called the mistakes, only he is unable to say wherein they consist.

There is reason to believe that the situation is not dissimilar when it comes to a response to beauty. It has been suggested by psychologists, for instance, that the majority of male subjects prefer the photograph of a girl which has been slightly retouched.[23] When the pupils of the eyes have been enlarged this allegedly makes her look more attractive, presumably because we feel that she likes to look at us. I have no stake in this particular experiment. My contention is simply that the reasons for our preferences in such matters may not be conscious at all. Hence the importance of trial and error, of slight and subtle modifications, which is precisely what we have observed in the

129. Michelangelo: *Adam*. Detail from the Sistine Chapel ceiling, *c.* 1508–12. Vatican City

quest for ideal beauty. To be sure, there are other effects which works of art can exert. After all, even the eighteenth century elaborated the distinction between the beautiful and the sublime.

In recent years I myself have been much occupied with these alternative values which have revealed to us the forces of the demonic and the primitive in the arts of all times and made us recognize, for instance, the nightmarish Aztec Earth Goddess from Mexico for all its horror as an incomparable achievement.[24] Even within the experience of Beauty itself there are many varieties, above all that pleasure in decoration and ornament to which I also devoted a study.[25] But these other interests have not turned me into a relativist. On the contrary, I believe that we shall more easily do justice to the richness of artistic creativity if we accept the old insight that in the age of the High Renaissance the conquest of natural appearances went hand in hand with the realization of a human ideal of Beauty.

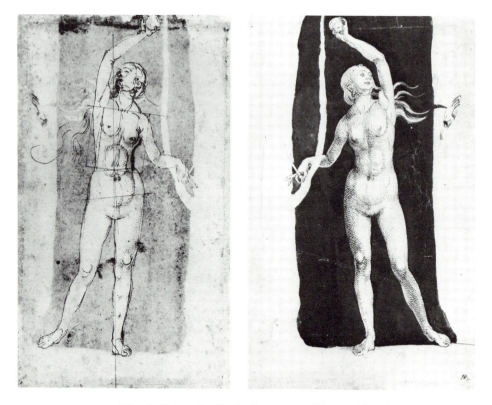

130. Albrecht Dürer: *Studies for Eve*, c.1506. Vienna, Albertina

Raphael:
A Quincentennial Address

When I received the wholly unexpected and quite overwhelming honour of
a letter from Professor Argan, asking me whether I would accept an invitation
to address this illustrious audience, I replied in all sincerity, '*Non sum dignus*'.
But I ventured to add that if a genuine veneration for the Prince of Painters
constituted a sufficient qualification for this role, I would be proud to accept.
I was emboldened by the thought that the choice of a Viennese from England
who is not even a specialist in the field might suitably reflect the fact that
Raphael belongs to the whole world and that his fame and his significance
extend far beyond the confines of one country, beyond the concern of one
academic discipline. The man born half a millennium ago has been called
'divine' in innumerable eulogies and indeed he has established himself on
the Olympus of our culture, dwelling there in our thoughts side by side with
the pagan gods and perhaps with the saints.

Let me document this assertion by quoting from a page of Count Francesco
Algarotti's *Saggio Sopra la Pittura*,[1] published by that popular critic in 1762
and almost immediately translated into English, French and German, thus
symbolizing the consensus of the whole of Europe.

> Raphael is now universally allowed to have attained that degree of perfec-
> tion, beyond which it is scarce lawful for mortals to aspire. Painting,
> in some measure revived among us by the diligence of Cimabue, towards
> the decline of the thirteenth century, received no small improvement
> from the genius of Giotto, Masaccio, and others; insomuch that, in less
> than two hundred years it began to blaze forth with great lustre in the
> works of Ghirlandaio, Gian Bellino, Mantegna, Pietro Perugino, Leo-
> nardo da Vinci, the best grounded of them all, a man of great learning,
> and the first who contrived to give relief to pictures. But whatever improve-
> ment the art might have received from these different masters in different

A quincentennial address given on the Capitol in Rome in April 1983

parts of Italy, they still, to a man almost, servilely followed the same
manner, and all partook more or less of that hardness and dryness, which,
in an age still Gothic, painting received from the hands of its restorer
Cimabue, till Raphael, at length, issuing from the Perugian school, and
studying the works of the Greeks, without ever losing sight of nature,
brought the art, in a manner, to the highest pitch of perfection. This
great man has, if not entirely, at least in a great measure, attained those
ends which a painter should always propose to himself, to deceive the
eye, satisfy the understanding, and touch the heart. So excellent are his
pieces that the spectator, far from praising his pencil, seems sometimes
entirely to forget that they are the feats of it he has before him; solely
intent upon and, as it were, transported to the scene of action, in which
he almost fancies himself a party. Well, indeed, has he deserved the
title of *Divine*, by the beauty and comprehensiveness of his expression,
the justness and nobleness of his compositions, the chastity of his designs,
and the elegance of his forms, which always carry a natural ingenuity
along with them; but above all, by that inexpressible gracefulness, more
beautiful than beauty itself, with which he has contrived to season all
his pieces.

One might almost envy the Count the proud assurance with which he states
and explains Raphael's pre-eminence among all the painters. To put it bluntly,
our loves have become less exclusive. However much we admire Raphael,
we would not be prepared to declare that he was more perfect than Giotto,
or that it is not lawful for mortals to aspire beyond him. What makes us
uneasy is the claim that there is but one perfection in art and that but one
master can lay claim to having attained it as far as any mortal can. But before
we criticize this Academic view for its narrowness, let us see what it implies:
Algarotti has elucidated his reasons with admirable clarity. Raphael, he says,
'has ... at least in a great measure, attained those ends which a painter should
always propose to himself.' And what are these ends, in Algarotti's view?
'To deceive the eye, satisfy the understanding, and touch the heart.' In other
words his view of art may be described as an instrumental one, and as soon
as you adopt this viewpoint you may also speak of a less and a more perfect
achievement of the end in question. Let us not quibble about the question
whether paintings by Raphael frequently deceive the eye; it is enough to con-
cede that the noble hall of the *School of Athens* (Fig. 131) comes closer to
creating an illusion of space than do the settings of Giotto (Fig. 132), and
that the still life in front of Leo X (Fig. 133) in the group portrait in the
Uffizi might not have been matched in the rendering of texture and light

131. Raphael: *The School of Athens*, 1511. Vatican City, Stanza della Segnatura

132. Giotto: *The Marriage of the Virgin*, *c*.1304–6. Padua, Scrovegni Chapel

133. Raphael: *Still life*. Detail from *Pope Leo X with Two Cardinals*, 1518–19. Florence, Uffizi

by any of the other painters mentioned. For Algarotti deceiving the eye is only the first and lowest of the aims of painting. The second is to satisfy the understanding, and he might not have found it difficult to apply this intellectual demand to Raphael's great allegorical or historical compositions which had been so frequently commented upon by the writers of the preceding generations.

But even these, he implies, are still to be ranked below the third and highest aim of art, to touch the heart. So powerful are these effects with Raphael, that, in the Count's words, we sometimes forget the instrument as we succumb to its spell. Like the spectator in the theatre (we may interpret his words), who is so carried away that he all but forgets that what moves him so deeply are but actors reciting their lines, we are transported by Raphael to the scene of action and almost fancy ourselves of the party, feeling relief at the angel's intervention in the punishment of Heliodorus (Fig. 134), or hearing the Sermon of St Paul on the Areopagus, as if we were among the assembled listeners.

Algarotti's *elogio* was written almost two and a half centuries after Raphael; but it is not unlikely that the artist would have been pleased by his praise and that his contemporaries would have accepted it as just. At least it may be argued that they shared the view about the aims of art propounded in this set piece. After all, Algarotti merely distilled into his few paragraphs the view of Raphael's art and position he found in Vasari and in many subsequent writers. It was Vasari who, in the first edition of his *Vite*, had praised

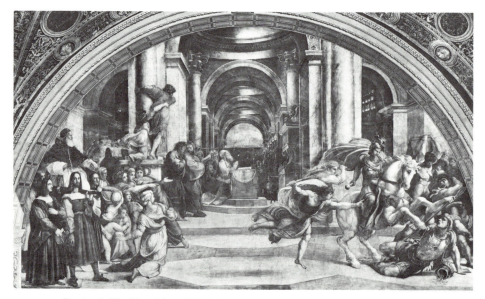

134. Raphael: *The Expulsion of Heliodorus*, 1511–12. Vatican City, Stanza d'Eliodoro

the master's art for its perfection, and it was soon found both tempting and possible to give this notion a more philosophical twist. There was always Raphael's letter to Castiglione in which he speaks of the 'idea' that came into his mind when painting a beautiful woman, a phraseology that derived from Neo-Platonism and could easily be used to offer a metaphysical explanation of Raphael's achievement of supernatural beauty.[2] To quote Algarotti, to attain that 'inexpressible gracefulness, more beautiful than beauty itself', in other words—the Platonic ideal.

And yet the idea of perfection, when applied to art, was bound to pose a problem to its interpreters: it was a static ideal. There is only one perfection in the place beyond the heavens where the Platonic ideas have their being. I hope to show that this static character of the idea of perfection carried within it the seeds of disintegration. It did so, rightly viewed, even in its Aristotelian version, on which Algarotti relies in company with Vasari. I call it Aristotelian because what I have described as the instrumental view of art is the one propounded in Aristotle's *Poetics* in his discussion of the evolution of Tragedy.[3] Tragedy, too, like any tool, had to develop till it could fully meet its purpose of moving the heart or rather cleansing the passions through fear and pity. But once you introduce a time element into the criticism of art, you are in danger of losing the certainty of a static and immovable Platonic ideal. To be sure an instrument can get better, but how can we ever prove at what point it has reached perfection? Aristotle confessed that he did not know whether tragedy had reached its final goal in such masterpieces as the *Oedipus Tyrannos* of Sophocles. For while the instrumental view is perfectly rational when discussing the evolution of means to certain ends, it is in the nature of things that it is not rational to decree an absolute beyond which, in Algarotti's words, 'it is scarce lawful for mortals to aspire'. Irrationalism leads to dogmatism and it is this dogma of the Academic creed that has tended to harm the very image of Raphael it was meant to exalt. Listen to one of its last exponents, the great French critic Quatremère de Quincy, writing in 1824:[4] 'Innumerable artists of different tastes and styles have in their turn explored new methods and have opened for themselves, with more or less success, a great variety of roads, but all of them have only served to make us understand by this comparison the superiority of Raphael.' Could the critic have proved that Rembrandt did not also touch the heart, as Raphael had done?

If the difficulty of sustaining this claim was not immediately recognized, the explanation lies in the popularity of a metaphor which was suggested by the Aristotelian approach, the metaphor of the development of art as a process of growth and decay, a metaphor that is explicitly introduced by Vasari

in the Introduction to the first part of his *Lives* where he says that the arts 'share with the human body the fact that they are born, grow, age and die'. The metaphor explained and vivified the idea of the perfection of the arts as witnessed in masters such as Raphael, but it left it open how after the period of growth, which could so well be illustrated in history, there followed that inevitable decline that led to death. The answer generally given, again on the authority of the ancients, was that such decline or decadence could only be explained in moral terms. After the achievement of perfection, ambition and the search for novelty led to an abandonment of that balance between means and ends which was the hallmark of great art. A striving for sensationalism and the inflation of effects by means of cheap short cuts dominated the scene. Clearly, then, in the history of any art there must be a thin but all-important line between maturity and over-ripeness, between what is right and what is too much, even in the deceiving of the eye, the satisfaction of the understanding or the touching of the heart. In the first case, we would get the irrelevant *trompe l'oeil*, in the second the enigmatic allegory, in the third sentimentality, instead of sentiment.

Maybe there have been developments in the history of the various arts which can rightly be interpreted in such quasi-moral terms, but what concerns me here is only that the temptation to do so was obvious, once an artist's achievement of perfection had been described in what I have called Aristotelian terms. If Raphael could indeed be seen as a link in a historical chain, if his art was perfect because the arts had achieved maturity in and through him, there was a certain contradiction between the static view of perfection as a realization of Platonic ideas and the organic view I have just outlined. The contradiction leapt to the eye, for Raphael's art was anything but static. Every reader of Vasari could describe the three phases of his style, his imitation of Perugino's manner in his youth, his emulation in his Florentine period of Leonardo and Fra Bartolomeo, and his adoption of Michelangelo's grand manner after he had seen the Sistine Ceiling. At what point in this trajectory should we look for perfect perfection? Vasari, the champion of the Michelangelo party, had no doubt that Raphael's most perfect achievements were the sibyls and prophets in Santa Maria della Pace (Fig. 135), which showed how much he had learned from his great rival. It was not a view which gained general acceptance. Yet the more Raphael's works were considered the only suitable model for students to copy and imitate, the more this question of their difference assumed practical significance. Thus when Goethe's friend Heinrich Meyer published three articles in the *Propyläen* of 1798, 1799 and 1800[5] offering a detailed description and evaluation of *Raphael's Works especially those in the Vatican*, he mentions, more in sorrow than in anger, that

135. Raphael: *The four Sibyls*, 1514. Rome, Santa Maria della Pace

frequently connoisseurs and artists prefer the paintings of Raphael's so-called second manner—that is those he painted shortly before his arrival in Rome and in his first few years there—to those of the so-called third manner:

> This is due to letting our sympathies decide in a matter where only reason should be allowed to judge. In the earlier works, the artist enchants us by the gracefulness of his youthful mind, his innocence and simplicity, and the fidelity and truth of his rendering of nature, while in the later creations a higher spirit, a hidden wisdom is at work: in the earlier period he desired to please everybody, while later he wanted merely to impress the crowd but to reveal himself exclusively to his friends.

This distinction is not very intelligible, and we cannot be surprised that it failed to convince. Indeed we know that at the very time when Meyer thus pleaded the case for the later works, the international community of artists assembled in Rome had already decided. Meyer tells us elsewhere that these painters openly denied Raphael's continued progress towards perfection and that they generally concentrated their attention on the *Entombment* and the *Disputa*, which they most liked to copy.[6]

These are the first stirrings of that anti-academic revolt which we associate with the rise of Romanticism and the cult of the so-called 'Age of Faith'. If earlier generations had concentrated their attention on the rise of the arts to perfection, the young men of the period after the French Revolution were obsessed with the dangers of corruption, the vicious reign of sensuality and meretriciousness in the arts of the *ancien régime* and in the centuries that

had brought about this debasement. What they looked for, as Meyer had sensed, was innocence, the outflow of a simple and pious heart, and thus they rejected not only the Baroque but also the glories of the High Renaissance which prepared the arts for their fall.

In the year 1811 a Count Uexküll wrote from Rome:

> A group of artists with rare talent have banded together here in order to paint almost exclusively sacred and legendary themes. Everything must be severe. Only the early artists between Giotto and Raphael are the true adepts of art. Early Germans of before 1520 they find acceptable, but even Raphael's manner of painting after he had abandoned the style of Perugino is considered an aberration of the great man.[7]

Mark the increasing radicalism. What Meyer had observed was a preference of the second manner over the third, now only the first seemed to qualify for perfection.

A letter from one of these German artists, Peter Cornelius, from the next year, not only confirms Uexküll's account, but also illustrates the mentality behind this reversal of taste. He admits to a friend that there is much to be learned in Rome in technical matters, but, he adds, 'there is also much seduction here, the most subtle in Raphael himself. Here lies the strongest poison... one feels like weeping tears of blood when one sees how a spirit who had beheld the All-highest, like that mighty angel at the throne of the Lord, that such a spirit could fall from grace.'[8] Raphael, the fallen angel, the tempter! You might say with Dante, '*non ragioniam di lor, ma guarda e passa*' (Let us not talk of them but look, and pass by). But I cannot quite do so, for not only was this turn of taste still potent in the English school of painting which called itself by the defiant name of the Pre-Raphaelites, not only did that great and unbalanced critic John Ruskin join in the denunciation of Raphael's masterpieces,[9] even today the aftermath of this revolt is only slowly fading.

Not that I need spend much time in rebutting the moral charge of Raphael having yielded to the corruption of the age. I could never improve on the noble words which Jakob Burckhardt devoted to this charge in his *Cicerone* of 1855. Discussing the *Transfiguration* (see Fig. 141), he says that it shows how Raphael attempted to the end of his life to master new means of artistic representation. 'Being an artist with a conscience he would not have been able to do otherwise... those who talk about his fall from grace have never grasped his innermost being.' For Burckhardt, Raphael's highest personal quality

was not so much aesthetic but moral, the great honesty and strong determination which always informed his struggle . . . he never rested on his conquests and exploited them as a comfortable possession. It is this moral quality that he would surely have retained throughout a long life. Remembering the truly colossal creativity of his last years we begin to realize what has been lost for ever by his early death.[10]

Some of us may prefer Burckhardt's beautiful eulogy to that of Count Algarotti with which I began. In any case it reminds us of the fact that the nineteenth century had to come to terms with a new image of Raphael. Those absolutes on which the Academic tradition had relied in its notion of perfection had been corroded by philosophical doubts. Neither Plato's vision of an immutable ideal of beauty, nor the Aristotelian notion of an organic growth and decline of the arts remained acceptable to nineteenth-century theories of art and of history. When the traditional picture of the rise of the arts had been discarded as naive, the figure of Raphael had lost the frame in which it had been customarily seen. Not only the historical frame. What happened in the course of the nineteenth century was the victory of an entirely new conception of art over the one which Algarotti had taken for granted. Briefly, the essence of art was no longer seen in its power of dramatic evocation, but in its quality of lyrical expression.

It was above all in the philosophy of Benedetto Croce that this new notion came to the fore; Croce (if I may say so in parenthesis), who was the spiritual mentor and intimate friend of my revered teacher Julius von Schlosser-Magnino. It was Croce who advocated the most radical distinction between what he called rhetoric and what he saw as pure expression. Rhetoric served practical ends and so he would have classified that instrumental view of art found in Algarotti as a rhetorical one. 'To deceive the eye, satisfy the understanding, and touch the heart', these are the aims of dramatic or rhetorical paintings. Not only for Croce, but for most nineteenth-century critics, the criterion of illusion seemed childish, that of intellectual qualities irrelevant and, most important of all, the idea that the artist should touch the heart was to be replaced by the demand that he must speak *from* the heart. Words like 'theatrical', 'rhetorical', were identified with insincerity, and even technical skill became suspect when it was not used in the service of a personal expression.

There certainly was a danger that the radiant sun of Raphael's art would be allowed to sink below this new horizon, for, to put it briefly, he and his contemporaries probably saw nothing wrong in rhetoric, which had provided the model for the theory of art in the ancient world and again in the Renaissance. But so varied and powerful are his creations that they were also found

to satisfy the new criteria. Indeed this revolution in the concept of art has allowed us to see his greatness in a new light. If what counted now was the personal touch, the immediacy of the spontaneous gesture, it was found that here, too, Raphael displayed perfection, particularly in his drawings. And so art lovers who had to be convinced of the master's greatness were directed from his finished work to his sketches and first ideas. External circumstances assisted this shift. It cannot be denied that the master's finished works, his oil paintings and his frescoes, have suffered greatly in the course of the centuries through decay and injudicious restoration. The drawings look much more as he left them. Moreover, they even survive the distortion of reproductions more easily than do the monumental paintings, needing less reduction in scale and relying on line rather than on colour (Fig. 138). Last but not least, they are more intimate testimonies to the master's infinite grace and creativity, the melodiousness of his gesture and the delicacy of his touch.

We must be grateful indeed for this treasure, which forms such a precious part of our artistic heritage, and it is to be hoped that the many exhibitions and publications marking his fifth centenary have introduced an ever-widening public to the miracle of Raphael's drawings. But if I may say so, it is to be hoped that these glimpses of his mind at work will increase the universal desire also to appreciate the purpose for which they were made, in other words the finished works which he wanted to realize.

But it is here, I sometimes think, that the new conception of art has led to unexpected and unwonted difficulties in the appreciation of the master's oeuvre. I am referring to the efforts to separate his own personal touch from the handiwork of his assistants and the share of his workshop. These efforts, needless to say, have resulted in many fresh insights, and nobody would like to discourage them. But they can be open to misunderstanding if they lead to the notion that it is only the artist's brushwork we want to see. This emphasis on the graphological characteristics of any master's handwriting informed, of course, the method of Giovanni Morelli and had its lasting effect on connoisseurs of art throughout the world. Connoisseurs rarely agree with each other, but the suspicions they are able to cast on any work of art which they deem to be merely a product of the workshop can have a damaging effect on the public's response. 'Do not trouble to look, it is not really by him.'

It is sometimes said that there are two types of connoisseurs, the expansionists and the restrictionists. As a mere outsider I think I have observed that restrictionists often enjoy a higher prestige in academic circles. To doubt the authenticity of a work, after all, shows you to be an extremely discriminating and fastidious judge who is not easily taken in by labels or traditions, but only relies on the seismograph of his own highly sensitive response. The

expansionists, on the contrary, will be more popular with the collectors and the dealers, for they are more ready to bestow on any work the accolade of a great name.

I have ventured to call myself an outsider in this game which is being played all around us by men of undoubted integrity and authority. I have remained an outsider partly, no doubt, from lack of capacity, but partly also from the conviction that in the case of Raphael the question which connoisseurs are expected to answer is somewhat wrongly put.

As a historian I have become convinced that if you ask of a Raphael of the Roman period whether there was workshop participation, the answer must be, 'well, of course'. But as a critic I am also sure that this should not be taken to mean that the work in question is not by Raphael. It is here, I think, that an awareness of the different conceptions of artistic creation to which I have referred might help to clarify the issue. To a conception which relies on the impact the work is to make on the beholder, by appealing to his understanding and touching his heart, the question of who actually wielded the brush is much less relevant than the overall effect. What mattered most in Raphael's day was, to use the terminology of rhetoric, *invenzione*. Now it is quite true that even the inventions that issued from Raphael's studio during the eleven brief years he spent in Rome, and notably in his last six years during the pontificate of Leo X, are of a staggering multitude and variety. It is understandable that scholars have thought it impossible that one man could have had a share in so many enterprises. After all, Raphael was appointed architect of St Peter's, he was responsible for the preservation of classical relics, he launched an ambitious plan to record and visualize the buildings of ancient Rome, a plan that fascinated his humanist friends; he was not above portraying an elephant or providing the scenery for one of Ariosto's comedies, which became the talk of the town. Could he, the argument goes, at the same time have completed the third Stanza, designed the cartoons of the tapestries to be woven in Flanders for eventual display in the Sistine Chapel, designed the *Loggie*, decorated the Chigi Chapel, the bathroom of Cardinal Bibbiena and the vault of the Villa of Agostino Chigi with the story of Psyche, while never ceasing to paint portraits and altar paintings such as the two great panels for the King of France, the St Michael and the Holy Family, the *Spasimo di Sicilia*, and embarking on his *Transfiguration*, painted in open contest with Michelangelo's client Sebastiano del Piombo?

I believe that the answer to this rhetorical question may well be that he could and did. There is no justification for setting arbitrary limits to the possible fertility of a great mind. Students of music know what masters such as Bach, Mozart and Schubert could produce in a similar period of six years, having

to write out their scores with their own hands. Raphael's creative mind was surely equally active.

If we disregard the letter to Castiglione, which he can hardly have drafted himself, we only have one authentic utterance by him in which he speaks about his art. It is reported by the exasperated envoy of the Duke of Ferrara who was charged with soliciting Raphael to complete a triumph of Bacchus which had been commissioned in March 1517. Having fed the Duke with empty promises for two years, Raphael consoled the envoy in March 1519 by saying that he would not have wanted to have it done three months earlier, 'because in these last three months I have seen more examples of perspective than I had ever seen before'—in other words, he had again learned so much that his work would be all the better.[11] It is convincingly conjectured that the reference is to Raphael's project for the reconstruction of ancient Rome, and if this is so, it shows not only how the master was conscious all the time of improving his art, but also how he profited from one enterprise for another. It is true that he never sent off the work for Duke Alfonso, indeed that frustrating correspondence has nourished the idea that Raphael was too overburdened to complete anything, but if you read the correspondence you find that it was the Duke who had at first not kept his bargain, and the master obviously did not see why he should exert himself.

In short, I would plead that we must not deny to Raphael the works he was assigned in his last years and for which, incidentally, he was also paid very handsomely.

Yet anyone familiar with the literature about Raphael will realize how frequently even the most authoritative critics have had no compunction in levelling this implied charge against the master. In fact there is almost unanimity on this score with regard to the frescoes of the third Stanza known as the Stanza dell'Incendio. The master is documented as having been at work there for three years, from 1514 till 1517, exactly as long as he worked in the first and second of the Stanzas. Even so, only the *Fire in the Borgo* (Fig. 136) has found some favour with the critics, while the other three walls have so puzzled observers that the majority have preferred to assert that Raphael cannot have had much to do with them.[12] I readily admit that to all of us these walls are surprising after the serene calm of the Stanza della Segnatura and the narrative masterpieces of the Stanza d'Eliodoro. The *Battle of Ostia* (Fig. 137), in particular, is a puzzling composition. It is a rather brutal account of the landing of prisoners from a boat, represented in a tangle of twisted bodies which are so compressed into intertwining knots that it is hard to see what is going on. The effect is so utterly different from what we have come to imagine as the spirit of the divine and graceful Raphael that it has

been generally felt that he had to be exonerated and that all the blame should go to his assistant Giulio Romano, who later in life showed himself indeed as an artist of coarser fibre. But this hypothesis meets with two difficulties. The first is presented by that famous drawing in red chalk of two nude models

136. Raphael: *Fire in the Borgo*, 1514. Vatican City, Stanza dell'Incendio

137. Raphael: *Battle of Ostia*, 1514–15. Vatican City, Stanza dell'Incendio

used in the fresco (Fig. 139).[13] It is inscribed in the hand of Albrecht Dürer:
'Raphael of Urbino, who is so highly esteemed at the Papal court, has done
these nude figures and sent them to me at Nürnberg to show me his hand,
1515.' So reluctant have the restrictionists been to admit the evidence of this
testimony that they came up with the wholly incredible hypothesis that Raphael
did not send one of his own drawings to Dürer—who had presented him
with his self-portrait—but the work of his assistant, which could only have
been a joke or an insult.[14] But here comes the second difficulty, which has
even less frequently been faced: Giulio was then in all probability a youngster
of sixteen. Could he have invented and prepared a composition of such unortho-
dox complexity? There is little indeed in Italian art before that period that
could have served him as a precedent. Michelangelo's lunette in the Sistine
Chapel of the Brazen Serpent comes to mind, but its compositional principles
are quite different. The nearest parallel for the knot of bodies is to be found
in the design of Leonardo's *Battle of Anghiari* (Fig. 140), for here too the
foreshortened figures on the ground are over-arched by the more prominent
group. Raphael may have seen the design or designs in Florence, but we
must not forget either that in that very year of 1515 Leonardo lived in the
Vatican. We are free to imagine anything we like about his relationship with

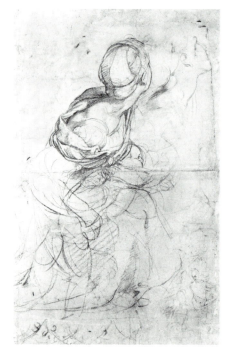

138. Raphael: *Woman and two children*,
c.1512. Oxford, Ashmolean

139. Raphael: *Two male nudes*, c.1515. (Study
for Fig. 137) Vienna, Albertina

Raphael, since we know absolutely nothing about this intriguing episode. Whether or not Raphael knew of Leonardo's repeated advice 'vary as much as you can', can we really doubt that this is what Raphael strove for? While in the *Coronation of Charlemagne* the complexity takes another form, the *Oath of Leo III* seems deliberately simple by contrast. Is it conceivable in any case that the master left the planning of such a commission to mere *garzoni*? Let us remember that what the *garzoni* were trained to do was to imitate the style of the master, the more convincingly the better. Thus, if I may be allowed a paradox, if anything of this period looks very much like Raphael's handiwork it may well have been executed by his assistants, but the less it looks like any other of Raphael's creations, the more it must be credited to the master himself.

Not that I would wish to suggest that even in these comparatively eccentric works he would not have been able to employ assistants and to make them paint under his direction. We must admit, I believe, that here is a *lacuna* in art-historical studies which it will be very difficult to fill. We know very little about that team-work that characterized a happy workshop. Clearly it was not every great artist who was suited to organize and inspire such teams. Leonardo does not seem to have done it, and part of Michelangelo's tragedy

140. Drawing after Leonardo's *Battle of Anghiari*, early 16th century.
Florence, Palazzo Rucellai

lay in the fact that he, too, wanted to carry out an enterprise like the tomb of Julius II almost single-handed. But by common consent Raphael was different.

It was part of the secret of his immense success in Rome that he had this gift of what might be called vicarious creation. This term might make a purist shudder, but let me recall that we have many instances of it today in the artistic life of our time—theatrical producers, film directors and others must be able to work with the human resources they are offered by guiding, cajoling or persuading. In this fruitful interaction it must not be asked who contributed what to the final form of the product. But maybe the most telling comparison would be with the conductor of an orchestra, who never puts his hand on an instrument and who, through explanations in rehearsal and finally through his conducting, leads and inspires the players to re-create the symphony or the opera as he had heard it in his mind. Sometimes, in watching such a maestro at work, you will see that a mere hint suffices to convey to the players that they should play a little more *forte* or *piano* and that through this subtle but all-important nuance the performance takes its memorable shape, as it did under Toscanini.

How we would long to have seen Raphael in his workshop, rehearsing a piece with his assistants! He might have asked them to pose one of their studio mates as a model, say for the figure of Christ in the act of saying *Pasce Oves Meas*. Without even taking a crayon or pen, he might have said lower the arm a little more, or merely demonstrated the gesture himself. And if I may continue with this historical fiction, he might later have returned from a meeting of the *fabrica di San Pietro*, inspected the drawings after the model, selected one and improved it so that it corresponded to his vision. Clearly, no such correction was a matter of form or of content alone. The formal melody of the movement also had to convey the mutual interaction of all the figures of the *storia* in mutual love or hostility, in joint contemplation or prayer. It is this unified mood which marks Raphael's composition from the outset, and who could so unify it but the master himself directing his team?

What I want to stress is the elasticity of this procedure which allows the artist's intervention at any stage of the process. Maybe in the decoration of the *Loggie* this intervention was really slight, though he surely would have shown his approval or his dissatisfaction to the members of the team and inspired them to do their best. In the case of the Sala di Psiche he may indeed have left it to Giulio Romano to do the actual painting of this fantasy, but this would not have militated against his conception of art which put the main stress on invention rather than execution. Raphael had been an indefatig-

able learner all his life, endowed with a wonderful gift of absorbing and trans-
forming the inventions of others and making them his own. Is it not more
than likely, therefore, that he was also an indefatigable and inspired teacher
who could induce his assistants to respond to his ever-new ideas?[15]

After all, this is precisely what Vasari stressed in his life of Raphael, which
for all its inaccuracies should be respected as a primary source. It was published
a mere thirty years after the master's death who, had he lived, would only
have been sixty-seven at the time. Moreover, in 1531 Vasari had spent an
important period of intense study in Rome, where he must have met many
of Raphael's contemporaries in so far as they had not been scattered by the
Sack of Rome, and he visited Giulio Romano, Raphael's heir, in Mantua.
Praising Raphael's affability and capacity to handle people, Vasari wrote: 'He
always kept an infinite number at work, helping them and teaching them
with that kind of love which is not generally lavished on craftsmen but on
one's own sons.' The accounts have been read to justify the idea that Raphael
did little himself. His contemporaries did not see his creations in that light.
Reporting on the completion of the *Loggie* in June 1519, Baldassare Castiglione,
surely no mean judge, wrote to Isabella d'Este: 'Now a painted loggia has
been decorated, furnished with stuccos in the ancient style, the work of
Raphael, as beautiful as possible, more so than anything that can be seen
today made by the moderns.' And when, at the end of that year, less than
four months before the master's death, the *arazzi* had returned from Flanders,
having been woven by Flemish craftsmen after Raphael's designs, Paride de
Grassi, the Master of Pontifical Ceremonies, wrote in the official diary: 'The
whole congregation in the chapel is stunned by their appearance; the general
verdict is that there is nothing more beautiful than these things in the whole
world.'[16] Nobody doubted at the time that the credit for these marvellous
works should go to the master who had inspired their creation and production.
Why should we?

Happily the last few years have witnessed a reaction against that restriction-
ism of which I have spoken.[17] We are again allowed and encouraged to enjoy
the manifestations of his genius in all the famous works which the documents
and tradition attribute to him. The quincentenary of his life among us offers
a wonderful opportunity for this re-orientation, which can only increase our
gratitude for the many separate gifts which together made up his unique genius.
'But'—to quote the words with which a writer of the cinquecento concluded
his eulogy of the master—'why should I go on? Could I ever praise such
a great man by talking? I shall praise him through my silence, knowing how
much more appropriate to his merits is this praise, which by common consent
is accorded him in all languages of the world.'[18]

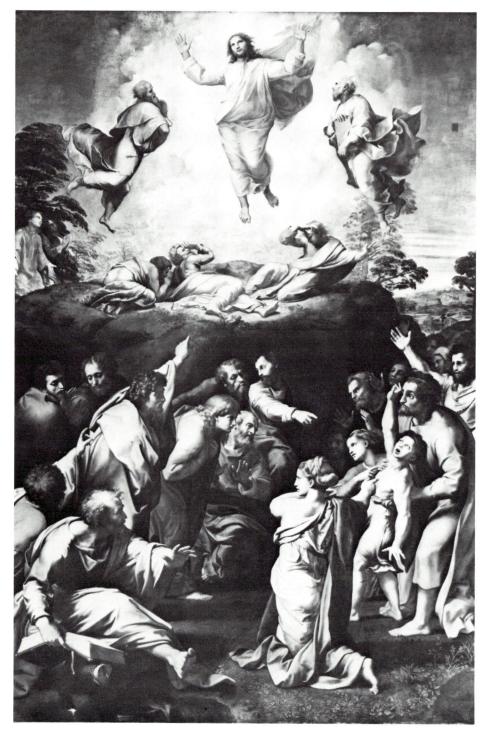

141. Raphael: *The Transfiguration*, 1518–20. Vatican City

The Ecclesiastical Significance of Raphael's 'Transfiguration'

Raphael's last painting (Fig. 141) appears to offer little scope for historical speculation since the main facts about its genesis and its meaning are known on good evidence.[1] The work was commissioned by Cardinal Giulio de' Medici (later Pope Clement VII) at some time before January 1517 for his see, the Cathedral of Narbonne. Another altar painting for that church was commissioned from Sebastiano del Piombo (Fig. 142), who enlisted the help of Michelangelo, and the two pictures were painted in rivalry,[2] Raphael's being incomplete when he died in April 1520. The main subject or subjects of his painting can be found in two episodes from the synoptic Gospels,[3] Christ's transfiguration on Mount Tabor, and the story which follows of the Apostles trying in vain to heal a demoniac boy, who is finally cured by Christ on his return from the mountain.

The voluminous literature on the painting concentrates mainly on two issues: one of connoisseurship, the other of aesthetic criticism. The former concerns the relative share of Raphael and his pupils in the preparation and execution of the painting, and will not here be discussed. The latter has centred since the eighteenth century on the problem of the conformity of the painting to the traditional postulate of 'unity', which is demanded by the classical theory of art. How could the Prince of Painters so ignore this demand as to represent two unrelated stories in one picture?[4] It was Goethe who proposed to put a stop to this carping criticism in a passage which, in the words of John Pope-Hennessy,[5] is 'the classic reply'. Acknowledging the perplexity of the Apostles in the foreground, he interpreted the appearance of the transfigured Christ above as a consoling vision promising divine assistance. But classic or not, the interpretation has long been found to be untenable. Jakob Burckhardt, for instance, acknowledged in a beautiful description of the painting in the *Cicerone* that none of the Apostles 'sees what happens on the mountain,

First published in *Ars Auro Prior* (for Jan Bialostocki), Warsaw, 1981

and the text of the Bible would exclude this altogether. The combination of the two scenes exists only in the mind of the beholder.'

If Burckhardt, and those who followed him, have seen correctly that contrast, not unity, is the theme of the painting, we are surely entitled to ask what purpose this contrast between two scenes was intended to serve? Two answers have found most favour in the literature: one stylistic, the other theological.[6] The stylistic answer refers to the rivalry with Sebastiano and suggests that Raphael felt prompted to add a highly dramatic scene below the Transfiguration so as not to be outclassed by Michelangelo's pupil. This interpretation has drawn fresh strength from the existence of a drawing considered by K. Oberhuber[7] to reflect the original plan for the painting. This drawing shows only the Transfiguration. The argument was accepted by John Pope-Hennessy, but Herbert von Einem has pointed to certain weaknesses in the composition which suggest that the drawing in question is rather a feeble attempt to turn the upper half of Raphael's painting into a self-contained work.

The theological answer first proposed by Friedrich Schneider in 1896 and accepted by such authorities as Ludwig Pastor, Oskar Fischel and (by implication) John Pope-Hennessy refers to the Feast of the Transfiguration on 6 August which was instituted by Pope Calixtus III in 1457 and linked with a victory over the Turks. The troubled atmosphere of the lower half of the painting would then be an allusion to the perils of Christianity in general and Narbonne in particular. This somewhat implausible reading would hardly have been adopted by so many if it did not help to solve a subsidiary riddle of the painting—the two deacons seen in Raphael's painting on the side of the hill contemplating the miracle of Christ's Transfiguration. Since two martyr deacons are also celebrated in the liturgy of that day, the Saints Felicissimus and Agapetus, their rather incongruous presence could thus be accounted for.

It was again Herbert von Einem who challenged this assumption and put forward a more acceptable alternative—he sees the two saints as the martyrs Justus and Pastor, to whom the Cathedral of Narbonne, which guards their relics, is dedicated. In turning these supernumerary figures into assistants to the sacred scene Raphael's patron may well have remembered the precedent of Fra Angelico's fresco in the monastery of San Marco where St Dominic and the Virgin flank the scene on Mount Tabor.

But none of these interpretations appears to me to confront the real enigma, the decision to fill the largest part of the composition with an episode telling of the helplessness of the disciples. Like Raphael's contemporaries we are used to seeing altar paintings representing miracles performed by Christ and by saints, and this habit is so strong that the picture has sometimes been

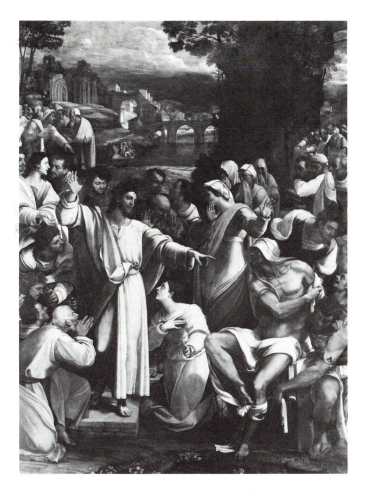

142. Sebastiano del Piombo: *The Raising of Lazarus*, 1517–19.
London, National Gallery

captioned *The healing of the Demoniac*.[8] But what is here shown is emphatically not a miracle, but the failure of the Apostles to perform a healing. Since the Apostles (with the exception of Judas) are of course saints,[9] this choice of a theme seems to call for an explanation.

Looking at the Biblical text and at the traditions of the Church it does not seem too hard to suggest an interpretation of this choice. It is not only Christ who is absent from the scene below, but also the three Apostles he took with him onto the mountain, that is St Peter, St James and St John. If we assume that the discomfiture of the nine Apostles is due to the absence, not only of Christ but also of St Peter, the elements of the puzzle fall into place. For in that case the painting can be seen as one in a long tradition serving the assertion of the *Primatus Petri* and by implication *Primatus Papae*.[10]

I believe that the commentaries to the Gospel text support this interpretation. Nicolaus de Lyra links the fact that Christ selected Peter as a companion on the mountain with the conferment of the keys.[11] The same commentary also sets out the reasons for the helplessness of the Apostles whom Christ left behind. Briefly, they were envious, and the sin of envy sapped their power to perform miracles.[12]

We would not have to go far to account for the choice of such a subject at the time when the picture must have been commissioned. At least one interpreter has actually attempted to turn it into a polemical allegory of Luther's Reformation.[13] The suggestion has rightly been dismissed both on chronological and iconographic grounds, but challenges to the Primacy of the Pope were altogether in the air, and particularly in France, where the painting was to be sent. The French-inspired Council of Pisa aimed at deposing Julius II had ended in failure, but it was only on 19 December 1516 that the Concordat with France was approved by the Lateran Council.[14] At the same time the opportunity was taken to reaffirm the doctrine of absolute Papal Supremacy as formulated by Boniface VIII in the Bull *Unam Sanctam*.[15] The presumed date of the commission of the altar painting, the end of 1516, would thus have been a fitting time to remind the recalcitrant French of the authority of St Peter and his successors. The plan to show not a miracle but a non-miracle would remind the faithful for all time of the helplessness even of the Apostles when they were left without their *princeps*.

Unlike Sebastiano's dramatic rendering of Christ *thaumaturgos*, Raphael's painting, which still needed the attention of the workshop, did not go to Narbonne. Shortly before his elevation to the Papacy, Giulio set it up at S. Pietro in Montorio with the significant inscription: DIVO PETRO PRINCIPI APOSTOL. JULIUS MEDICES CARD. VICECANCELLARIUS D.D. ANNO D. MDXXIII.

In the light of this inscription we need not doubt that St Peter is the central figure, theologically and artistically. Theologically his role as a witness of the Transfiguration is strengthened by his Second Epistle, I.16-18, which refers to his presence at the miracle when God repeated the words spoken at Christ's Baptism.[16] It is all the more likely that we must see Peter in the one Apostle who is shown raising his head while the other two cannot sustain Christ's radiance. In giving Peter this central position Raphael would merely have followed the precedent of Perugino's fresco of the Transfiguration in the Cambio where God's words are inscribed above and Peter says: DOMINE, BONUM EST NOS HIC ESSE.[17] In Raphael's composition, therefore, it is at Peter (and through him at Christ), that the emphatic hands from below are pointing, and though these gestures cannot be reconciled with the Biblical narrative, they are surely significant in underlining the true message of the painting.

'That rare Italian Master . . .'
Giulio Romano,
Court Architect, Painter and Impresario

Sometimes an unadorned enumeration of facts can throw more light on that much-discussed topic, the social history of art, than more ambitious generalizations. Thanks to the copiousness of the Gonzaga archives more is known about the day-to-day activities of Giulio Romano during the fifteen years he served Federico Gonzaga than about those of any other Renaissance master.[1] The appendix to Frederick Hartt's standard monograph on the artist[2] (here abbreviated as H.) lists and summarizes 247 documents, the large majority of which refer to this period. Some ninety of them, dealing with the construction and decoration of the Palazzo del Te—the best preserved and most conspicuous of Giulio's works—have also been listed and supplemented in the more recent book by Egon Verheyen[3] on that building. Further archival gleanings relating to other enterprises were published in a volume commemorating the four hundred and fiftieth anniversary of the artist's arrival in Mantua.[4] Thus it would be a work of supererogation to review this evidence once more; all that is intended here is to convey an impression of the outer circumstances of the life of an artist who enjoyed an extraordinary fame among his contemporaries and received the final accolade of the mention in Shakespeare's *The Winter's Tale* quoted in the title of this essay and discussed in its conclusion.

There are several earlier witnesses to this fame, most of all Giulio's biography which Vasari included in the first edition of his *Vite* of 1550, an invaluable source, since Vasari had been the guest of the artist in his house in Mantua in 1541 and thus speaks as an eyewitness. We also find several reflections of Giulio's high reputation in the letters of Pietro Aretino and in one of his plays, in the architectural writings of Sebastiano Serlio and in Benvenuto Cellini's autobiography.[5]

Giulio certainly had a splendid start in life as an assistant, and probably the favourite helpmate, of Raphael in Rome. Vasari, who was reckless about

First published in *Splendours of the Gonzaga*, London, 1981

dates but more reliable about other matters, says that Giulio was born in 1492 and came to Raphael's workshop *da putto*, as a little boy. Since Raphael's activities in the Stanze of the Vatican only began around 1509 Giulio would on Vasari's reckoning have been seventeen at the time, surely not a 'little boy'. Luckily we need not bother our heads over this contradiction since Giulio's age at the time of his death in 1546 is given in Mantua as forty-seven, which means that he was born in 1499 and was no more than ten at the time when Raphael started to work in Rome. These were also the years when young Federico Gonzaga was at the court of Julius II as a hostage and it is tempting to speculate whether the two met when Raphael painted the prince.[6] They were roughly of the same age. It so happens that the question of Giulio's age during the years of his apprenticeship is of more than biographical relevance. The knowledge that he—like most painters—started work as a boy is relevant also to the assessment of Raphael's own development. Too many critics and art historians of the past who relied on Vasari's information blamed Giulio for any feature of Raphael's oeuvre which did not fit in with their preconceived idea of the divine Urbinate. However precocious Giulio may have been, he cannot have taken such an active part in the workshop before the very last years of Raphael's career. In any case Giulio's name only turns up in the documents after Raphael's death at Easter 1520 when the fights, intrigues and squabbles for the succession began. Raphael seems to have been able to hold his large team together—and Giulio was to show later that he had profited from this lesson—but as early as 17 June 1520 we hear that Giulio and Giovanni da Udine quarrelled 'like madmen' over the completion of the Villa Madama in Rome (H. 23). At the same time Sebastiano del Piombo, backed by Michelangelo, tried to secure the main commission, the decoration of the Sala di Costantino, but Giulio and Penni won in the end, claiming— possibly correctly—that they were in possession of drawings by Raphael for this project.

No doubt Giulio had a right to claim a special relationship with Raphael, who had made him his heir. The document recording the marriage between Lorenzetto (a sculptor from Raphael's circle) and Giulio's sister Girolama mentions that this union had been Raphael's wish (H. 34, 35).

What was decisive for Giulio's future, however, was the fact that Raphael's patron and friend Baldassare Castiglione took an interest in the master's successors. He saw to it that the sum still owing for Raphael's last commission, the *Transfiguration*, was paid out to Giulio and his companion Francesco Penni (H. 30). As early as 1521 he also reported to Federico Gonzaga that the two would like to enter his service after the work in the Sala di Costantino was completed (H. 29). Some fifteen months later Giulio was paid for a model

he had sent to Mantua at the Marchese's request for a new wing of the castle of Marmirolo (now vanished) (H. 36), and the contacts never broke off. It is unlikely, however, that the further delay in making the move to Mantua was to Giulio's detriment. He must have used his time to good purpose to continue Raphael's activities in recording the ancient treasures of Rome. He himself had a sizeable collection, which he gave to Federico; he was also consulted as an authority on ancient sculpture and engraved stones, and his subsequent work in Mantua amply testifies to the degree to which he had mastered and assimilated the idiom of Roman art.

There is a pleasing glimpse of Giulio's life in Rome in Cellini's autobiography,[7] where we are told of a banquet to which all members of a circle of artists were asked on condition that each brought a beautiful courtesan with him; the prize went to Cellini, who had dressed up a young man as a girl. Giulio, who was of the party, is recorded to have been deep in conversation with Michelangelo da Siena on serious and profound topics. There is no reason to doubt the fact that Giulio's existence in Rome was imperilled by a notorious scandal. He had made a series of pornographic drawings representing various forms of sexual intercourse which had been engraved by Marc Antonio Raimondi and published together with a sequence of descriptive sonnets by Pietro Aretino. Aretino was probably the initiator, though he later claimed that he had merely commented on Giulio's inventions.[8] According to Vasari[9] it was only the engraver who got it in the neck, but Giulio may have found it prudent to remove himself from the scene, having been promised a safe haven in Mantua.

When he arrived there in 1524, aged twenty-five, Lorenzo Leonbruno held the position of principal artist of the Gonzaga court. It was he who directed the building and decoration of the castle of Marmirolo over which the Marchese had consulted the Roman artist. There is a pathetic letter of Leonbruno's which shows that he had reason to fear such a rival.[10] Asking Federico humbly for a favour, he writes that receiving it would 'give me new life and would so illuminate my intellect that I shall create new marvels (*bizarrie*) such as have never been seen before'. Alas, when it came to the invention of *bizarrie* for the pleasure and entertainment of the court nobody was likely to be a match for Giulio Romano.

The documents do not tell us, however, how Giulio was employed during the first years of his stay. The first record, dating from more than a year after his arrival (22 November 1525), mentions a design for a *saliera* of silver (H. 58). Two months later (23 January 1526) we hear of three drawings made by Giulio for Isabella d'Este (H. 63). In February 1526 we hear for the first time of work being carried out for the Palazzo del Te (H. 65).

On 16 March of that year Federico Gonzaga, in a letter only recently published,[11] asks *Julio Romano, Vicario della corte nostra*, jointly with another official to attend to the repairs of the ruined walls of the castle of Bigarello. But only on 5 June of that year did he receive the letter patent by the Marchese making him a citizen of Mantua (H. 68). We may thus assume that the designs Giulio had submitted for the Palazzo del Te and the aptitude he had shown in organizing the building works were responsible for his rapid rise. One week after his appointment as a citizen he is allocated a house, the document describing him as a famous painter (H. 69). On 31 August, that is some two years after his arrival, Federico signed a letter patent conferring on Giulio the vacant office of Vicar of the Court and Superior General of all the Gonzaga buildings inside and outside Mantua because 'We have had ample experience of the ability and integrity of our most beloved citizen and painter' (H. 70). Soon afterwards Giulio was given the income from the state sawmill, and other privileges followed. On 20 November he was also made 'Superior of the Streets of Mantua', in other words city architect, and is said to have shown himself no less worthy in architecture than in painting (H. 73). About that time (15 October 1526) the Marchese sent a note to Giulio: 'Messer Giulio, one of my bitches has died when having litter and we want to have her buried in a beautiful marble tomb with an epitaph. We thus wish you to make two designs which should be beautiful to be executed in marble and once you have made them send them or bring them to me as quickly as you can. *Bene valete*' (H. 72).

It is the first note in that voluminous correspondence which gives us such a perfect picture of the master's position and of the character and expectations of his employer. However much the Marchese may have been fond of art and of splendour, this was only one of his interests or passions. He certainly was a discerning and exacting patron of painting and always insisted on receiving the best that was available. Even so it is likely that for him the chase and all that went with it meant even more than art. His famous stud, his innumerable splendid hounds and dogs, his hunting hawks, among which he had as many favourites as among his horses and dogs, were immensely important to him. To record these favourites for posterity, to paint their portraits on the walls of his castle, to design tombs for them, seemed to him a worthy use of art. Nor is it an accident that the Palazzo del Te, which now obsessed this impatient prince, started as a monumentalized stable. In Giulio, Federico had found an artist to whom (in Vasari's words) 'one only had to mention an idea for him to understand and draw it'.

When Benvenuto Cellini came to Mantua after the sack of Rome 'through a world full of war and pestilence', he found Giulio there 'living like a lord

and building a splendid work for his master'.[12] A large team of artists, crafts-men and workmen assembled under Giulio's direction carried out his plans and ideas and were paid out by him. The documents explain in detail the division of labour between the various assistants, builders like Maestro Battista (who was later to succeed Giulio in office), the painters Rinaldo Mantuano (who gave Giulio a good deal of trouble), Benedetto Pagni, Fermo da Caravaggio, Primaticcio (who earned his spurs in stucco work at Mantua and later acquired fame in France), and Recanati (the gilder); gilding was an expensive enterprise since genuine gold leaf was used, and the Marchese's treasurers were not always happy to supply it. In 1528 Gianfrancesco Penni, Giulio's erstwhile partner in Rome, also appears in the documents (H. 95), but he does not seem to have enjoyed his subordinate position and soon left.

But this large team, although kept at work continuously, never satisfied the Marchese's impatience. The way he urged and pressed the painter to complete the work testifies to his interest. Most of the many letters we have from Giulio's hand are responses to these constant threats and cajolings. They show him as the perfect courtier: always compliant and resourceful in finding excuses and making fresh promises. 'If it pleases you, make them lock me in that hall till it is finished,' he writes on one occasion, 'but I cannot do anything against God's will' (31 August 1528, H. 108).

The conditions under which the artist had to work can be seen to get worse with the number of commissions he received. The visit of Charles V to Mantua in 1530 necessitated designs for sumptuous pageants,[13] and when in 1531 Federico, having been made a Duke, was to marry Margherita Paleologa from Casale, her reception again demanded an enormous expenditure of effort and money, which must have strained the resources of the court to the utmost. The officials responsible for these multifarious enterprises frequently express their despair and pessimism to their absent Lord. 'I cannot do anything but to urge and to hurry and I also urge Messer Giulio Romano,' writes the major-domo Calandra on 3 October, 'but truly I see a chaos.'[14] He suggests that the Duke should write fierce letters to Giulio. He should enlist more workers and pay them better, for otherwise the work would not be finished in time. 'Giulio Romano replies to me it will be done, it will be well finished in time, he can say so in his position but I see very little order' (6 October 1531, H. 117). Giulio in his turn had to find new ways of reassuring his master. 'Her Excellency the Marchesa'—Isabella d'Este—had inspected it all and had liked it, he himself would not be found wanting, but he was short of money, of lime, of workmen, of timber, of carts and most of all of dry weather.

Even so, the little Palazzina (Figs. 143 and 144), specially erected next to the Castello for the new Duchess and linked to it by a covered bridge,

somehow was ready in time, richly decorated with armorial bearings and frescoes. Maybe the haste with which it was completed also accounts for its ultimate demolition; the derelict building was considered unsafe and pulled down in 1899.[15] The only surviving record of the pretty interiors which were prepared under such pressure are a few inadequate photographs taken at the time (Figs.

143. Castello and Ponte San Giorgio, showing former Palazzina Paleologa, Mantua

144. Former Palazzina Paleologa, 1531–2, Mantua

145 and 146); some of the better preserved rooms—not all dating from Giulio's time—were taken down and subsequently reconstructed within the Palace. Hartt illustrated only one of them, and they have been neglected in the literature. No major claim can be made for their artistic merit, but like everything Giulio touched, they testify to his fertile imagination and to the skill with which he directed such enterprises.

Meanwhile, of course, work on the Palazzo del Te (Fig. 147) had to go on, indeed it was only a year or two later that it reached its grisly culmination in the famous or notorious Sala dei Giganti, a room which today might merit an 'X certificate' (Fig. 148). Around 1536 new plans were put in train for transforming various suites in the Palace, notably the Appartamento di Troia, which was, among other things, to house the series of *Caesars* commissioned from Titian. The documents tell the same story of frustrations and delays but also of ultimate achievement. Giulio not only had to cope with the whims and ambitions of his exacting employer but also with the hardships of the climate. Placed between lakes and swamps as a fortress guarding the Po Valley, Mantua had to pay for its relative security by endemic malaria.

145. Sala delle Quattro Stagioni, 1531–2, former Palazzina Paleologa, Mantua

146. Ceiling of the Loggetta, 1531–2, former Palazzina Paleologa, Mantua

When Benvenuto Cellini had contracted the fever shortly after his arrival he cursed 'Mantua, its Lord and anyone who felt like staying there', an outburst which was not well received.[16] Giulio, who seems to have constantly fallen ill, and whose assistants and servants also suffered from fever, stayed on. He had to fight the wearying battles with the Duke's treasurers to finance more gilding, he had to direct untrained and unwilling work-forces during floods and incessant rain, while assistants sometimes stole his drawings or carried out his ideas so badly that he lost all pleasure in his work. Nevertheless, he never tired of suggesting new ideas, of preparing new rooms for the Duke's residences inside and outside Mantua, of making designs for castles, gardens, tapestries, majolica, tableware, costumes, stage sets and pageants for festivals and funerals, still finding time to work on his paintings and to make drawings for engravers and sculptors.

At least one of his letters referring to work in the Castello may here be quoted *in extenso* to illustrate his trials and triumphs as an impresario.[17]

Most illustrious and excellent Lord,
Count Brunoro has reproached me for being negligent in informing your

147. North Entrance, c.1527, Palazzo del Te, Mantua

148. Sala dei Giganti, 1532–4, Palazzo del Te, Mantua

Excellency about the progress of the building works. So far I have left
this to Messer Zaffardo, who told me that your Excellency had commis-
sioned him to advise you from time to time how the works proceeded.
It is quite true that I was unwilling, because things did not go as I would
have wished, for in the first week I was short of the gold from coins
and of lime and the captain would not lend me any. Still, in the end
he gave me a little and so I put the Castello in good order: Messer Agostino
will have vaulted the two rooms in the next week, that is the first floor,
and he will also have finished the garden wall and I promised him to
pay him from my own money so that he could hurry and your Excellency
could be satisfied and find the garden green within two weeks.

Underneath I was not able to work on the moat because of the height
of the water level, even so they began vaulting and the work will go
on.

As to the painted room, Anselmo will have finished painting within
ten days and then the gilding will proceed using five hundred pieces
of gold every week, for Messer Carlo has promised me not to fail supplying
the coins for so large a sum. The little room next to the room is gilded
but the falcons have not been painted. Six are still outstanding and as
soon as I have them I shall have them done. I have given instruction
to begin work on the wainscot of walnut wood to the marquetry workers,
the de la Mola and other masters who deal with wooden panelling. The
two cornices to go into the room are finished as far as the woodwork
is concerned and I have completed one and this is where I shall put
the horses which are being done, for there are still three of them missing
which will go into the smaller places and I have already prepared the
frames and the canvas.

And if it pleases your Excellency to advise and instruct which horses
and which falcons should be painted, they will be made immediately,
but I would think it should be horses which are not too large and should
be brightly coloured, if there is no shortage of the necessary.

There is nothing, however, which will make me delay except the quan-
tity of gold which will go on to the vault and further down to match
the beauty of the vault.

I have also made two places ready to accommodate the lights so that
they should not smoke and I have commissioned them to begin work
on the mantelpiece of stone, which will be the most beautiful so far made.

That other white little room will be finished within ten days and then
they will immediately go to the next. As to the storage shed, it will be
finished within a week but it will be necessary to spend a little on the

chimney or else the rats would use it as a ladder to get into the dovecote. However, I have found a good remedy and it would have been finished earlier if it had not been for the rain and for being unable to get the timber.

As to Marmirolo, more could already have been done if the foreman had not left; and since there was nobody to do the plastering and to erect the scaffolding Maestro Luca spent a few days there in vain; then I made the foreman return and Maestro Luca has finished two beautiful landscapes, and I have tidied up things well there, for there is another painter there who is meanwhile doing the cornices and the decorations and I have given him instructions to paint the War in Tunis according to the account of that man from Cyprus.

As to the new rooms between the two gardens, they will be begun on Monday and there is a clear instruction to complete the fireplaces, to construct them and to do two ceilings above to the mezzanine, to make the doors and windows and the frames for the glass; Messer Carlo has begun to give me the money for this and on that Monday I shall send Anselmo to have the panelling varnished in the rooms and in the hall. I have done my very best to satisfy your Excellency with more zeal than has in fact been apparent. It seemed to me better to be able to make my apologies and I only will say so much that if I am short of money for the job I shall freely spend my own, little as I have of it. I do so for the favour of your Excellency to whom I humbly recommend myself and kiss your hands.

Mantua, 10th June 1536.
Your Excellency's humble servant,
Giulio Romano.

A modern reader of this letter would hardly guess that its humble writer was by that time a very celebrated artist. The Duke of Ferrara asked for his services to learn of 'certain of his ideas' (7 April 1537, H. 195), but Federico only reluctantly gave him leave. Pietro Aretino invited him to Venice (H. 239), the Directors of the Works of San Petronio in Bologna commissioned him to design a façade for the still unfinished church (H. 241 b), the Congregation of the Church of the Steccata, Parma, approached him (H. 224–233) and so did the Bishop of Verona, for whom he designed the frescoes for the apse of the cathedral in 1534. He also served his master on these journeys: he purchased Indian peacocks and took over the busts Federico had commissioned from the sculptor Alfonso Lombardo (H. 202).

He had meanwhile married (2 June 1529), and had three children, two girls Criseide and Virginia and a boy called Raffaello, after his master; he lived in a splendid house which he had built himself and which is still partly preserved. It was there that he entertained Vasari on his visit and showed him his rich collection, some of which—like Dürer's self-portrait—he had inherited from Raphael. Even the tone of the Duke's letters changed markedly in the last few years; *Maestro Julio nostro charissimo* (our dearest Master Giulio) is now the form of address (H. 222).

It was as a church architect that Giulio rose to fame during the last six years of his life when Cardinal Ercole Gonzaga took over the direction of the state on the death of Federico in 1540. He commissioned Giulio to remodel the church of the monastery San Benedetto al Polirone and what is left of it inspires much respect for Giulio's architectural skill and tact.[18] Early in 1545 Giulio was also asked to submit a detailed plan for the renovation of the Duomo of Mantua. We do not know how much of this plan was carried out in the few remaining months of Giulio's life, but there can be little doubt that the highly original and successful transformation of the Romanesque interior into a splendid Renaissance building still bears the mark of his genius. It was at this juncture that Giulio received the invitation to take over the building of St Peter's in Rome after the death of Antonio da Sangallo.[19] Who knows whether it would have been crowned with Michelangelo's cupola if he had accepted? That he hesitated to shoulder such a burden is understandable. Maybe his health played a part in this decision. As early as 24 December 1537 (H. 199) he complained in a letter that his eyesight suffered so much from endless bleedings and drugs that he could only work with difficulty by candlelight. In February 1545 according to Aretino rumour had spread that he was dead. In the summer of the next year we hear that he suffered from fever and stomach-ache but there was no need for worry (H. 242). However, on 15 September 1546 he writes to Ferrante Gonzaga that he expects his illness to get worse.[20] Six weeks later, on 1 November 1546, the Register of Deaths shows the entry 'Died today, Messer Giulio Romano di Pippi, Overseer of the Ducal Buildings . . . of fever . . . aged 47' (H. 244).

The letter from the Cardinal, dated 7 November, to his brother Ferrante (H. 245) merits reprinting in full as a fitting memorial.

The most grievous loss of our Giulio Romano hurts me so much that I seem to have lost my right hand. I would not have cared to inform your Excellency so quickly if I did not think that the later one hears of such a loss the worse it is, particularly since he was engaged in the purification of the water.

Like those who seek always to extract something good from any evil, I tell myself that the death of that rare man will at least have helped me by ridding me of the appetite for building, for silverware, for paintings, etc., for in fact I would not have the heart to commission anything of this kind without the designs of that fine mind; hence as soon as a few things, for which I possess his designs, have been finished I want to bury all my desires with him; as I said. May God give him peace, which I hope He certainly will, for I knew him as a good and very pure man, as far as the world is concerned and I hope also in the eyes of God. With tears in my eyes I can never have enough of speaking of his achievements, and yet I must stop since it has pleased Him who governs all to put an end to his life.

It is well known that Giulio Romano is the only artist of the Renaissance whose name occurs in Shakespeare's works. The passage from Act V, Scene 2, of *The Winter's Tale* is here reproduced in the spelling of the First Folio:

The Princesse hearing of her Mothers Statue (which is in the keeping of *Paulina*) a Peece many yeeres in doing, and now newly perform'd, by that rare Italian Master, *Iulio Romano*, who (had he himselfe Eternitie, and could put Breath into his Worke) would beguile Nature of her Custome, so perfectly he is her Ape: He so neere to *Hermione*, hath done *Hermione*, that they say one would speake to her, and stand in hope of answer.

It has long been observed that the eulogy here applied to Giulio as a rival of nature may well derive from the use which was made of this formula by one of Vasari's humanist helpers who supplied him with a fictitious epitaph of the master at the end of his *Vita* of 1550:[21] 'Jupiter saw sculpted and painted bodies breathe and the dwellings of mortals equal heaven through the skill of Giulio Romano. Hence he was angered and having summoned a council of all the Gods carried him off from the earth, since he could not tolerate being vanquished or equalled by an earthborn man...'

Whoever wrote these lines skilfully fused two motives appropriate to the artist. The first stems from the real epitaph of Giulio's master Raphael in the Pantheon in Rome, penned by Bembo: 'This is Raphael's tomb, when he lived it was mother nature's fear to be vanquished by him, and when he died, to die too.' The second, of course, alludes to Giulio's most famous work, the Sala dei Giganti, which, after all, represents the theme of Jove calling the council of the Gods to punish the giants for attempting to scale

heaven. If Shakespeare had seen the epitaph in Vasari, moreover, he might well have inferred from it that Giulio was a sculptor whose statues deceptively resembled life (*Videbat Iuppiter corpora sculpta pictaque spirare*).

There is no need, therefore, to fall in with Hartt's ingenious proposal to link Shakespeare's reference to a Bolognese master of painted stucco reliefs mentioned in a document, who may have been a namesake of our Giulio Romano.[22]

What appears not to have been noticed is the fact that *The Winter's Tale* is not the first play in which high praise is lavished on Giulio Romano.[23] A precedent was set by Pietro Aretino's comedy *Il Marescalco* which was published in Giulio's lifetime in 1533.[24] Aretino was fond of boosting the reputation of his friends by having them mentioned on the stage. *Il Marescalco* is set in Mantua and features among its *dramatis personae* a comic pedant somewhat reminiscent of Holofernes in *Love's Labour's Lost*. In Act IV, Scene 5, of the comedy, one Messer Jacopo addresses the Pedant thus: 'Master, let us walk as far as San Bastiano, in other words to the Te, to see if Giulio Romano will have unveiled some divine painting.' *Pedant*: 'Let us proceed. Oh what fine structure is that palace which has issued from the architecture of his exquisite model: he has imitated Vitruvius, the ancient perspectivist.'[25] Clearly the passage served Aretino in two ways. He praised his friend for the work that was in progress at the time, and he made ample fun of the affected jargon used by the Pedant in pretending to be a connoisseur of architecture.

In Act V, Scene 3, the Pedant also wishes to show off his knowledge of painters and painting and again includes Giulio: 'If [we refer to] painters there is Titian, the rival of nature and indeed her master, and certainly there will be the most divine Fra Sebastiano of Venice [Sebastiano del Piombo]. And maybe Julio Romano nursling of the court and of the Urbinate Raphael.'[26] The conventional praise Shakespeare was to use later is here applied to Titian rather than Giulio.

What makes these precedents particularly suggestive is the fact that *Il Marescalco* was reprinted in London in 1588, together with three other comedies by Aretino, by that busy Elizabethan printer John Wolf.[27] Thus not more than twenty-three years separate that edition and the first performance of Shakespeare's play in around 1609/10. Any member of the theatrical world whose curiosity was aroused by Aretino's references might have come across the eulogy in Vasari's edition of 1550 and combined them into the image of 'that rare Italian Master'—or could it have been Shakespeare himself?

Architecture and Rhetoric in
Giulio Romano's Palazzo del Te

The Palazzo del Te, which figures in the preceding survey of Giulio Romano's work in the service of the Gonzaga, is a characteristic product of its time. Its function seems to have been from the beginning to entertain and to impress. Hence Giulio pulled out all the stops to create those *bizarrie* which his predecessor Leonbruno had promised in vain.[1] Flimsy as the structure really is, it is intended to give the impression of a heavily rusticated stone building (Figs. 149 and 150), a design which incorporated some of Giulio's most notorious surprise effects such as the triglyphs in the entablature of the courtyard (Fig. 151) which appear to wait for the mason's hand to be put into place. A similar striving for variety and effect also dominates the frescoed rooms of the palace, with the portraits of horses in the Sala dei Cavalli (Fig. 152), the sensual mythologies of the Sala di Psiche (Fig. 153), the austere simulated marble reliefs of the Sala di Stucchi (Fig. 154) and the climax of it all—the Sala dei Giganti (Fig. 148), where the walls seem to be crashing down on the unsuspecting visitor.

No wonder that this *plaisance* aroused very different reactions in different visitors. The tourists of the nineteenth and early twentieth centuries who came to Italy in search of beauty largely passed it by. It was only after the First World War that interest began to focus on the post-classical style of the late Renaissance known by the dismissive term of 'Mannerism'.[2] It was felt that a kinship must exist between the psychological *malaise* that pervaded the modern movements and the shrill effects of Mannerist art. When, in the early thirties of this century, I made the palace the centrepiece of my doctoral dissertation on Giulio Romano's architecture[3] I certainly stood under the spell of this fashionable interpretation, though as I have explained elsewhere my work in the Gonzaga archives soon weaned me of the idea that this art was a manifestation of a profound spiritual crisis.[4] Still, what I saw and stressed

A lecture given in Mantua in August 1982

149. Palazzo del Te, 1527–34, Mantua

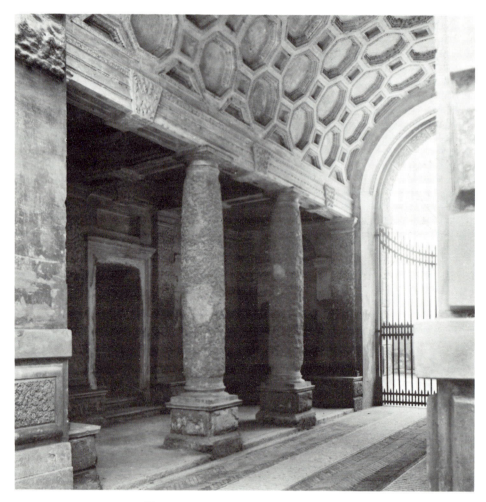

150. Entrance arch, 1532, Palazzo del Te, Mantua

was the contrasting effects Giulio liked to employ of unexpected dissonances and cool classical forms. I was particularly interested at the time in the psychological significance of both these modes of expression, equating the oppressive forms and cruel imagery with the tendencies of Mannerism, and the detached reserve with a Neo-classical trend, symptomatic of the master's inner conflicts.

Returning to the palace after the war I wondered whether I had not taken it too seriously, and was glad that I had at least paid some attention to the

151.Courtyard façade, *c.*1532, Palazzo del Te, Mantua

152. Sala dei Cavalli, 1527–8, Palazzo del Te, Mantua

153. Sala di Psiche, 1528, Palazzo del Te, Mantua

social conditions in which it took shape.[5] Not that this aspect would necessarily disprove my psychological interpretation—after all when Diaghilev said to Cocteau '*étonnez-moi*' the artist so addressed was bound to search his own mind and his own nightmares for surprise effects. But with the accumulation of new evidence in the form of drawings and documents showing that the building had been much altered in the course of the centuries, I preferred to leave it to the next generation to re-interpret this Renaissance 'folly'.

Yet, having read more recent publications[6] with interest and profit, it seemed to me a pity that the contemporary texts I had used in my thesis should be buried in the ruins of my early interpretation, and it is to these texts that I propose to return here, since I believe that they still demand to be considered. I refer most of all to the passage in the Fourth Book of Sebastiano Serlio's treatise on architecture in which he speaks of our palace.

It was the habit of the ancient Romans to mix the rustic style not only with the Doric but also with the Ionic and the Corinthian orders. Thus it will not be a mistake to make such a mixture with one of these styles representing in this way partly a work of nature and partly the work of the craftsman; because the columns bound by rustic stone, and also the architrave and the frieze interrupted by the columns, show the work of nature, but the capitals and part of the columns and also the cornice with the pediment represent the work of the human hand and this mixture is in my opinion very pleasing to the eye and shows great strength . . . and Giulio Romano has taken more delight in this mixture than anyone else, witness various places in Rome and also in Mantua, that most beauti-

ful Palazzo del Te, not far outside that city, truly a model of architecture and of painting for our age.[7]

It seems to me that the importance of that comment has not been diminished by the interesting discovery that the eighteenth-century restorers frequently exaggerated the roughness of the rustic. Given Serlio's interpretation of the rustic as the work of nature I ask myself whether he had not heard it from Giulio's own lips. Clearly he had seen the palace, is it not likely that he also talked about it with its architect?

In Serlio's opinion the mixture with the rustic 'is very pleasing to the eye and shows great strength'. Another text by Serlio which I quoted in my dissertation allows us to go further still. I refer to the passage in the Munich manuscript where he describes the doorway of a Roman camp in Dacia: 'This is the main doorway of the encampment... It is composed of the Corinthian Order mixed with the rustic to demonstrate metaphorically the tenderness and pleasantness of the Emperor Trajan in forgiving and his robustness and severity in punishing.' Elsewhere in the same manuscript he says that 'The encampment had two gateways of extreme difference in workmanship. The one in the rustic style was on the side where the barbarians were more ferocious... and the other of Corinthian workmanship was on the side towards Italy.'[8]

There are not many observations of this kind in the sixteenth-century treatises on architecture. Where do they come from? Here Serlio names his informant as Marco Grimani, the Patriarch of Aquileia. It is easy to see that the Patriarch owed this way of looking at architecture neither to Vitruvius nor

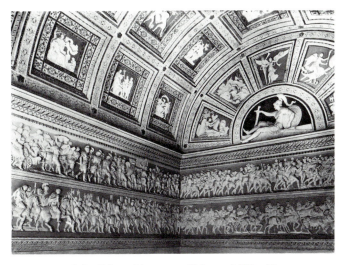

154. Sala di Stucchi, *c.*1530, Palazzo del Te, Mantua

to Alberti. He must have derived it from the theory of rhetoric.[9] It was in the ancient treatises on oratory that the Renaissance scholar learned how to throw a bridge between form and meaning, between sense impression and the expression of emotion. It was a fundamental axiom of ancient rhetoric that there should be a correspondence between the sound of a statement and its meaning.

The closest parallel to the interpretation which Serlio owed to Grimani can be found in the treatise by Dionysius of Halicarnassus, *De collocatione verborum*, where the ancient author speaks of the impression of strength that can be achieved through the absence of polish by means of hard and even harsh sounds, and where he compares these effects with the roughness of primitive buildings. The austere style demands the arrangement of words in an abrupt way 'not unlike those ancient buildings made of uncut square blocks, not even arranged at right angles, which give the impression of an improvised piling-up of rough stones'.[10]

One cannot be sure that Grimani had these very words in mind, though they were printed by Aldus Manutius in Venice in 1508 in a collection of Greek rhetorical texts. In any case that aesthetic doctrine which Dionysius illustrated with the help of architecture occurs frequently in ancient treatises on oratory. Demetrius in his treatise *On Style*, which was also printed in the same edition, teaches that an excessively polished composition does not suit a strong language, but that dissonant sounds contribute to the vigour of a speech. Words which occur to the speaker at the moment, especially in a moment of rage, are more effective than an excessive care for form and harmony.[11]

The same idea is ventilated in a text which was much better known, *The Orator* by Cicero, but here there is a slight shift of emphasis. Where Cicero talks about his favourite subject, the distinction between the three styles of speech, he begins by explaining the character of the humble style. What characterizes that style is a certain artlessness; all the tricks of oratory such as rhythm and euphony must be discarded. While it was an accepted rule of style to avoid the *hiatus* and the *concursus*, that is the clash of vowels or other dissonances, Cicero admits that in this particular case such errors can contribute to a pleasing impression of negligence. It is true that he adds significantly that there exists such a thing as a calculated negligence (*sed quaedam negligentia est diligens*). Just as certain women are more beautiful without adornments, so a simple and indeed careless style gives pleasure (*subtilis etiam incompta oratio delectat*).[12]

What Cicero stresses in the aesthetics of the natural and the artless is not so much its vigour as its pleasing character. It is well known that the praise

of cultivated negligence was elaborated by Baldassare Castiglione in one of the most famous passages of *The Book of the Courtier*, his praise of *sprezzatura*, which means literally disdain.

Castiglione's starting-point is the conviction that what must be avoided at all costs is affectation. 'Hence it can be said that the true art consists in not looking like art.'[13] The consequences which Castiglione derived from this maxim are well known. Speaking of music he reminds his readers that pure harmony can also displease, while certain dissonances are delightful. As to painting 'it is said that it was proverbial among some of the best painters of antiquity that too much application can be harmful and that Apelles censured Protogenes because he did not know when to take his hand off the panel.' He adds from his own observation that 'frequently in painting a single effortless line, a single brushstroke drawn with facility in such a way that the hand has moved by itself according to the painter's intention without being guided by any study or skill, clearly reveals the excellence of the artist. Anybody can apply this observation according to his own judgement and the same is true of all other matters.'

Among the 'other matters' there was certainly architecture. I have said that Serlio may have had contact with Giulio. I can repeat with much more certainty that Giulio Romano must have frequently talked to Baldassare Castiglione. When Giulio introduced in his work the idea of the 'unfinished' he developed, I believe, another form of intentional negligence.

I agree with the opinion of those authors who maintain that in his playful use of the unfinished as a form of negligence Giulio made a virtue of necessity. The whole procedure of the construction of the palace forced him to improvise and what better solution could he find than to combine the reality of improvisation with the appearance of a deliberate disdain of pedantic rules. There is no contradiction here between these ideas and those of Serlio, because what the 'disdain' really signifies is the virtue of naturalness rather than artifice.

But it seems to me important to emphasize that licence ceases to be licence if there are no rules to contravene. In architecture no less than in rhetoric there is an enormous difference between being ignorant of the rules and breaking them intentionally. In other words, the desired effect depends on the perceptions of a public that can appreciate the deviation from the rules.

I no longer believe that Mannerism can be called an anti-classical style, but one cannot doubt that it was a post-classical style which is, in a sense, parasitical on the classical. In my dissertation I also quoted Serlio's testimony on that point. In his *Libro extraordinario*, which contains rather bizarre designs for portals (Fig. 155), he defends himself against the insinuation that he did not know the classical rules and writes:

I must tell you, honoured reader, why I have frequently been so licentious. I know that the majority of people are mostly desirous of new things and that many of them want in every little work they commission to place inscriptions, coats of arms, reliefs, ancient or modern portraits and similar things. It is for that reason that I have indulged in these licences, frequently breaking an architrave or a frieze, or the cornice, but always relying here on the authority of some Roman buildings... I have rusticated columns and pilasters and sometimes interrupted the friezes... but if you remove these features and replace the cornice where it is broken or complete the columns which are incomplete the design will remain intact and in its pristine shape.[14]

It can hardly be denied that the existence of these rules provoked ambivalent feelings among certain artists of the period. After all, there is evidence of this reaction in a famous passage of Vasari, himself an architect of the sixteenth century and born only twelve years after Giulio, for whom he had a profound admiration. I refer to the famous words of praise for Michelangelo's New Sacristy of San Lorenzo, Florence: 'For the interior he designed a decoration composed in a style of greater variety and greater novelty than any ancient or modern masters had been able to create up to that time.'[15]

155. Sebastiano Serlio: Gateway in a mixture of orders. From his *Libro extraordinario*, 1551.

After praising the novelty of the architectural elements Michelangelo had designed Vasari continues:

> He made them rather different from those which people had made so far who followed the measurements, the orders and the rules generally in use according to Vitruvius and the antique... This licence has much encouraged those who studied his work to imitate him, and new imaginative work resulted... Hence, artists owe him an infinite and eternal obligation for having broken the fetters and the chains which had forced men constantly to follow the common road.

What interests me most in this passage is not so much the praise Vasari bestowed on the master he so much admired as his hostility to the 'fetters and chains' imposed by Vitruvius and the ancients. Could one imagine Giuliano da Sangallo or Bramante rebelling in this way?

It certainly was an anachronism to equate the so-called Mannerism with the artistic situation of the early twentieth century, but today, after that distance of time, it is not hard to see how this anachronism arose. What the two periods have in common is a certain loss of innocence for which even naturalness becomes an artifice.

When I wrote my dissertation I ventured to go further still: I suggested that the ambivalent feelings towards rules and conventions were not confined to the sphere of art. I referred to the impassioned words of Torquato Tasso in the *Aminta*, where he deplores the loss of pristine innocence and the tyranny of honour:

> O lovely Golden Age, not just because the rivers flowed with milk and the woods were rich in honey ... But only because that vain word without meaning, that idol of errors, idol of deceit, which by the vulgar insane was later called *honour*, that tyrannized over our nature, did not mix its sufferings among the sweet joys of the amorous youth; nor was its hard law known to those minds grown up in liberty; but their golden and happy law was the one Nature herself had inscribed: 'If it pleases it is permitted' ... It was you, Honour, who first threw a veil over the fount of delight ... Go from here and disturb the dream of the illustrious and powerful: Let us, the neglected and lowly crowd, live without you in the manner of the ancient people.[16]

Was this really what Tasso thought? Yes and No. We must not make the mistake of confusing art with life. The chorus which I quoted is part of a dramatic work and Tasso, being a great poet, here expresses sentiments with which we are all familiar. You might call it rhetoric, since every playwright

must be a master of rhetoric. I believe that what art historians sometimes overlook (and this applies also to my own dissertation) is precisely that dramatic and rhetorical dimension. When we speak of the meaning of a work of art we need not think that the work was intended to proclaim a truth.

In accordance with the trends of our time the most recent studies of the palace have been particularly concerned with its political meaning. Thus Professor Forster's interesting observations drawing attention to the similarity between the imperial palace represented in a mosaic at Ravenna and the Garden front of the Palazzo del Te have prompted him to interpret the whole of the building as a propagandist celebration of the imperial power or at least the imperial aspirations of Federico Gonzaga.[17] Professor Verheyen has gone further still and has interpreted the greater part of the pictorial decorations of the interior as political propaganda.[18]

But what is propaganda? *Propaganda Fides* means the work of spreading the faith and of converting the pagans. Propaganda is tantamount to an effort to influence public opinion. The typical instruments of propaganda are sermons for the masses and the popular press. You do not make propaganda by means of a garden façade or frescoes in private cabinets. I believe that we use this term too freely if we want to say that the Gonzaga desired to persuade anyone of their political power by their palaces. No one who had inside knowledge of the game of politics would have allowed himself to be so easily influenced.

But rhetoric is not always intended to persuade. Rhetoric does not claim to speak 'the truth and nothing but the truth'. *Aliud est laudatio, aliud est historia* (praise is one thing, history another) said Bruni.[19] In the game of rhetoric one could compare the ruling prince to Jove and his mistress to Venus and could do so easily because reality did not enter. What we can learn from the parallel with rhetoric is to respect the autonomy of art. The Palazzo, its architecture and its frescoes take us into an unreal world, much as did the festivals and spectacles of the time. If we place too much weight on these rhetorical fictions we make them dissolve.

'The painter', said Plato, 'makes a dream for those who are awake',[20] not his personal dream and even less his private nightmare, as I once believed. What counts is the power of the imagination to leave empirical reality behind. I certainly would not deny that a link must exist between the creation and its creator, just as there must be some relation between the position of the patron and his taste in art. Giulio Romano was no Raphael and Duke Federico was no Agostino Chigi. But today it seems to me that what mattered is the existence of a world of art, a world of dreams, a universe created for our delight.

Michelangelo's Cartoon in the British Museum

The British Museum possesses among its countless treasures a life-size cartoon by Michelangelo (Fig. 156), dating from the master's old age, which is usually displayed just inside the entrance of the Department of Prints and Drawings.[1] It shows the Holy Virgin in the centre with the Christ Child nestling between her legs on the ground, but of the other figures represented only the little St John, marked by his lambskin, can be immediately identified. The rest of the group is not easily deciphered because the surface is rubbed and there are a number of *pentimenti* among both the completed and the incomplete sections. The reading, however, is facilitated by the existence of a painting (Fig. 157) clearly based on this cartoon. There is no doubt that it is to this painting that Vasari referred in the second edition of his life of Michelangelo where he speaks of Ascanio Condivi, the author of the most reliable biography of Michelangelo which Vasari had unscrupulously plagiarized:

> Ascanio della Ripa Transone [Condivi] took great trouble, but one could not see any result either in his finished works or in his drawings. He laboured several years on a panel for which Michelangelo had given him the cartoon. In the end the great expectations one had of him vanished in thin air. I remember that Michelangelo felt so sorry for his hard work that he assisted him with his own hands but it was of little use.[2]

It must be admitted that the painting now preserved in the Casa Buonarroti is particularly unattractive and that its subject-matter is as unclear as is that of the original design after which Condivi worked. Strangely enough the interpretation of this group has been made more difficult rather than easier by the fact that it was given a name in a document immediately after Michelangelo's death. It is listed among the works of the master given to the notary who acted for him in these words: 'Another large cartoon with the drawing

Not previously published

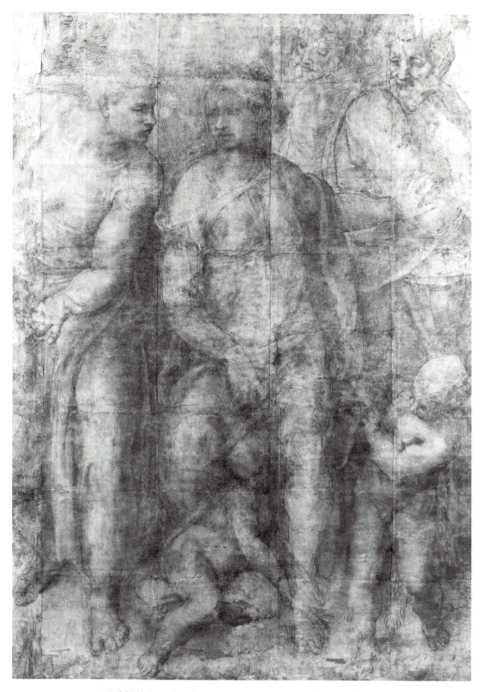

156. Michelangelo: *Cartoon*, c.1560. London, British Museum

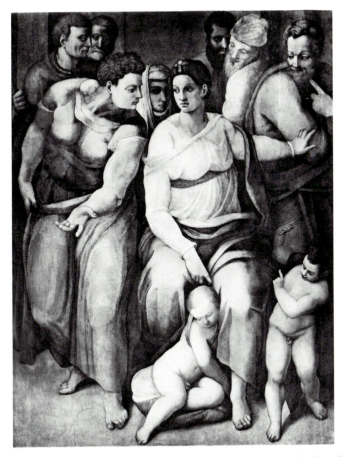

157. Ascanio Condivi after Michelangelo: *Holy Family*, c.1560. Florence, Casa Buonarroti

of three large figures and two boys, called *Epifania*.'[3] Epiphany, of course, is the name of the feast of the Adoration of the Magi and so it is natural that historians tried to account for the enigmatic group of the cartoon (and the panel) in terms of this traditional subject-matter. It can be said without fear of contradiction, however, that none of these ingenious efforts was at all convincing. It is for this reason that I suggested some time ago[4] that the word '*Epifania*' mentioned in the document as the name of the cartoon did not refer to the feast but to the Greek church father Epiphanias.

Once a hypothesis can be confirmed it is rarely of much interest to be told how it was arrived at. If I still venture to explain this case of serendipity I do so because it illustrates the role which coincidence plays in our type of research. I was not looking for a solution and could never have found it by systematic research, particularly as Greek patristics is a closed book to me. But turning the pages of Johannes Wilde's catalogue of Michelangelo's

drawings in the British Museum and reading his entry in which all the docu-
ments are quoted, there floated into my mind the title of an article I had
read as a student at a time when I was interested in the application of psycho-
analysis, the title 'Der heilige Epiphanias verschreibt sich' (A Freudian slip
in the writings of St Epiphanias), which is included in the book by Theodor
Reik, *Der eigene und der fremde Gott* (The God of one's own and the God
of others), published in Vienna in 1923.

The unintentional and revealing 'slip' which Reik (rightly or wrongly) attri-
butes to the Saint occurs in the course of a savage attack on a sect of Christians
who did not believe that Mary remained a virgin after the birth of Christ.
The reason for this belief, which Epiphanias counted among the eighty heresies
he had set out to 'cure' in a weighty book entitled *Panarion* (The Medicine
Cupboard),[5] is easily explained; there are a number of passages in the Gospels,
in the Acts of the Apostles and in the Epistles which refer to brothers and
sisters of Christ, some of them even by name.[6] The most explicit of these
is the account in Matthew XIII, 54–6 (and Mark VI, 3):

> And when he came into his own country, he taught them in their
> synagogue, insomuch that they were astonished, and said: 'Whence has
> this man this wisdom, and these mighty works? Is not this the carpenter's
> son, is not his mother called Mary? and his brethren James, and Joses
> and Simon and Judas? and his sisters, are they not with us?

Given the overriding importance which was attached to virginity, particu-
larly among the ascetics, these references could not but be a stumbling-block
to those teachers who propagated the cult of Mary as a perpetual virgin. It
is perhaps not surprising that the polemics which this issue aroused attracted
the attention of a psychoanalyst because it inevitably centred on the question
whether Mary led a normal married life with Joseph after the birth of her
first-born. Both St Jerome and, as we have seen, St Epiphanias rejected this
insinuation with horror, but their way out of the problem posed by the explicit
text of the scriptures differed. St Jerome took a philological line.[7] He insisted
that the Greek words *adelphoi* and *adelphai* used by the Evangelists need not
necessarily mean brothers and sisters but could also mean cousins. There
was no objection to Christ having had cousins. Epiphanias in the treatise
which concerns us proposed another solution. He insisted (without mentioning
the source of his knowledge) that Joseph was a widower of eighty years when
he married Mary, and therefore too old to beget children; the brothers and
sisters mentioned in the Bible came from his earlier marriage and should
therefore be described as Christ's half-brothers and half-sisters. To think other-
wise was to pollute the reputation of Mary, though Reik maintained that

in the course of his excited expostulations Epiphanias at one point wrote the opposite of what he wanted to say, thus giving away his unconscious qualms about this unlikely explanation.

According to Epiphanias,[8] then, the Holy Family consisted of Mary, Joseph, the Christ Child and six grown-up half-brothers and sisters, four males called James, Joses, Simeon and Judas, and two females, Mary and Salome.[9] There are certainly four male heads visible in the background of Condivi's painting, which can also be discerned in the background of the cartoon. There is one head of a woman next to that of Mary in the painting which Michelangelo appears to have planned and there is a curious gap which may well have been intended to accommodate yet another female head. If this identification looks somewhat forced, the argument seems to be clinched by the strange gesture of the Virgin, who is represented pushing St Joseph away as he looks at her with love or longing. There could be no clearer way of indicating the doctrine to which Epiphanias attached such importance, the doctrine that Mary never had intercourse with Joseph. Once we see the group in this light we may also notice the strange ambiguity of the gesture of Mary's right hand and her relation to the Christ Child, whom she appears to be holding by a leading-string.

Admittedly there are still many puzzling features in this composition, which Michelangelo appears to have altered several times. Who is the person at Mary's right, is it male or female? Is it pointing or arguing? Something in Michelangelo's own cartoon recalls the subject of the Annunciation with the angel approaching the Virgin and one feels almost tempted to think of such a starting-point since the subject much engaged his mind during the last years of his life, but it would be difficult to square this interpretation with that of the other figures. Could the figure indeed represent the missing sister, Salome? Could Condivi have so interpreted her since Michelangelo had failed to indicate her sex? At any rate, it looks as if Condivi had turned Michelangelo's feminine personage into a man, however ambiguous the indications may be.

It may well be, however, that another document which has also been known for a long time points the way to a solution: by the end of the sixteenth century the cartoon had entered the collection of Fulvio Orsini, Canon of S. Giovanni in Laterano (1530–1600), where it is described in an inventory as 'A cartoon with a Madonna and a St Julian and other figures by the hand of Michelangelo',[10] a description which understandably puzzled Johannes Wilde.

There are several saints of that name in the calendar of the Church, but there is one whose presence in the group may offer an important clue. He was a martyr who is worshipped together with S. Basilissa, both being

renowned for their chastity, having led a virginal life together.[11] Now it turns out that there is a reference to Julian and Celsus as the patrons of the chapter of S. Giovanni dei Fiorentini in Rome. That church of the Florentine colony in Rome, which is situated on a triangular plot between the Via Giulia and the Tiber, has a complicated history.[12] An earlier oratory was to be turned into a church in 1520 by Jacopo Sansovino, who was followed by Antonio da Sangallo the Younger, but the funds ran out and only in late October 1559 did the Florentine colony decide to continue the construction. It was then that they consulted Michelangelo, now eighty-four years of age, who submitted a number of drawings.[13] Michelangelo's assistant Tiberio Calcagni executed measured drawings and a clay model and later supervised the construction of a wooden model. By June 1562 Calcagni had been replaced by another official and after that we hear no more of Michelangelo's participation.

The date assigned by Wilde to our cartoon (between 1546 and 1550) is admittedly earlier than this episode, but there is no solid evidence that would prevent us from moving it even closer to the last years of the master's life. If St Julian was indeed one of the patron saints of the chapter of the Florentine church this would explain the commission and the circumstances under which Condivi endeavoured to turn the cartoon into an altar painting for the church itself or for the chapter.

It is worth quoting the text of the legend[14] to illustrate the emphasis placed on the theme of chastity which we also encountered in Michelangelo's cartoon.

St Julian was born in Antioch, the capital of Syria, as the son of noble and God-fearing parents, who devoted much care in educating him in the fear of the Lord and the love of His most sacred Name. When he had reached the age of eighteen, and they saw that he was ready to establish himself in the world and thus to become the support of their old age, they urged him to get engaged to marry. At first this request caused St Julian much pain, for on the one hand, having already made the vow of perpetual continence, he did not want to do anything that would prejudice his promise, on the other hand he feared to disobey his parents in a matter they desired of him. He asked for a week of grace to reflect on his choice and to commend the matter to the Almighty, and throughout that time he devoted himself to prayers imploring with all his heart the help of Divine Goodness. On the seventh day Our Lord appeared to him and asked him to obey his parents, for He would assist him by seeing to it that the person he chose as a wife would conserve her virginity together with him and that both of them would be the occasion of salvation

for several others; after that He touched with His hand the face of Julian, who remained profoundly consoled by that vision. Relying wholly on God's promise, he no longer raised any difficulties to marry a young girl called Basilissa whom his parents had introduced to him. The Divine Lord did not break the word He had given to His servant, for in the very wedding night, when the married couple retired to their chamber, where they began their conversation with a prayer, Basilissa smelt a very pleasant odour, like that of roses, carnations and lilies, though these were not in season, as it was winter. Delighted by that surprising matter, she asked her husband what it signified, and after Julian had replied that it was the agreeable odour of chastity which God gave as a foretaste of the pleasures of paradise, and which He held ready for those who, for the sake of His love, conserved their bodies pure and immaculate before His Majesty, Basilissa was also persuaded to make with him the vow of preserving her virginity in their marriage.

The legend goes on to tell of the miraculous light that began to fill the chamber, of two choirs of male and female saints led by Christ and the Virgin respectively, who sang their praises, and of further apparitions placing a wreath on their heads, and of their names being inscribed in a book in golden letters.

Clearly, the saint who abstained from consummating his marriage would form a fitting companion to the group of the Holy Virgin restraining St Joseph. As matters stand, this can only be speculation. It would be reassuring if a document were found concerning the existence of an altar dedicated perhaps to 'Maria the Perpetual Virgin and St Julian'. If such an altar was ever set up Condivi's panel was certainly not placed upon it and in any case the arrangements and dedications of the altar in the church were thoroughly changed early in the seventeenth century, so that no trace of any such project can have survived.

Certainly, it would have been an unusual project without iconographic precedent, but then the group is undeniably unusual. The only remote precedent which can be cited are representations of the so-called Holy Kin showing the Virgin and St Joseph with all the relations legend had come to assign to them, but this tradition is much more at home in the North than in Italy.[15] What may be called the message or the theological content of the group, however, would not be in any way unusual. The cult of Mary had always stressed her character as a virgin; after all, it was to enable the faithful to address her as such that St Jerome had reassured them that the brothers and sisters of Christ mentioned in the Gospels were cousins. But he also knew that this solution could not rule out the possibility that St Joseph had lived

with her in a normal marriage after the birth of Christ. It was here that the story told by St Epiphanias was undeniably superior, as he meant it to be. The writings of this unusually intolerant theologian were unknown to the Middle Ages, but they were accessible to the Roman Church in the sixteenth century and occasionally referred to during the Council of Trent.[16] It would have given an extra emphasis to the cult of the chaste St Julian to link him with the Virgin Mary as described by St Epiphanias. But this did not quite solve the problem for the artist asked to carry out such a commission, for though he could show the other version of the Holy Kin by surrounding the figure of the Virgin with her grown-up step-children it was less easy to indicate that her husband Joseph was a husband only in name. It was no doubt for that reason that Michelangelo introduced that harsh and violent gesture of the Virgin pushing Joseph away. It looks as if this gesture had been an afterthought, but it alone carried the message.

That this message would have appealed to Michelangelo we know. The same Condivi who laboured so pathetically in translating the cartoon into a painting tells us in his biography of Michelangelo, published in these very years (1552), what Michelangelo himself thought and said about this question. He had mentioned to the master that some people had criticized his Pietà in St Peter's in Rome since in this group the mother looked younger than her son.

> One day, when I talked about this with Michelangelo he replied: 'Don't you know that chaste women preserve the bloom of youth much longer than those who are not chaste? How much more must that be true of a virgin who has never for a moment succumbed to the slightest lascivious desire that would corrupt her body. I would go even further and say that this freshness and bloom of youth, as well as being preserved in the natural way, was in her case quite believably assisted by Divine inter-vention in order to prove to the world the virginity and perpetual purity of that mother ... and therefore we should not be surprised if, for this reason, I made the Holy Virgin, Mother of God, appear very much younger in comparison to her son than would normally be required by someone of that age ...'[17]

This strongly held conviction might explain the reason why the aged master allowed himself to be persuaded to accept a commission for an altar painting destined for the Florentine colony in Rome with such an unusual design show-ing the two patron saints of the church, St Julian and S. Giovanni, flanking an unprecedented group of the Holy Family with Mary *Virgo Perpetua*.

Notes

GIOTTO'S PORTRAIT OF DANTE?

1. *Tom Phillips, Recent Paintings, Water-colours and Drawings*, Catalogue, Marlborough Fine Art (London) Ltd., 1–27 February 1978.
2. The MS is thought to have been produced in Zürich between 1314 and 1330. See Ewald Jammers, *Das königliche Liederbuch des deutschen Minnesanges*, Heidelberg, 1965.
3. Peter Brieger, Millard Meiss, Charles Singleton, *Illuminated Manuscripts of the Divine Comedy*, 2 vols., Princeton, 1969.
4. The main monograph is Richard Thayer Holbrook, *Portraits of Dante from Giotto to Raphael*, London, 1911. See also G. L. Passerini, *Il Ritratto di Dante*, Florence, 1921; Carl Frey, *Die Loggia dei Lanzi zu Florenz*, Berlin, 1885, pp. 56–8; Frank Jewett Mather Jr., *The Portraits of Dante compared with the measurements of his skull*, Princeton, 1921; Fabio Frassetto, *Dantis Ossa, La forma corporea di Dante*, Bologna, 1933; Oskar Wulff, 'Das Dante Bildnis' in *Kunstchronik und Kunstmarkt*, XXXII, 1921, pp. 909–12; A. D'Ancona, 'Il vero ritratto giottesco di Dante' in *La Lettura*, Milan, 1901, pp. 203–8. For further references see the bibliography of the Bargello frescoes in note 11 below.
5. *Le Vite*, ed. G. Milanesi, I, 'Commentario alla Vita di Giotto', Florence, 1878, pp. 413–22. The author had previously voiced his doubts in 'Lettera al Ministro della Pubblica Istruzione' in *Giornale del Centenario di Dante*, 1865, 17, 37, 38, to which he refers.
6. *Le Vite*, ed. G. Milanesi, I, p. 373.
7. H. Keller, 'Die Entstehung des Bild-nisses am Ende des Hochmittelalters' in *Römisches Jahrbuch für Kunstgeschichte*, III, 1939, pp. 227 ff.
8. R. T. Holbrook, op. cit., note 4, pp. 73 ff. A detailed account is also in J. A. Crowe and G. B. Cavalcaselle, *A New History of Painting in Italy*, London, 1864, pp. 259–70.
9. Franz Adolf von Stürler (1802–81) lived in Florence from 1831 to 1853.
10. J. von Schlosser, *Lorenzo Ghibertis Denkwürdigkeiten (I Commentarii)*, 2 vols., Berlin, 1912, Vol. II, p. 36.
11. For the fullest discussion with illustrations and bibliography see Giovanni Previtali, *Giotto e la sua bottega*, Milan, 1967 and 1974, pp. 335–40. See also I. B. Supino, *Giotto*, Florence, 1920, pp. 229–43; C.-A. Isermeyer, *Rahmengliederung und Bildfolge in der Wandmalerei bei Giotto und den Florentiner Malern des 14. Jahrhunderts*, Würzburg, 1937, pp. 27 ff. For others see Roberto Salvini, *Giotto, Bibliografia*, Rome, 1938; Cristina de Benedictis, *Giotto, Bibliografia*, Vol. II, 1937–70, Rome, 1973.
12. Millard Meiss, op. cit., note 3, pp. 40–1.
13. C.-A. Isermeyer, op. cit., note 11.
14. Crowe and Cavalcaselle, op. cit., note 8. Like Milanesi, Cavalcaselle had first proposed his theory in 'Lettera al Ministro della Pubblica Istruzione' in *Giornale del Centenario di Dante*, 20, 29, 42, 43.
15. Filippo Villani, 'De Cimabue, Giocto, Maso, Stephano et Taddeo pictoribus' in C. Frey, ed., *Il Libro di Antonio Billi*, Berlin, 1892, pp. 73 ff. Meiss, op. cit., note 3, here corrects all earlier accounts.
16. E. Schaeffer, *Das Florentiner Bildnis*,

Berlin, 1904, p. 25, and Excursus with bibliography.

17. Boccaccio, *Vita di Dante*, ed. D. Guerri, *Opere*, Vol. XII, Bari, 1918, pp. 32–3.

18. Passerini, op. cit., note 4, p. 25. In any case this idea is hard to reconcile with the claim made by Mather (op. cit., note 4) that the outlines of the Bargello portrait exactly match those of Dante's skull. It is a test which few portraits are likely to pass. But to examine its validity the proportions of many of the profiles occurring in the cycle and in trecento art altogether would also have to be measured.

19. Pier Liberale Rambaldi, 'Dante e Giotto nella letteratura artistica' in *Rivista d'Arte*, IX, 3–4, 1937; see also A. Chastel, 'Giotto coetaneo di Dante' in *Studien zur Toskanischen Kunst; Festschrift für Ludwig Heinrich Heydenreich*, Munich, 1963, pp. 37–44; reprinted in the author's *Fables, Forms, Figures*, Paris, 1978, I, pp. 378–86.

20. J. von Schlosser, 'Zur Geschichte der Kunsthistoriographie' in *Präludien*, Berlin, 1927, pp. 248 ff.

21. Villani, op. cit., note 15.

22. A. d'Ancona, ed., *Antonio Pucci, Per le Nozze Bongi-Ranalli* (15 June 1868).

23. R. H. Franz, *Antonio Pucci ein Wegbereiter der Renaissance*, 1935, p. 13, gives his dates as 1310–90. See also Feruccio Ferri, *La Poesia popolare di Antonio Pucci*, Bologna, 1909.

24. Ghiberti, *I Commentarii*, ed. Schlosser, II, p. 36. See also Salomone Mopurgo, 'Bruto, "il buon giudice" nell' Udienza dell'Arte della Lana in Firenze' in *Miscellanea di Storia dell'Arte in Onore di Igino Benvenuto Supino*, Florence, 1933, pp. 141–63.

25. *Le Vite*, ed. G. Milanesi, pp. 399–400. *Fortezza con l'animo* means, I would think, that the Judge is enjoined to be strong in mind, *Prudenza con le leggi*, prudent in legislation, *la Giustizia con l'armi e la Temperanza con le parole* suggests to me that he should take up arms in a just cause but be temperate in words—in short we have here a moral injunction which may well have been written somewhere on the painting.

26. N. Rubinstein, 'Political ideas in Sienese art: the frescoes by Ambrogio Lorenzetti and Taddeo di Bartolo in the Palazzo Pubblico' in *Journal of the Warburg and Courtauld Institutes*, XXI, 1958, pp. 179–207.

27. The text of these sonnets is reprinted by Mopurgo, op. cit., note 24.

28. *Tu che se' posto a regger con giustizia,*
 Ragione osserva in ogni tuo giudizio,
 Da te cacciando di superbia il vizio
 D'invidia mala, d'ira e d'avarizia,
 Dal gusto non dari(sic) non amicizia,
 Ma' ti rimuova, ma come Fabrizio,
 Sobrio, costante e fermo nell'ufizio
 In ben oprar diritto t'assercizia:
 Pronto all'udire e tardi al giudicare
 Odi ciascuna parte e poi sentenza
 Quel che ragion ti mostra che de' fare.
 Così facendo sempre, la potenza
 Del tuo comun vedrai multiplicare
 E'n pregio montar la tua Fiorenza.
 MSS: Magl. VII, 8, 1145, c. 86 b. Quoted Ferri, op. cit., note 23, pp. 145–6.

29. See Ferri, op. cit., note 23, p. 125.

30. Dante, *Purgatorio*, Canto I, 37.

31. See Rubinstein, op. cit., note 26.

32. Holbrook, op. cit., note 4, p. 136.

33. In 'the praise of Dante' published by A. d'Ancona, the term applies to the inscription on his tomb.

34. Michael Levey has drawn my attention to the fact that most of these Dante portraits look to the right while the Bargello head looks to the left.

35. Peter Murray has discussed the probable influence of this passage on Giotto's fame in his lifetime in 'Notes on some early Giotto sources' in *Journal of the Warburg and Courtauld Institutes*, XVI, 1953, pp. 58–80.

36. Walter Paatz, 'Die Gestalt Giottos im Spiegel einer zeitgenössischen Urkunde' in Erich Meyer, ed., *Eine Gabe der Freunde für Carl Georg Heise*, Berlin, 1950, pp. 85 ff.

37. 'Ed era Guelfo, e non fu Ghibellino' in the poem published by d'Ancona (see note 22).

38. Petrarch, *Senilia*, Lib. I, ep. V, *Opera*, Basel, 1581, pp. 745–6.

39. See Meiss, op cit., note 3, p. 42.

40. Ghiberti, *I Commentarii*, ed. Schlosser, II, p. 38.

41. L. Bruni, 'Vita di Dante' in J. R. Smith, *The earliest lives of Dante*, New York, 1901, pp. 90 ff.

42. See T. Hankey, 'Salutati's epigrams for the Palazzo Vecchio at Florence' in *Journal of the Warburg and Courtauld Institutes*, XXII, 1959, pp. 363–5.

43. Corrado Ricci, *L'Ultimo rifugio di Dante*, 2nd ed., Milan, 1921, p. 412.

44. Holbrook, op. cit., note 4, p. 172.

45. Cesare Marchisio, *Il Monumento pittorico a Dante in Santa Maria del Fiore*, Rome, 1956.

46. Pliny, XXXV, 2, 9.

LEONARDO ON THE SCIENCE OF PAINTING: TOWARDS A COMMENTARY ON THE 'TRATTATO DELLA PITTURA'

1. Carlo Pedretti, *The Literary Works of Leonardo da Vinci*. A commentary to Jean Paul Richter's edition, London, 1977, Vol. I, pp. 12–47.
2. *Leonardo da Vinci's Treatise on Painting (Codex Urbinas Latinus* 1270). Translated and annotated by A. Philip McMahon, Princeton, 1956 (here abbreviated as Cod. Urb. and McM). The translations in the text are my own.
3. Carlo Pedretti, *Leonardo da Vinci on Painting, a lost book (Libro A)*, Berkeley and Los Angeles, 1964.
4. V. Zubov, *Leonardo da Vinci* (trans. D. Kraus), Cambridge, Mass., 1968. Martin Kemp, *Leonardo da Vinci, The Marvellous Works of Nature and Man*, London, 1981.
5. See my 'Representation and Misrepresentation' in *Critical Inquiry*, XI, 2 December 1984, pp. 195–201.
6. 'Light, Form and Texture in Fifteenth Century Painting' in *The Heritage of Apelles*, Oxford, 1976, esp. pp. 32–5.
7. See my 'Experiment and Experience in the Arts' in *The Image and the Eye*, Oxford, 1982, esp. pp. 225–6.
8. John Ruskin, *The Elements of Drawing*, first published London, 1857, para. 152.
9. Cod. Urb. 54r, 77, 77v, 231v, 232, 232v, 233, 233v, 234, 234v, 235, 235v, 237v.
10. D. Linberg, *Theories of Vision from Al-Kindi to Kepler*, Chicago, 1976; see also Martin Kemp, op. cit. pp. 130 ff.
11. Cennino Cennini, *Il libro dell'arte*, edited and translated by Daniel V. Thompson, New Haven, 1932–3, p. LXXXV.
12. 'The Heritage of Apelles' in the volume of that name, Oxford, 1976.
13. John Ruskin, *Modern Painters*, London, 1843. Included in *The Works of John Ruskin*, eds. E. T. Cook and Alexander Wedderburn, 39 vols., London and New York, 1903–12.
14. McMahon exceptionally missed the meaning of the last paragraph because he, like other editors, decided to ignore the sequence of the sections in the Codex Urbinas, and in doing so separated two paragraphs on fol. 252r, making one part of his section 910 and the following one his section 920. A glance at the facsimile (Fig. 29) suffices to see that the words of the first paragraph 'come sia detto di sotto' refers to the ensuing section headed 'Delle trasparentie delle foglie' (on the transparencies of leaves) and not to the lower part of the tree nor (as Ludwig has it, who also rearranged the sections, 'Sein Ort (an den Baumblättern) ist, wie gesagt werden soll, unterwärts' (loc. cit. section 848), a wording which hardly makes sense (Heinrich Ludwig, *Das Buch von der Malerei*, Vienna, 1882).

 In fact the paragraph to which Leonardo refers the reader runs as follows: 'When the light is in the East and the eye sees the plant from below towards the West it will see the larger part of the tree to be transparent apart from those (leaves) which are in the shadow of other leaves; and the western part of the tree will be dark because it will be shaded by half the branches, that is the part that is turned towards the East.' (McM 928) Naturally it is this situation which the end of the previous paragraph promises to 'discuss below' (questa è situata come sia detto di sotto).

 Another minor source of confusion which prevented a proper evaluation of this important section lies in the fact that, having announced he would leave transparency 'on one side' and enumerated four shades, Leonardo disregards this numbering and refers to transparency as the second 'accident', which I have preferred to translate as 'the other', an alternative also chosen by Ludwig, who is correct at this point.
15. John Ruskin, op. cit., note 13, Part II, Section VI, Chapter 1.

LEONARDO AND THE MAGICIANS: POLEMICS AND RIVALRY

1. The references are to the new edition of the Codice Atlantico, *Il Codice Atlantico di Leonardo da Vinci, Edizione in Facsimile dopo il restauro dell'originale conservato nella Biblioteca Ambrosiano di Milano (Trascrizione diplomatico e critica di A. Marinoni)*, Florence, 1973 et seq. and to Jean Paul Richter's *Literary Works of Leonardo da Vinci* (here abbreviated as C.A. and R.). For references to the *Trattato* (except the *Paragone*, published by Richter) see note 2 of the previous chapter. Sometimes I have departed from the published translations. For the dating of the prophecies see Pedretti, *A Commentary to Jean Paul Richter's edi-*

tion . . ., Oxford, 1977, II, pp. 277 ff. For Leonardo's fables see H. Hudde, 'Natur statt Tradition: Leonardo da Vincis Fabeln' in *Idea*, Jahrbuch der Hamburger Kunsthalle, IV, 1985, pp. 53–73.

2. See A. Marinoni, *Leonardo da Vinci, Scritti letterari*, Milan, 1974, the most up-to-date edition of Leonardo's writings. (The number of prophecies cited in the text also includes some fragments.)

3. For Leonardo's period see the catalogue of the exhibition *Firenze e la Toscana dei Medici nell'Europa del Cinquecento*, 1980. *Sezione Astrologia, magia e alchimia* (pp. 313–435) by P. Zambelli (with extensive bibliography).

4. Vann'Anto, 'Gli indovinelli di Leonardo' in *Letteratura Moderna*, VII, 4, July-August 1956 (Milan, Università Bocconi), mentions various parallels between Leonardo's prophecies and popular riddles. See also G. A. Rossi, *Storia dell'enigmistica*, Rome, 1971, and M. de Filippis, *The Literary Riddle in Italy to the end of the Sixteenth Century*, University of California Press Publications in Modern Philology, Vol. 34, n. 1., Berkeley and Los Angeles, 1948.

5. *Poetics*, XXII, 1458a.

6. See C. Vasoli, 'Note su Leonardo e l'alchimia' in *Leonardo e l'età della Ragione*, eds. E. Bellone and P. Rossi, Milan, 1982, pp. 69–77. The dating is controversial and varies between about 1490 (Marinoni) and about 1510 (Pedretti).

7. For the scientific nature of the *Trattato* see also the preceding essay in this volume.

8. For the full text and dating see note 6.

9. F. Yates, *Giordano Bruno and the Hermetic Tradition*, London, 1964; D. P. Walker, *Spiritual and Demonic Magic from Ficino to Campanella*, London, 1958.

10. *Art and Illusion*, Oxford, 1960.

11. See my essay 'Illusion and Art' in R. L. Gregory and E. H. Gombrich, *Illusion in Nature and Art*, London, 1973, p. 191, where I cite the opinion of an eminent zoologist.

12. L. Beltrami, *Leonardo da Vinci, Documenti e Memorie*, Milan, 1919, Doc. 107 (letter of 3 April 1501 to Isabella d'Este from Fra' Pietro da Novellara).

13. Vasari, *Le Vite*, ed. Milanese, Florence, Vol. IV, 1879, pp. 23–4.

14. op. cit., p. 46.

15. op. cit., p. 47.

16. op. cit., p. 37.

17. K. T. Steinitz, *Leonardo Architetto Teatrale e Organizzatore di Feste*, Vinci and Florence, 1969.

18. According to Pedretti's reading the passage rendered by Richter as 'like openings (*bocche*) into hell' should be interpreted as 'like the voice (*boce = voce*) of hell', Pedretti, op. cit., Vol. I, p. 386.

19. For the dating around 1500 see Pedretti, op. cit., Vol. II, pp. 277, 291–3.

20. There exists an attempt to base a novel of 113 pages on this outline. I refer to the book, *The Deluge, Leonardo da Vinci*, edited by Robert Payne (a Lion Science Fantasy Novel, New York, Lion Books, 1955), where the 'editor' makes use of various fragments by Leonardo to construct the narrative of a fantastic dream, but, unhappily, it is of scant literary merit. A historical appendix argues that Leonardo possibly derived his inspiration from the apocalyptic sermons of Savonarola.

21. G. Castelfranco, *Studi Vinciani*, Rome, 1966, pp. 137, 148.

22. See the Catalogue of the exhibition 'Leonardo e le vie d'acqua', Milan and Florence, 1983.

23. Vasari, op. cit., p. 20.

IDEAL AND TYPE IN ITALIAN RENAISSANCE PAINTING

1. Erwin Panofsky, *Idea*, Hamburg, 1924. Eng. translation Columbia, USA, 1968.

2. Vicenzo Golzio, *Raffaello nei documenti, nelle testimonianze dei contemporanei e nella letteratura del suo secolo*, Vatican, 1936, pp. 30 ff.

3. M. T. Cicero, *De Inventione*, II.1, cited with several ancient parallels in J. Overbeck, *Die antiken Schriftquellen*, Leipzig, 1868.

4. Marsilio Ficino, 'Sopra lo amore over Convito di Platone', Florence, 1544, sixth speech, chapter 18 (slightly shortened).

5. Giovanfrancesco Pico della Mirandola to Pietro Bembo: *De Imitatione*, Sept. 1512, ed. Giorgio Santagelo, Florence, 1954, pp. 27 ff.

6. Itaque cum nostro in animo Idea quaedam et tamquam radix insit aliqua, cuius vi a quodiam muneris obeundum animamur, et tamquam ducimur manu, atque ab aliis quibusdam abducimur.

7. *Art and Illusion, A Study in the Psychology of Pictorial Representation*, New York and London, 1960.

8. Ancient references to these artists are cited by J. Overbeck, see note 3.

9. 'The Ideas of Progress and their Impact on Art', The Mary Duke Biddle Lectures, The Cooper Union, New York, 1971, privately printed (published in German as *Kunst und Fortschritt*, Cologne, 1978).

10. S. L. Alpers, 'Ekphrasis and aesthetic attitudes in Vasari's Lives' in *Journal of the Warburg and Courtauld Institutes*, XXIII, 1960, pp. 190–215.

11. The essential contribution to this interpretation is due to Emile Mâle, *L'Art religieux de la fin du Moyen Age en France*, Paris, 1908. See also my Walter Neurath Memorial Lecture, 'Means and Ends, Reflections on the History of Fresco Painting', London, 1976.

12. 'occhi spiritati', Proemio delle vite, Vasari, *Le Vite*, ed. G. Milanesi, Florence, 1878, I, p. 242.

13. R. W. P. Scheller, *A Survey of Medieval Model Books*, Haarlem, 1963.

14. Robert Oertel, *Fra Filippo Lippi*, Vienna, 1942, p. 36.

15. See my study of 'Leonardo's Grotesque Heads' in *The Heritage of Apelles*, Oxford, 1976.

16. Kenneth Clark, *Leonardo da Vinci*, Cambridge, 1952, p. 28.

17. *Vita* di Andrea del Verrocchio, ed. G. Milanesi, III, p. 364.

18. *Vita* di Raffaello da Urbino, ed. G. Milanesi, IV, p. 317.

19. See also my chapter 'The Leaven of Criticism in Renaissance Art' in *The Heritage of Apelles*, Oxford, 1976, pp. 119–20, with further bibliography.

20. K. Lange and F. Fuhse, *Dürers schriftlicher Nachlass*, Halle a.S., 1893, p. 300; for the following see also my chapter cited above in note 19.

21. See also my chapter 'Visual Discovery through Art' in *The Image and the Eye*, Oxford, 1982.

22. Lange-Fuhse, op. cit., note 20, p. 180.

23. Desmond Morris, *Manwatching, A Field Guide to Human Behaviour*, London, 1977, pp. 169 ff, after E. Hess, *The Telltale Eye*, New York, 1975.

24. 'The Primitive and its Value in Art' in *The Listener*, 15 and 22 February and 1 and 8 March 1979.

25. *The Sense of Order. A Study in the Psychology of Decorative Art*, Oxford, 1979.

RAPHAEL: A QUINCENTENNIAL ADDRESS

1. Bologna, 1762, pp. 157 ff. For the bibliography see J. Schlosser-Magnino, *La letteratura artistica*, Florence, 1956, p. 682.

2. For the text of the letter see V. Golzio, *Raffaello nei documenti*, Vatican, 1936, pp. 30–1. I have discussed the famous letter in the preceding essay in this volume.

3. See my book *Kunst und Fortschritt*, Cologne, 1978 ('The Ideas of Progress and their Impact on Art', The Mary Duke Biddle Lectures, The Cooper Union, New York, 1971, privately printed).

4. *Histoire de la vie et des ouvrages de Raphael*, Paris, 1824, pp. v–vi.

5. Reprinted in Heinrich Meyer, *Kleine Schriften*, Heilbronn, 1886; the quoted passage is on p. 208.

6. *Neu-deutsch religiös romantische Kunst* (1817), ed. cit. p. 101.

7. Cornelius Gurlitt, *Die deutsche Kunst im neunzehnten Jahrhundert*, Berlin, 1899, p. 44.

8. Hermann Uhde-Bernays, *Künstlerbriefe über Kunst*, Dresden, 1926, p. 350.

9. John Ruskin, *Modern Painters*, part IV, chapter 4, 'Of the False Ideal', in *The Works of John Ruskin*, ed. E. T. Cook and A. Wedderburn, London, 1903, Vol. V, pp. 70–90.

10. Jakob Burckhardt, *Gesamtausgabe*, IV, ed. H. Wölfflin, 1933, Vol. II, pp. 285 and 309.

11. Golzio, op. cit., note 2, p. 92.

12. For the earlier bibliography see Luitpold Dussler, *Raphael, A Critical Catalogue*, London, 1971. In his beautiful monograph on Raphael (London, 1948) Oskar Fischel attributes *The Battle of Ostia* exclusively to Giulio Romano. The main dissenting view is to be found in the article by Konrad Oberhuber, 'Die Fresken der *Stanza dell'Incendio* im Werke Raffaels' in *Jahrbuch der Kunsthistorischen Sammlungen in Wien*, n.f. XXII, 1962, but Roger Jones and Nicholas Penny, *Raphael*, New Haven and London, 1983, reject these 'gallant attempts to detect merits' in the designs of at least two of the frescoes.

13. For a full bibliography and a discussion of this drawing see the catalogue, *Raphael in der Albertina*, Vienna, 1983, under no. 39.

14. Erwin Panofsky, *The Life and Art of Albrecht Dürer*, Princeton, 1955, regarded the drawing as the product of the workshop but thought that Dürer had misinterpreted Raphael's gift. The main credit for its rehabilitation must go to John Shearman, writing in the *Burlington Magazine*, CI, 1959, pp. 456 ff. I have discussed some other aspects of the

workshop problem (in relation to Ghiberti) in *Tributes*, Oxford, 1984, p. 202.

15. For a convincing assessment of this situation and the problem it poses in the attribution of drawings from the later Roman period see the British Museum catalogue of *Drawings by Raphael* by J. A. Gere and Nicholas Turner, London, 1983, p. 164.

16. For both quotations see Golzio, op. cit., note 2.

17. Cecil Gould, 'Raphael versus Giulio Romano: the swing back' in the *Burlington Magazine*, August 1983, pp. 479–87.

18. Bernardino Baldi, *Memorie concernendo la città di Urbino*, Venice, 1590; see Golzio, op. cit., note 2, pp. 327–8.

THE ECCLESIASTICAL SIGNIFICANCE OF RAPHAEL'S 'TRANSFIGURATION'

1. The most recent review of the evidence and bibliography is the English edition of L. Dussler, *Raphael, A critical catalogue*, London and New York, 1971.
2. The letter by Leonardo Sellaio to Michelangelo of 19 January 1517 (V. Golzio, *Raffaello nei documenti*, Vatican, 1936) suggests that both Sebastiano and Raphael had started work by that time.
3. Matthew XVII, 1–20; Mark IX, 1–28; Luke IX, 28–43.
4. H. Lütgens, *Raffaels Transfiguration in der Kunstliteratur der letzten vier Jahrhunderte*, Göttingen, 1929. Some of these opinions are also quoted in H. von Einem, *Die 'Verklärung Christi' und die 'Heilung des Besessenen' von Raffael*, Abhandlungen der Akademie der Wissenschaften und der Literatur in Mainz, Geistes- und sozialwissenschaftliche Klasse, 1966, no. 5.
5. J. Pope-Hennessy, *Raphael*, London and New York, The Wrightsman Lectures, 1970, pp. 71–5.
6. E.g.: H. Wölfflin, *Classic Art*, London, 1952; S. J. Freedberg, *Painting in Italy, 1500–1600*, Harmondsworth, Middlesex, 1970, pp. 47–9 (The Pelican History of Art). After this article had been published, a much more elaborate interpretation was put forward by Catherine King, 'The Liturgical and Commemorative Allusions in Raphael's *Transfiguration and Failure to Heal*' in *Journal of the Warburg and Courtauld Institutes*, XLV, 1982, pp. 148–59.
7. K. Oberhuber, *Vorzeichnungen zu Raffaels 'Transfiguration'*, Jahrbuch der Berliner Museen, NF. IV, 1962. The drawing is illustrated in J. Pope-Hennessy, op cit., note 5, and H. von Einem, op. cit., note 4.
8. Most recently H. von Einem, op. cit.
9. O. Fischel, *Raphael*, London 1948, p. 282, sees Judas in the bearded Apostle with protruding lower lip, right in the centre of the composition. If Raphael

thought of him at all I should rather look for Judas in the isolated figure close to the margin of the group who lifts his hand. It is interesting that Vasari in his vivid description of the painting speaks of 'the eleven disciples at the foot of the mountain awaiting their master'. He obviously had not counted them, but assumed they would all be present, except Judas.

10. L. D. Ettlinger, *The Sistine Chapel before Michelangelo, Religious Imagery and Papal Primacy*, Oxford 1965, esp. Chapter VI, 'Oxford-Warburg Studies'.
11. Nicolaus de Lyra (*Postilla super totam Bibliam*, Strasbourg, 1492) to Matthew XVII, 1: 'Isti tres sunt assumpti ad videndum gloriam futurae resurrectionis propter prerogativam eminentiae spiritalis inter alios. Petrus enim propter fervorem fidei erat inter alios principalis propter quod et principaliter datae sunt ei claves ecclesiae ut patet precedenti capitulo. Johannes autem excellebat in prerogativa virginitatis, propter quod erat inter alios Christo magis familiaris. Jacobus autem inter alios discipulos primum sustinuit martyrium propter Christum.'
12. Nicolaus de Lyra, op. cit., to Matthew XVII, 16: 'Considerandum quod alii discipuli videntes quod non essent admissi ad secreta Christi sicut alii tres discipuli predicti aliquod humanum passi incurrerunt quendam motum turbationis et invidiae [...] Dixerunt ei: Quare nos non potuimus? Quia unum peccatum trahit ad aliud, inde est quod postquam incurrerant motum turbationis et invidiae contra alios apostolos [...] incurrunt quendam torporem in fide, ex quibus secutum est quod non potuerunt demoniacum curare.' According to Cornelius a Lapide's commentaries this interpretation goes back to Origen, who (contrary to other authorities) referred Christ's words 'O generatio incredula'

to the Apostles: 'Origenes censet haec dici ad novem Apostolos, qui, tribus cum Christo in Tabor ascendentibus, in valle cum turba remanserant: Nam hi soli lunaticum hunc curare tentaverant eo tempore, quo tres reliqui cum Christo transfigurando in montem secesserant. In hisce enim novem videtur fides Christi satis fuisse imminuta [...] tum quia Christo in monte cum tribus commorante reliquis nove, quasi cum plebe derelictis, torpor quidam fidei obrepserat.' (*Commentarii in Scripturam Sacram*, VIII, Lugduni, 1868, p. 838.)

13. Aldo de Rinaldis in *L'Illustrazione Vaticana*, VI, 1935.

14. C. J. Hefele, *Histoire des Conciles*, trad. française augmentée ... par H. Leclerq, VIII, 1, Paris 1917, pp. 528 ff.

15. In the Bull *Pastor Aeternus* issued by the First Vatican Council in 1517 (cf. C. J. Hefele, loc. cit.) it is stressed that not even the *auctoritas conciliaris* could oppose Papal authority. It appears that Giulio de' Medici also clung to this conviction during his Papacy as Clement VII, and did all in his power to prevent the convening of a General Council; cf. L. von Ranke, *Die Römischen Päpste*, Leipzig 1889, I, pp. 74–7.

16. 'Non enim doctas fabulas secuti notam fecimus vobis Domini nostri Jesu Christi virtutem et praesentiam; sed speculatores facti illius magnitudinis. Accipiens enim a Deo Patre honorem et gloriam voce delapsa ad eum hujuscemodi a magnifica gloria: Hic est Filius meus dilectus, in quo mihi complacui; ipsum audite. Et hanc vocem nos audivimus de coelo allatam, cum essemus cum ipso in monte Sancto.'

17. The inscription is not always legible on old photographs but clear in the illustration given by H. von Einem (op. cit.).

'THAT RARE ITALIAN MASTER...': GIULIO ROMANO, COURT ARCHITECT, PAINTER AND IMPRESARIO

1. This essay is based on the introductory chapter of my doctoral thesis *Giulio Romano als Architekt* submitted to the University of Vienna in the spring of 1933. The chapter dealing with the Palazzo del Te and other extracts were published under the title 'Zum Werke Giulio Romanos' in the *Jahrbuch der Kunsthistorischen Sammlungen in Wien*, N.F. VIII, 1934, and IX, 1935, and in an Italian translation in *Quaderni di Palazzo Te*, July–December, I, 1984.

2. F. Hartt, *Giulio Romano*, New Haven, 1958.

3. E. Verheyen, *The Palazzo del Te in Mantua, Images of Love and Politics*, Baltimore, 1977. See also my review in the *Burlington Magazine*, CXXII, January 1980.

4. *Studi su Giulio Romano, Omaggio all'Artista nel 450' della venuta a Mantova, (1524–1974)*, Accademia Polironiana, San Benedetto Po, 1975.

5. For a survey of these testimonials see P. Carpeggiani, 'La fortuna critica di Giulio Romano architetto' in *Studi su Giulio Romano...*, 1975, op. cit.

6. J. Cartwright, *Isabella d'Este*, London, 1903, II, pp. 53, 72–4.

7. B. Cellini, *La vita scritta da lui medesimo*, Chapter XXX, Florence, 1901.

8. P. Aretino, *Il Primo libro delle lettere*, 1537, Nos. IX, CCCXXI.

9. Vasari, *Le Vite*, ed. Milanesi, V, pp. 395 ff; Life of Marcantonio Bolognese.

10. P. Carpi, 'Giulio Romano ai servigi di Federico II Gonzaga' in *Atti e Memorie della R. Accademia Virgiliana di Mantova*, Mantua, 1920, Doc. I.

11. *Studi su Giulio Romano...*, 1975, op. cit., note 4, p. 44.

12. B. Cellini, *La vita*, op. cit., Chapter XL.

13. A contemporary description of the decorations on the processional road, designed by Giulio, is translated in F. Hartt, op. cit., pp. 269–70.

14. C. d'Arco, *Delle Arti e degli Artefici di Mantova*, Mantua, 1857, No. 147; this letter is not listed in Hartt.

15. The only detailed account is in the reports on the restoration carried out under the direction of Clinio Cottafavi, *Bollettino d'Arte*, IX, 1929/30, pp. 276 ff.

16. See above note 12.

17. The full text is printed in the article by P. Carpi, 1920, op. cit. I should like to thank Dr David Chambers and Dr Laura Lepschy for help in the elucidation of some obscure terms.

18. P. Piva, 'Giulio Romano e la Chiesa Abbaziale di Polirone', an important paper printed in *Studi su Giulio Romano...*, 1975, op. cit.

19. We only have Vasari's word for this, but since he reported it in his first edition of 1550 less than four years after the event (which must have been public knowledge) there is no reason to doubt it.

20. See the letter published by Jane Martineau in David Chambers and Jane Martineau, eds, *Splendours of the Gonzaga*, exh. cat., Victoria & Albert Museum, 1981, p. 196.
21. See the second of my articles, op. cit., p. 126, note 1.
22. F. Hartt, 1958, op. cit., p. 194, note 1.
23. The latest discussion of the passage known to me is G. Bullough, *Narrative and Dramatic Sources of Shakespeare*, London, 1975, VIII, p. 150.
24. P. Aretino, *Tutte le Commedie*, a cura di G.B. de Sanctis, Milan, 1968.
25. *Jacopo: Andiamo, maestro, in fine a San Bastiano, volli dire al Te, che forse Giulio Romano averà scoperto qualche istoria*

divina. Pedante: Eamus: o che bella macchina è il palazzio che da la architettura del suo modelliculo è uscito: Vitruvio prospettive prisco ha imitato.
26. *Pedante: Si pictoribus, un Tiziano emulus naturae immo magister, sarà certo fra Sebastiano de Venetia divinissimo. E forse Julio Romano curiae, e de lo Urbinate Rafaello alumno.*
27. *Quattro Comedie del Divino Pietro Aretino*, printed in London by John Wolf, 1588. On this printer see M. Bellorini, 'Le pubblicazioni italiane dell'editore londinese John Wolf, 1580–1591' in *Miscellanea*, I, 1971, pp. 17–65. The author argues (p. 41) that these editions were not intended only for the Italian market.

ARCHITECTURE AND RHETORIC IN GIULIO ROMANO'S PALAZZO DEL TE

1. *Studi su Giulio Romano . . .*, Accademia Polironiana, San Benedetto Po, 1975, and see the preceding essay in this volume, pp. 147–60.
2. The best access to the large bibliography of this topic is still provided by the record of the Section on Mannerism in the *Acts of the Twentieth International Congress of the History of Art*, Princeton, N.J. 1963 (with contributions by Craig Hugh Smyth and John Shearman). My own introduction to that section is reprinted in *Norm and Form*, London, 1966.
3. See note 1 of the preceding essay.
4. See my 'Focus on the Arts and Humanities' in *Tributes*, Oxford, 1984, p. 14.
5. See my review of Egon Verheyen's *The Palazzo del Te in Mantua*, Baltimore, 1977, in the *Burlington Magazine*, January 1980, pp. 70–1.
6. See in particular, E. Verheyen, 'Jacopo Strada's Mantuan Drawings of 1567/68' in the *Art Bulletin*, XLIX, 1967–9, and K. Forster and R. Tuttle, 'The Palazzo del Te' in *Journal of the Society of Architectural Historians*, XXX, 1971, pp. 267–93. For the subsequent literature see the Catalogue of the Exhibition, *Splendours of the Gonzaga*, eds. David Chambers and Jane Martineau, Victoria & Albert Museum, London, 1981.
7. Sebastiano Serlio, *Regole generali di Architettura*, Venice, 1537, Libro IV, p. 133v.
8. Munich, Staatsbibliothek, cod. icon, N. 190, based on Book VI of the treatise by Polybius devoted to Roman encampments.
9. J. Shearman has drawn attention to the importance of the theory of rhetoric. See

his 'Giulio Romano: tradizione, licenze, artifici' in *Architettura Bollettino del Centro Internazionale di Andrea Palladio*, IX, 1967, pp. 354–68.
10. *Denys d'Halicarnasse, La Composition Stylistique*, ed. G. Aujac, Paris, 1981, VI, p. 22.
11. Demetrius, *On Style*, ed. W. Rhys Roberts, Hildesheim, 1969, V, pp. 299–300.
12. M. T. Cicero, *The Orator*, XXIII, 77, 78.
13. Baldassare Castiglione, *Il libro del Cortegiano*, I, Chapters 26–8, Venice, 1527.
14. S. Serlio, *Regole*, loc. cit. The description of Fig. 155 reads as follows: 'This gate has elements of the Doric, the Corinthian, the Rustic and also (to tell the truth) of the bestial: the columns are Doric, their capitals are a mixture of the Doric and the Corinthian, the pilasters around the gate are Corinthian in their decorative detail and so is the architrave, the frieze and the cornice. The whole gate is surrounded by the Rustic as will be seen. As to the bestial order, it cannot be denied that since there are a few stones made by nature which have the shape of beasts, they are bestial work.'
15. G. Vasari, *Le Vite*, ed. G. Milanesi, VII, Florence, 1881, p. 193.
16. Torquato Tasso, *Aminta*, Act I, Scene 2.
17. As cited above under note 6.
18. E. Verheyen as cited above under note 5.
19. Leonardo Bruni, *Epistolarum*, Lib. VIII, ed. Mehus, Florence, 1741, Lib. VII, epistola 4.
20. Plato, *Sophist*, L. 266c.

MICHELANGELO'S CARTOON IN THE BRITISH MUSEUM

1. Johannes Wilde, *Italian Drawings in the Department of Prints and Drawings in the British Museum, Michelangelo and his Studio*, London, 1953, No. 75.
2. Wilde, loc. cit.
3. Wilde, loc. cit.
4. *Drawings by Michelangelo . . .*, An Exhibition held in the Department of Prints and Drawings in the British Museum, 6 Feb. to 27 April 1975, No. 153.
5. *Patrologia Graeca*, XLI, 173–1199; XLII, 11–831.
6. The following passages from the New Testament are relevant: Matthew I, 25; Matthew XIII, 54–6 (Mark VI, 3); Mark III, 31 (Luke VIII, 19) John VII, 3; Acts I, 14; and Galatians I, 19. See James Hastings, ed., *A Dictionary of the Bible*, Edinburgh, 1898, pp. 320–6, with bibliography.
7. St Jerome, *De Perpetua Virginitate B. Mariae, Adversus Helvidium* (written in 387), *Patrologia Latina*, XXIII, 193–216.
8. *Patrologia Graeca*, XLII, 709–10.
9. Various women called Salome in the Gospels and in legend were sometimes identified in later accounts, see *Enciclopedia Cattolica*, X, Città di Vaticano, 1953, s.v. Salome.
10. Pierre de Nolhac, 'Les Collections de Fulvio Orsini' in *Gazette des Beaux Arts*, XXIX, 1884, p. 433: 'Quadro grande corniciato di noce con un cartone d'una Madonna et un S. Giuliano et altre figure, di mano di Michelangelo.'
11. F. G. Hollweck, *A Biographical Dictionary of Saints*, London, 1924. I am greatly indebted to Mrs Jill Tilden for spotting this vital piece of evidence.
12. Walther Buchowiecki, *Handbuch der Kirchen Roms*, Vienna, 1967–74, II, pp. 87 ff.
13. James Ackerman, *The Architecture of Michelangelo*, London, 1971, pp. 340–1.
14. P. Guérru, ed., *Les Petits Bollandistes, Vie des Saints*, Paris, I, 1978 (9 January).
15. Karl Künstler, *Ikonographie der christlichen Kunst*, Freiburg-im-Breisgau, I, 1928, p. 331; Engelbert Kirschbaum, S. J., *Lexikon der christlichen Ikonographie*, Rome etc., IV, 1972, pp. 163–7. There is a painting by Perugino of this subject in the Museum of Marseille (cf. Venturi, *Storia dell'arte italiana*, VII, 2, p. 560).
16. K. J. von Hefele, *Histoire des Conciles*, Paris, 1907–52, pp. 6, 182, 516; Paolo Sarpi, *Istoria del Concilio Tridentino*, Florence, 1966, II, pp. 748, 769.
17. Ascanio Condivi, *Vita di Michelangelo Buonarroti*, ed. Antonio Maraini, Florence, 1927, pp. 29–30.

SOURCES OF PHOTOGRAPHS

The publishers would like to thank all the private owners, institutions and museum authorities who have kindly allowed works in their collections to be reproduced. Every effort has been made to credit all persons holding copyright or reproduction rights. Particular thanks are due to the many institutions who have agreed to waive all or part of their normal fees in order to subsidize the cost of including the colour plates.

III, 22, 118: Gemäldegalerie, Staatliche Museen Preussischer Kulturbesitz, Berlin (West); 64: © A.C.L. Brussel; 1, 4, 5, 6, 10, 25, 60a, 60b: Archivi Alinari, Florence; II, V: Scala, Florence; 11, 140: Gab. Fotografico, Soprintendenza benì Artistici e Storici di Firenze; 3: Universitäts-Bibliothek Heidelberg (Cod. Pal. Germ. 848 (Grosse Heidelberger Liederhandschrift 'Codex Manesse'), fol. 124r); 96, 101, 108, 121, 156: Reproduced by Courtesy of the Trustees of the British Museum; VI: Photo courtesy A.F. Kersting, London; 2: Photo courtesy Marlborough Fine Art (London) Ltd. (© Tom Phillips, reproduced by kind permission of the artist); 30, 62, 75, 76, 90, 115, 127, 142: Reproduced by courtesy of the Trustees, The National Gallery, London; 143, 145, 146, 147, 148, 153: Studio Fotografico Giovetti, Mantua; 66; Bildarchiv Foto Marburg; 114; © 1986 by the Metropolitan Museum of Art; 138: Photo courtesy the Ashmolean Museum, Oxford; 111: The Governing Body, Christ Church, Oxford; I: Cliché des Musées Nationaux, Paris; 13–19, 23, 24a, 29, 32, 34–36, 39, 40, 41a, 42a, 43a, 44: taken from the facsimile edition of 1956 of the Codex Urbinas by kind permission of the publishers, Princeton University Press; IV, 37, 38, 48–55, 97–100, 106, 107, 109, 110, 116: Copyright reserved, Reproduced by gracious permission of Her Majesty The Queen; 83 (Samuel H. Kress Collection), 123 (Widener Collection 1942): National Gallery of Art, Washington.

Bibliographical Note

Details of the previous publication of the essays in this volume are as follows:

GIOTTO'S PORTRAIT OF DANTE? The *Burlington Magazine* Sixth Annual Lecture delivered on 23 April 1979 at the National Portrait Gallery, London, and published in the *Burlington Magazine*, CXXI, August 1979, pp. 471–81. © The Burlington Magazine.

LEONARDO ON THE SCIENCE OF PAINTING: TOWARDS A COMMENTARY ON THE TRATTATO DELLA PITTURA. Expanded version of a contribution to *Leonardo e l'età della Ragione*, eds. Enrico Bellone and Paolo Rossi, Milan, 1982, pp. 141–54, delivered at the Congress of that name on 29 September 1982.

LEONARDO AND THE MAGICIANS: POLEMICS AND RIVALRY. A lecture delivered in Italian on 16 April 1983 at Vinci during the annual celebrations of Leonardo's birthday and published as *Lettura Vinciana* XXIII by Giunti Barbera, Florence.

IDEAL AND TYPE IN ITALIAN RENAISSANCE PAINTING. The Gerda Henkel Lecture, delivered in German in Düsseldorf on 29 March 1982 and published by Westdeutscher Verlag, Opladen, 1983.

RAPHAEL: A QUINCENTENNIAL ADDRESS. A shortened Italian version of this address was delivered on 14 April 1983 on the Capitol in Rome at the inaugural ceremony of the quincentenary of Raphael's birth and published without notes in *Accademie e Biblioteche d'Italia*, LI, 4–5, 1983, pp. 250–8. The English version was first published in *Art History*, VII, June 1984, pp. 164–75. © RKP 1984.

THE ECCLESIASTICAL SIGNIFICANCE OF RAPHAEL'S 'TRANSFIGURATION'. First published in *Ars Auro Prior*, Studia Ioanni Bialostocki Sexagenario Dicata, Warsaw, 1981, pp. 241–3.

'THAT RARE ITALIAN MASTER...' GIULIO ROMANO, COURT ARCHITECT, PAINTER AND IMPRESARIO. First published in *Splendours of the Gonzaga*, eds. David Chambers and Jane Martineau, Catalogue of an exhibition at the Victoria & Albert Museum, London, 1981, pp. 76–85.

ARCHITECTURE AND RHETORIC IN GIULIO ROMANO'S PALAZZO DEL TE. Revised version of a lecture delivered in Italian at that Palazzo in Mantua on 30 August 1982 and published in *Quaderni di Palazzo Te*, I, June–December 1984, pp. 17–21.

MICHELANGELO'S CARTOON IN THE BRITISH MUSEUM. Not previously published.

Index